For the Millions

THE ARTS AND INTELLECTUAL LIFE IN
MODERN AMERICA

Casey Nelson Blake, Series Editor

A complete list of books in the series
is available from the publisher.

For the Millions

American Art and Culture Between the Wars

A. Joan Saab

PENN

University of Pennsylvania Press
Philadelphia

10 9 8 7 6 5 4 3 2 1

Published by
University of Pennsylvania Press
Philadelphia, Pennsylvania 19104-4011

Library of Congress Cataloging-in-Publication Data

Saab, A. Joan.
 For the millions : American art and culture between the wars / A. Joan Saab.
 p. cm.—(The arts and intellectual life in Modern America)
 Includes bibliographical references and index.
 ISBN 0-8122-3818-4 (cloth : alk. paper)
 1. Art, American—20th century. 2. United States—Civilization—1918–1945. I. Title. II.
Series.

N6512.S213 2004
709'.73'09043—dc22 2004042042

For Steve, Finn, and Wilson

Contents

Introduction
The Democratization of American Culture

In a short pamphlet entitled *American Taste* (1929), the cultural critic Lewis Mumford lamented "the general debacle of taste" in the United States from the mid-nineteenth through the early twentieth century. "What," he asked, "has made American taste so sickly and derivative, a mere echo of old notes which reverberate in the halls of museums or tremble dimly in ancient homes and forgotten attics?" "What," he continued, "caused the collapse of taste during the last hundred years, and what is responsible for its present anemia—a pathetic state in which beauty lives for us only through repeated 'transfusions from other cultures'?"[1] For Mumford, bad taste was a symbol of larger social and cultural crises brought on by increased industrialization and what he saw as a growing schism between art and everyday life. Like many critics at the time, Mumford was interested in creating a uniquely American aesthetic, one divorced from an imported past and firmly rooted in the tenets of participatory democracy. The derivative nature of American culture, its reliance on European styles, and its relegation to museum halls, ancient homes, and forgotten attics demonstrated to him the degree to which aesthetics had been removed from American public life. In *American Taste*, as in much of his other writing, Mumford echoed Walt Whitman's demands for "a program of culture, drawn out, not for a single class alone, or for the parlors or lecture rooms, but with an eye to practical life"; in other words, he joined in the quest for a democratic aesthetic.[2]

Like Whitman, Mumford located his aesthetic in "practical life." For him, the "seventeenth-century American farmhouse, with its usable kettles and pans, its neatly paneled walls with a simple checked molding . . . was the last example in America of a healthy tradition, untainted by foreign modes and meaningless precedents and strange fashions."[3] According to Mumford, in the intervening two hundred years, in large part as a result of industrialization, "American taste retreated from the contemporary stage, and sought to build up little ivory towers of 'good taste' by putting together

fragments of the past." Despite the nostalgic tone of his piece, Mumford located "active taste" not in the past but in the present and said it must be rooted in usefulness; "it must live primarily in its own time" and "show its respect for the past by leaving it where it belongs." Mumford was guardedly optimistic about the future of American taste and concluded his essay by forecasting a change in cultural consciousness: "When American taste recognizes that there is more aesthetic promise in a McAn shoe store front, or in a Blue Kitchen sandwich palace than there is in the most sumptuous showroom of antiques . . . we shall, perhaps, have the opportunity to create form throughout our civilization."[4]

While today we may have learned from Las Vegas, in 1929 Mumford's choice of a sandwich joint and a shoe-store display as the site for the country's aesthetic salvation marks an important turning point in the still ongoing national quest to link art and democracy.[5] Rather than focus exclusively on what Mumford was lambasting, "the sickly and derivative" nature of American art, we should instead examine the forms he applauded, the McAn shoe-store front and the Blue Kitchen sandwich palace. Indeed, fifty years after *American Taste*, the postmodern philosopher Jean Baudrillard famously echoed Mumford when he wrote, "The Freeways, the Safeways, the skylines, speed and deserts—these are America, not the galleries, churches and culture."[6] Mumford's 1929 lament and Baudrillard's 1986 pronouncement can be seen as part of a larger social and cultural dialogue, one that reaches back to the nineteenth-century transcendentalist writings of Ralph Waldo Emerson and Henry David Thoreau as well as forward to more recent debates over the role of National Endowments for the Arts and Humanities regarding the place of art within a democratic culture. *American Taste* and its suggestions to leave the "little ivory towers" dependent upon the "ancient banquets of art" and raise contemporary storefront and fast-food architecture to a higher cultural plane mark a key episode in this history.

The decade of the 1930s was perhaps the most significant era in this broader historical effort to link art and democracy. The desire to locate, or create, a cultural foundation for participatory democracy seemed to escalate during the Depression as a diverse public participated in wide-ranging debates over the meanings and forms that the fine arts could take.[7] It is this pervasive and passionate belief in the power of art to do good—as opposed to present-day lamentations that much contemporary art is dangerous and corrupting—that I find particularly compelling.[8] Unfortunately, there are a wealth of contemporary examples in which art has been coded nefarious,

or worse, as irrelevant to American life: the debates over Richard Serra's *Tilted Arc* in the 1980s; the continued hysteria surrounding the exhibition of the work of Robert Mapplethorpe (in 1989 at the Corcoran Museum in Washington, D.C., in the 1990 Cincinnati obscenity trial, and in the recent controversies around Richard Meyer's inclusion of Mapplethorpe's image of the young Jesse McBride in his 2002 book *Outlaw Representation*); and the brouhaha over the *Sensation* exhibit at the Brooklyn Museum in 1999. This is not to say that no one charged the art of the 1930s as "subversive" and "degenerate"—for there were such voices—but unlike contemporary debates over the "culture wars," in which the debate has been dominated by politicians, religious leaders, academics, and critics, during the 1930s members of the general public repeatedly and passionately embraced the possibility that art was important and that it could transform American society in positive ways.[9]

In the early twentieth century, new definitions of culture as a totalizing way of life borrowed from anthropology and sociology challenged the prevailing genteel definition put forth by Matthew Arnold as "the best which has been thought and said in the world."[10] Mumford was part of a radical group of public intellectuals and critics who were disillusioned by what they saw as the cultural bankruptcy of industrial capitalism and who embraced the new possibilities offered by more experiential definitions of culture. Frustrated by the state of American taste and its reliance on cultural hierarchies based on pseudoscientific calibrations of brow height, Mumford joined with his contemporaries Randolph Bourne, Van Wyck Brooks, and Waldo Frank in the search for what Brooks called a "usable past" and a "genial middle ground" upon which to base American cultural and civic life.[11] The practice Mumford described as the building up of "little ivory towers of good taste" closely mirrors what sociologist Paul DiMaggio and historian Lawrence Levine each have termed "the sacralization of culture," a process that took place in the late nineteenth and early twentieth centuries and led to rigid distinctions between "highbrow" and "lowbrow" forms of culture.[12] Yet as Levine has argued, the classifications of highbrow and lowbrow were not "natural products of long standing" but "relatively recent categories" that were "rooted in a quest for intellectual and cultural authority." By exploring changing audiences for Shakespeare and opera in nineteenth-century America, Levine aptly demonstrates that the "panoply of cultural creations, attitudes, and rituals which we have learned to call high culture was not the imperishable product of the ages but the result of

a specific group of men and women acting at a particular moment in history."[13]

Indeed, by the late nineteenth century, taste had become a tool of cultural hegemony, a means of delineating and enforcing class boundaries within the atmosphere of enormous economic and cultural change that accompanied what historian Alan Trachtenberg has termed the "incorporation of America."[14] Late nineteenth- and early twentieth-century cultural elites created institutions that they could control and manage. They drew and policed clear boundaries between art and entertainment, between the Metropolitan Museum of Art and Coney Island, and developed a new relationship between the audience and the work of art based on exclusion. Nonelites were allowed, and in many cases encouraged, to visit the hallowed galleries of these large urban institutions, but those in charge had a definite agenda regarding their experience of the spaces as well as the collections within them.[15] As a trustee of the Philadelphia Museum of Art declared in 1922, "A large number of our visitors are foreign born or of foreign parents. To them the museum must take the place of the cathedral."[16]

Within these cathedrals of culture, an emphasis on the authenticity of the art object became a means of asserting cultural control. To this end, nineteenth-century elites fetishized the artwork's aura—the quasi-spiritual qualities with which we imbue an original based on how its presence in the present gives us a sense of being proximate to the unique moment of its creation—to offer lessons in class and citizenship based on passive spectatorship.[17] Art became didactic, something to be looked at with reverence to promote what elites considered "proper" behavior, quiet contemplation, and orderly conduct. For the most part, their efforts worked. The boundaries between high and low art and the audiences for each were solidified. "Art" was something sacred, the property of the elite and the comfortably middle class.

During the early twentieth century, however, a variety of individuals and institutions began to look for ways to challenge the sacred aura of art and transform older notions of cultural capital by *desacralizing* art and making it accessible to a larger part of the public.[18] Realizing that taste was not just about class distinctions, these individuals focused on locating a more democratic aesthetic divorced from, or oblivious to, the market and rooted in experiential and other social factors.[19] Like Mumford, they often measured value in terms of the object's usefulness rather than its unique or timeless aura as they attempted to link art and democracy as a way of

announcing the country's cultural maturity that would parallel the nation's emerging superpower status.[20]

The United States had emerged from World War I as an economic and military power. Culturally, however, many critics argued that the country lacked a distinct aesthetic tradition, particularly one that reflected its democratic foundations. In 1929, for example, Waldo Frank labeled the United States "the grave of Europe." He wrote, "We built our towns, our morals, our politics, our dogmas, our manners, our arts, from the relics of a world that is no longer dramatically ours and that was not America, and that is dying. Almost everything that popularly goes for 'culture,'" he continued, "art, literature, rhetoric, beauty, values, rituals—are all transplanted parts of a dead whole."[21] That same year, nativist art historian Thomas Craven argued in his essay "The Curse of French Culture" that American art was old and sterile and that its practitioners were artistic and financial failures. Craven believed that American artists would not be able to create a viable native art by copying the French because "the American soil could not nourish a metaphysical imported style."[22] While Craven's antimodernist stance differed from Frank's liberal outlook, the two agreed upon the need for an art with American antecedents that scorned European domination.

Prior to this point, the American art world had indeed been dominated by European models in terms of style, subject matter, and display and sales techniques. The National Academy of Design, opened in 1825 and the most powerful institution in the nineteenth-century American art world, for example, was modeled directly on the French salon system. Artists met with patrons and competed for attention at the academy's yearly exhibitions. Such an arrangement reinforced sacred notions of culture, since both the artists and the patrons of the academy tended to be upper-class white men whose transactions were premised on personal relationships. The National Academy's salon-style system of patronage shifted at the turn of the twentieth century with the arrival of the art dealer as a major player in the American market. This new system did not, however, present a major challenge to the Eurocentric, sacred model of art, which had preceded it. On the contrary, by recommending art as a sound investment to the emerging mercantile classes, these dealers solidified the idea of art's timelessness by promoting the works of Old Masters and contemporary European artists.[23] The sacred aura of the artwork had market value.

In the first part of the twentieth century, two major groups of artists emerged to challenge the Eurocentric model and transform the American art world: the modern artists who gathered around the German-born pho-

tographer Alfred Stieglitz at his New York studio and gallery, known as 291, and the group of former newspaper sketch artists known as the Eight or the Ash Can school. The Eight followed the aesthetic mandates of the artist Robert Henri, who urged them to reject conventional notions of beauty and to "bring to the public a greater consciousness of the relation between art and life" by painting works that "would reflect the actual life and character of the people," even "that commonly regarded as ugly."[24] Through his gallery spaces, Stieglitz championed the work of then lesser-known American artists such as Paul Strand, Charles Demuth, and Georgia O'Keeffe whose work celebrated indigenous American forms such as grain elevators, skyscrapers, and artifacts from the American Southwest. Through regular shows of their works, he transformed the American art market, allowing artists rather than dealers to dictate public tastes.[25] Stieglitz was also an important figure in not only introducing European modernism to New York audiences but also applying these radical new styles in an American context. The Stieglitz group regularly experimented with avant-garde techniques. They incorporated the nonrepresentational styles and colors of fauvism, expressionism, and cubism into their depictions of American life. For American modernists at Stieglitz's gallery the American scene was a jumble of dynamic spaces and discordant sounds that easily lent themselves to abstract renderings.

The artists of the Ash Can school also found inspiration in the activities of daily life that surrounded them. Their paintings contained representations of common people engaged in mundane chores and popular entertainments: washerwomen hanging laundry, late-night boxing matches, commercial movie halls, and grimy tenement fire escapes all became subjects for their cameras and brushes.[26] While the Ash Can painters were revolutionary primarily by the nature of their subject matter and the Stieglitz group were revolutionary in their styles and attitudes toward the art market, neither group used art in the service of direct social change at this particular moment in time.[27] Yet both Stieglitz and Henri and their followers contributed to broadening the audience for art in the United States by championing American artists and American themes.[28] Although they did not really transform conventional definitions of what constituted a work of art, by including the quotidian in their frames and working toward a uniquely American aesthetic they set the stage for the more overt democratizing efforts of the 1930s and created an iconography of modernism rooted in distinctly American forms and technologies—the skyscraper, the assembly line, and mass-produced consumer goods.[29]

In part as a result of Stieglitz and Henri's efforts on behalf of American art, by the late 1920s and early 1930s a number of artists and critics had begun celebrating the possibility of finally realizing a democratic American art, one that both represented the American landscape and reached the American public. In his 1928 book *The American Renaissance*, art historian R. L. Duffus noted that "America, having expressed herself politically, mechanically and administratively, is on the point of attempting to express herself aesthetically. This has been thought before . . . but now one believes it to be true."[30] Duffus's assertion that "this has been thought before" speaks to the country's longstanding desire to link art and democracy as a means of announcing America's cultural maturity. Throughout the 1930s, Whitman's 1871 challenge that "democracy can never prove itself beyond cavil, until it founds and luxuriantly grows its own forms of art, poems, schools, theology, displacing all that exists, or that has been produced anywhere in the past, under opposite influences" gave way to debates over what these art forms should look like and how they should be produced. Now, instead of forecasting the possibility of an art that was both uniquely American and democratic, critics began announcing its arrival. They began addressing head-on the crisis that Mumford had articulated in *American Taste*. In 1932, for example, Peyton Boswell, editor of *Art Digest*, identified the birth of "a moment looking forward to the production of works that avoiding foreign influences, actually expresses the spirit of the land," and later that year, *New York Times* art critic Edward Alden Jewell excitedly exclaimed, "Today with pride that has no need to wear the tinkling bells of jingoism, we see the work of our artists taking a place that is second to none."[31] The transformation of American art and culture had begun.

In the academy, the quest for distinctly "American" cultural forms— be they found in art or literature—has been one of the central issues guiding American cultural historians and scholars in American Studies during the past century. Indeed, it was at the core of the myth and symbol analysis that marked the latter's birth as a field of inquiry.[32] It is also central, albeit as a foil, to much current cultural studies scholarship that challenges the idea of distinct, homogeneous cultural experience as well as the notion of "America" itself as a unified concept.[33] Although the focus on American exceptionalism has the potential to encourage unwieldy generalizations, flagrant racism, and xenophobia, as well as intellectual patriotism, the question of what is "American" about American culture persists.[34] And while a handful of contemporary scholars, myself included, may be put off by such a blatantly nationalistic project, the desire to locate a distinctly American

art remains. Instead of dismissing this quest, then, as a form of aggressive cultural nationalism, I have chosen to approach it from a different angle by focusing on the moment during which, in addition to questioning what democracy in art would look like, a diverse group of individuals and institutions not only began to announce its arrival but also attempted to share it with a wider public, in both theory and practice. Cries for a national art form and desires to link democracy to the arts seemed to escalate during the 1930s, as debates over what constituted "America," and who defined the arts took new form and reached a much larger audience than ever before. Many of the participants in these debates were already aware of the constructed nature of the idea of "America," and they self-consciously attempted to include those previously outside of its purview within their new constructions and in so doing to democratize cultural capital.

The often contentious relationship between art and democracy is central to my book. In many ways, linking the two concepts contains an inherent contradiction. In the traditional sense, the "work of art" connotes something special and unique. It is something done by the "artist," a position often held by outsiders (geniuses, oddballs, visionaries, cranks). Democracy, in contrast, is a political system premised on equal rights and the will of all the people.[35] Yet, by coding their work as "democratic," a variety of American government officials, individual artists, and private institutions stretched the boundaries and uses of art to include such diverse things as common household goods, after-school workshops, unemployment relief, department store displays, and world's fair exhibits. Throughout the 1930s, the idea of democracy in art encompassed a variety of competing agendas, including those of left-wing individuals within the Communist Party USA, Madison Avenue advertising executives advocating democracy through equal access to consumer goods, and nativist critics promoting nostalgic agrarian models of a democratic nation. "Art" during this period included the outright propaganda of radical artists in the John Reed Club, machine-made commercial goods, realist tableaus, and abstract representations of "the American Scene." All were presented as "democratic," and in many cases these diverse styles and works directly challenged one another.

Perhaps the elasticity of these two terms, democracy and art, sprang from the social and political conditions of the day. Much like the definition of art, the meaning of democracy was visibly open to debate during the 1930s. The seemingly relentless hardships of the Great Depression prompted many Americans to question consumer capitalism and its links to democratic government. Simultaneously, the rise of socialism and fascism in Eu-

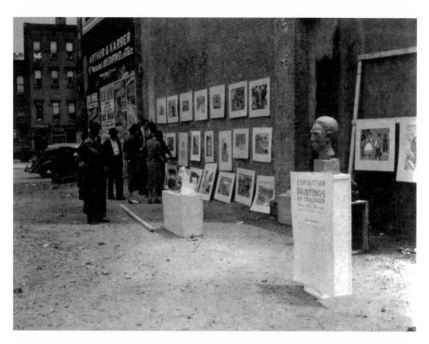

Fig. 1. Art exhibit in an alley, New York City, c. 1938. As part of its effort to broaden the audience for art in America, the WPA sponsored art shows in venues not typically associated with the fine arts. This exhibition in a New York City alley featured paintings by children, a common theme on the Federal Art Project. (National Archives.)

rope and Asia undermined many people's faith in the potential for democracy around the world. Throughout the 1930s, defining the arts became a way of defining national identity.[36] With the Depression as a backdrop, many deliberately tried to use art in the service of democracy. People as diverse as government administrators, social workers, established artists, farmers, museum personnel, university professors, industrial designers, urban planners, schoolteachers, doctors, patients, journalists, novelists, clergymen, rabbis, and housewives actively debated the definitions, uses, and significance of art in daily life, and in the process challenged aesthetic categories and transformed traditional ideas of American cultural production.

This book examines two major players in this process, the Federal Art Project and the Museum of Modern Art (MoMA), and the influence their

Fig. 2. Visitors to the Museum of Modern Art exhibition *Useful Objects Under $10*.
In its *Useful Object* shows, MoMA encouraged visitors, who tended primarily to be
women, to handle the goods on display, a tactic more closely aligned with
department stores than art museums. (Digital Image © Museum of Modern
Art/Licensed by SCALA/Art Resource, New York, N.Y.)

aesthetic and educational programs had on determining the place and value
of art in modern America. In both theory and practice, the Federal Art
Project promoted what I call the "pedagogy of artistic production," which
argued that making art would make good citizens. At the same time,
MoMA developed a "pedagogy of cultural consumption," which linked the
aesthetically informed purchase of selected industrial goods to a function-
ing democracy. As the two institutions attempted to define themselves, as
well as their broader missions, they contributed to a broader desacralization
of American art and the creation of a more democratic modernism in the
United States.[37]

In many ways mine is an institutional history. Yet it is also the story

of the many individuals who shaped and were shaped by these institutions. Neither the Federal Art Project nor the Museum of Modern Art was a monolithic entity; yet the histories of both are often told as such. The identities and shifting ideologies of those involved in formulating and instituting their policies contain odd alliances and interesting contradictions. By reexamining these alliances and contradictions, this volume challenges the dominant histories of these institutions and allows for more voices to enter the extensive, and in many cases ongoing, dialogue on American modernism.

Appropriately, then, this book culminates in an examination of the 1939 New York World's Fair, perhaps the ultimate example of American modern culture in the 1930s and one of the few places where both the Federal Art Project's and MoMA's models of cultural democracy came into direct contact. In many ways, the coexistence and contestation between these two models of art as exhibited at the fair signal the apex of democracy in art in the United States. Yet the fair also marks the beginning of the demise of a participatory form of American modernism and a return to more spectacular definitions of aesthetic experience rooted in passive looking rather than active creation and use.[38] It is thus my contention that the educational programs created by the Museum of Modern Art and the Federal Art Project during the 1930s challenged traditional definitions of art and value in the United States while still allowing for public participation in debating the meaning and form of a democratic art. Focusing on the participatory nature of American art during the Depression decade demonstrates that the history of modernism and the determination of aesthetic value in the United States have been rich and varied. Indeed, American modernism was not merely an imported style, nor was it dependent only upon the cultural appetites of elites; rather, its history is more heterogeneous—inspired by the dynamism of storefronts, subways, and elevated trains as well as by jazz riffs, advertising slogans, and mass-produced Lucite combs.

I have chosen to focus on pedagogies for a number of reasons. Teaching the public was crucial to the broader missions of both the Federal Art Project and MoMA. Without public support or participation, neither the Federal Art Project's production-based definition of art, as something that all Americans could create, nor MoMA's consumption-based model of art, as something that all Americans could buy, could take hold. More important, focusing on their educational agendas allows us to see the processes by which individuals and institutions disseminated their ideologies to a

wider public and to interrogate the uses of art as both cultural capital and a crucial form of communication in the creation of democratic communities. Furthermore, throughout the 1930s American critics and philosophers explicitly linked art and education to democratic theory. Mumford and his contemporaries repeatedly stressed the importance of the arts in creating organic democratic communities, while the philosopher John Dewey, in his prestigious Charles Eliot Norton Lectures, delivered at Harvard University and published in 1934 as *Art as Experience*, elaborated on the possibilities of using art, "the most effective form of communication that exists," to promote the critical dialogue that he saw as crucial to a functioning democracy.[39]

Dewey was one of the key theorists of art and democracy in the 1930s. He directly challenged the boundaries between high and low culture and consciously expanded the definition of what constituted aesthetic experience: "The arts which today have the most vitality for the average person are the things he does not take to be arts: for instance the movie[s], jazzed music, the comic strip and, too frequently, newspaper accounts of love-nests, murders and exploits of bandits. For when what he knows as art is relegated to the museum and gallery, the unconquerable impulse towards experiences enjoyable in themselves finds such outlet as the daily environment provides."[40]

Like Van Wyck Brooks and Lewis Mumford, Dewey decried what he called "invidious distinctions" within the arts. "All rankings of higher and lower," he wrote, "are ultimately out of place and stupid. Each medium has its own efficacy and value." For Dewey, art was a tool for effecting social change. To this end, he believed that it must be integrated into everyday life, arguing that "the work of esthetic art satisfies many ends . . . it serves life rather than prescribing a defined and limited mode of living." Education was the cornerstone of Dewey's project. He aimed to teach the public how to use art as a tool for creating democratic communities and hoped to "restore continuity between refined and intensified forms of experience that are works of art and the everyday events, doings, and sufferings that are universally recognized to constitute experience."[41] Dewey's thinking about art closely paralleled his educational philosophy. By advocating an individual-centered atmosphere in which experience was key, he aimed to forge connections between the classroom and daily life. He also directly challenged educational hierarchies. His goal in progressive education was to "bring all things educational together, to break down the barriers that divide the education of the little child from the instruction of the maturing

youth; to identify the lower and the higher education, so that it shall be demonstrated to the eye that there is no higher or lower, simply education."[42]

Experience was key to Dewey's educational and aesthetic philosophies. He strongly believed that "a philosophy of art is sterilized unless it makes us aware of the function of art in relation to other modes of experience."[43] Dewey's notions of experience, however, are a bit "slippery."[44] While he was dedicated to making connections between aesthetic and other forms of experience, he did differentiate between them. He continued to insist that aesthetic experience was a distinct category. Yet Dewey directly challenged traditional definitions of art by focusing on the process of making art rather than its product. He wrote: "Art is a quality of doing and what is done. . . . When we say tennis playing, singing, acting, and a multitude of other activities are arts, we engage in an elliptical way of saying that there is art *in* the conduct of these activities. . . . The *Product* of art—temple, painting, statue, poem—is not the work of art. . . . Art denotes a process of doing or making."[45]

Moreover, Dewey was interested in exposing the constructed nature of aesthetic hierarchies: "Theories which isolate art and its appreciation by placing them in a realm of their own, disconnected from other modes of experiencing, are not inherent in their subject-matter but arise because of specifiable extraneous conditions. Embedded as they are in institutions and in habits of life, these conditions operate effectively because they work so unconsciously."[46] Rather than take these cultural hierarchies as natural, Dewey challenged the systems that created them and that systematically compartmentalized art in a separate realm. Instead, he was adamant that aesthetic experience should be an intimate part of everyday life. To this end, he called for a radical new definition of art, one that challenged the "ready-made compartmentalization [and] . . . conception of art that spiritualizes it out of a connection with the objects of concrete experience."[47]

Dewey's articulation of a pragmatic aesthetic was key to both the Federal Art Project's and the Museum of Modern Art's desacralization efforts. Both Holger Cahill, director of the Federal Art Project, and Alfred Barr, the first director of MoMA, were profoundly influenced by Dewey's experiential notion of art: The models that they created to redefine art and disseminate it to the millions directly reflect his calls to integrate art and life, albeit in different ways throughout the decade. The experiential and democratic forms of American modernism called for by Dewey and evident in the Federal Art Project's and MoMA's early programs are frequently overshad-

owed by early twentieth-century European models of modern art—the cubism of Braque and Picasso, the surrealism of Ernst, the expressionism of Dix—and eclipsed by the postwar formalism of the Abstract Expressionists: Jackson Pollock, Mark Rothko, and Franz Kline. Moreover, the art of the 1930s is often dismissed by scholars as stylistically "bad" and iconographically little more than propaganda either glorifying "traditional American values" or promoting the work of "doctrinaire communists."[48] Art history textbooks often label the Depression decade one of "reaction or rebellion."[49] Indeed, representations of stony-faced midwestern farmers, of migrant workers in moments of repose, of urban immigrants performing daily tasks in crowded tenements or protesting social injustices in the city streets dominate the visual imagery of the 1930s. Yet these images are richer than mere propaganda. Freed from the dictates of representing "objective reality," many artists during the Depression decade self-consciously and directly engaged modernist styles and subject matter. While invoking the problems of everyday life in their art, they often presented these problems by means of a modernist aesthetic sensibility, using, for example, dynamic and fluid shapes and colors rather than literal representations.[50] Although some recent scholars have examined the 1930s as a foil for the postwar "triumph" of abstract expressionism, Clement Greenberg's formalist model of postwar American painting as a move away from the art of the 1930s nonetheless still dominates historical narratives of American modernism.[51]

In all these analyses, the artistic legacies of the 1930s emerge as little more than post office murals, agitprop, or a body of work to later defy. The artistic production of the 1930s, however, transcends the reaction/rebellion dichotomy.[52] The cultural democratization that took place during the decade was not a uniform process. At times both the Federal Art Project and the Museum of Modern Art challenged sacred notions of culture by destabilizing the artwork's unique and timeless aura through offering radical new definitions of art. At other times, however, their efforts appeared to democratize the sacred object by making its aura more accessible to the mass public. Yet through their educational philosophies and exhibitions, both institutions transformed the ways in which aesthetic value had been determined in the United States and helped to redistribute the nation's cultural wealth, making cultural capital available to more Americans.

Like the Farmer or Bricklayer

In August 1935 President Franklin D. Roosevelt inaugurated the Federal Art Project as part of a national work relief program. Along with the Public Roads Administration, the Public Works Administration, and the United States Housing Authority, the Federal Art Project was under the aegis of the Works Progress Administration (WPA), directed by Harry Hopkins, a longtime Roosevelt supporter and friend. The WPA imposed few limits on the type of work it financed; its general guidelines specified only that the projects be useful and be undertaken in areas where unemployment was high. Its definition of "useful work" was broad. In addition to the Federal Art Project, the WPA housed a number of other cultural relief programs: the Federal Writers Project, the Federal Theater Project, the Federal Music Project, and the Historical Records Survey. The first priority of the WPA cultural projects was making work. Hopkins repeatedly reminded WPA directors to "never forget that the objective of this whole project is . . . taking 3,500,000 off relief and putting them to work. The secondary objective is to put them to work on the best possible projects we can, but we don't want to forget that first objective, and don't let me hear any of you apologizing for it because it's nothing to be ashamed of."[1] The inclusion of the fine arts in the massive national relief project had been in the works since the early days of the New Deal. In a 1933 press release, Hopkins asserted that artists had been "hit just as hard by unemployment as any other producing worker"; later that year, the artist George Biddle wrote to Interior Secretary Harold Ickes urging the government to treat unemployed artists "as the farmer or bricklayer."[2]

In 1935, the idea of treating the artist as a "producing worker," akin to the farmer or bricklayer, was a novel concept. As I discussed in the Introduction, art in America prior to the 1930s was primarily the domain of a social elite intent on promoting its sanctity as a means of maintaining cultural control. The Depression, however, challenged this nineteenth-century model. Through large-scale educational campaigns, the New Deal cultural

programs attempted to shift cultural power away from the control of elites and make it more accessible to a broader constituency in the name of democracy. These programs aimed to desacralize art and artistic production and make cultural capital more accessible to the American public by challenging art's sacred aura and integrating it into everyday life. In many ways the Federal Art Project's efforts were rooted in New Deal rhetoric. Terms such as "useful" and "productive" were key buzzwords of the Roosevelt administration, and their meanings, like those of "art" and "democracy," were highly contested. But attempts to link these terms were more than just rhetorical. Throughout the decade, government officials, artists, and educators worked together to determine how to put these concepts into practice.

The Federal Art Project's language of desacralization was varied. For example, in one of the many publicity articles he wrote detailing the successes of the project, Holger Cahill, its national director, described it as "like a laboratory extending the kaleidoscope of Manhattan slums to the coal mining regions of Virginia, from Southern cities, clinging to the classic porticoes and the exquisite manners to the hardy pioneer realities of those who built stately cities in the far west." The Federal Art Project, he continued, "mingles in its aesthetic melting pot with equal understanding youngsters of all races, in every section of the country." Likening the government projects to a laboratory, a kaleidoscope, and an aesthetic melting pot, Cahill was facile with his metaphors and far-reaching in his scope. Indeed, he claimed, the project included "Negro children from swift tempered Manhattan and slower moving Tennessee; children of Italians, Hebrews, Greeks, and Armenians who have almost lost their native tradition in tenement squalor; color loving Slavs and Bohemians who have settled in rural districts as farmers, miners and factory workers."[3]

On the surface the kaleidoscope and the melting pot seem like contradictory metaphors. The idea of the kaleidoscope suggests a series of refracted images (urban slums and southern porticoes) forming an ever-changing collage of individuals from distinct regions and "native traditions." The melting pot, in contrast, erases individuality and geography and creates a more uniform yet multi-ingredient stew. Yet for Cahill, the kaleidoscope and the melting pot could coexist peacefully, since they provided models of successful cultural democracy through the production of art in the "national laboratory." In both cases, art was no longer limited primarily to a cosmopolitan elite; it became available across the country, in urban tenements and rural villages alike. By teaching the American public

how to appreciate as well as create art and by recognizing the American artist as a legitimate worker, Federal Art Project programs challenged the idea of art as a sacred object and the notion of the artist as a social outsider. Indeed, both the kaleidoscope and the aesthetic melting pot were key components of what I am calling the pedagogy of cultural production that guided much of the Federal Art Project's working ideology and contributed to attempts to democratize art in America and challenge existing aesthetic definitions and hierarchies.

The premise behind this philosophy can be traced back to William Morris and the nineteenth-century Arts and Crafts ideology of the workman-artist. For Morris, reconnecting art to craft was a response to the alienation and depersonalization of work resulting from increased mechanization during the industrial revolution in England. His, and those of his followers in the United States and elsewhere in Europe, was a small, utopian project.[4] The Federal Art Project, however, was more pragmatic than utopian and much wider in scope. Instead of advocating for the establishment of small artistic communities, it attempted to link art and work on a much grander scale, across the entire United States. The Federal Art Project's pedagogy of cultural production was an educational philosophy that highlighted the idea of the artist as an important worker within a cultural democracy. The goals behind it were multifold and, on the surface, also seemingly contradictory: to teach the public to appreciate art (and "to accept the artist as a useful, producing member of the social family"), to teach the public how to create art, and to teach artists how to leave their ivory towers and become integrated into the larger public as cultural workers.[5] On the one hand, the Federal Art Project promoted a model of true cultural desacralization. By arguing that all Americans had the capacity to produce art and highlighting their aesthetic experiences over the works they created, and by locating aesthetic value concretely in the present, the art project's personnel directly challenged the idea that art had an aura that was sacred and timeless. On the other hand, through their large-scale art appreciation efforts, the government-sponsored programs maintained art as a separate category. Instead of completely challenging the aura, they attempted to democratize art and make it more accessible to the general public. This was the central tension in the Federal Art Project's basic ideology. Rather than limiting production, however, the tension between desacralization and democratization helped to create an environment that allowed more Americans to "experience" art than ever before.

The Federal Art Project was not the government's first foray into arts

patronage.[6] It was, however, the first government-funded program to stress the process of artistic creation over the actual art product. Today, many people mistakenly lump all of the government-funded art projects of the 1930s under the umbrella of the WPA. There were actually four distinct projects, of which the Federal Art Project was by far the largest and most inclusive. Part of a larger relief program called Federal Project No. 1, which included the Federal Theater Project, the Federal Music Project, and the Federal Writers Project, the Federal Art Project operated from August 1935 until June 1943, cost approximately $35,000,000, and at its peak employed more than 5,000 artists.[7] The first of the four Depression art projects, however, was the Public Works of Art Project (PWAP), which employed nearly 3,700 artists and cost approximately $1,312,000. It ran from December 1933 to June 1934 as a crash relief program, overseen, without any strict relief criteria, by the Treasury Department. The Treasury Department also administered the second program, the Section of Painting and Sculpture, later called the Section of Fine Arts. Established in October 1934, its primary concern was with obtaining painting and sculpture to decorate new federal buildings, in particular courthouses and post offices. Before it ended in 1943, the section awarded approximately 14,000 contracts at a cost of roughly $2,571,000.[8]

In contrast to the Federal Art Project and the Public Works of Art Project, the section was not a relief program. Instead, commissions were decided by anonymous competitions. Both the PWAP and the Section of Fine Arts were run by Edward Bruce, a Treasury Department official and amateur artist. Bruce believed in the auratic power of art to transform society. "If we can create the demand for beauty in our lives," he exclaimed, "our slums will go. The ugliness will be torn down and beauty will take its place."[9] Bruce hired Forbes Watson, former art critic for the *Brooklyn Eagle* and editor of *The Arts*, as technical director of the treasury programs. Like Bruce, Watson believed that art would "devulgarize the community and . . . raise its social level to the highest spiritual plane on which the artist normally exists."[10] For both Bruce and Watson, art was something transcendent and sacred and artists were people who lived on a higher spiritual plane than other members of the community. Following Matthew Arnold's definition of culture as "the best which has been thought and said in the world," Bruce and Watson made the first goal of the Treasury art programs to secure art of "the best quality available" for public buildings.[11] While most of the section commissions were awarded through anonymous com-

petitions, "certain artists, because of their recognized talent," received work without participating in competitions.[12]

Early in 1935 Bruce applied to the newly created WPA for money to hire approximately 500 artists to decorate the nearly 1,900 buildings under the Treasury Department's jurisdiction that did not yet have art. Although the WPA had plans for its own massive art relief program, Bruce and Watson argued that the department should still oversee the decoration of government buildings. The WPA granted their request but stipulated that all Treasury artists who received WPA money had to adhere to WPA guidelines. Thus, 90 percent of the artists working for the Treasury Relief Art Project (TRAP) first had to qualify for relief. Bruce hired Olin Dows, an artist and administrator, to oversee the TRAP programs. Initially Dows wanted to reject WPA money because it came with the condition that the labor had to come from the relief rolls. Dows feared that this stipulation "would produce a lot of bad stuff" and "hurt the government's patronage of art seriously." For Dows, like Bruce and Watson, the goal was to produce great art that would reflect the government's beneficence and transform both local communities and the nation as a whole. Initially Bruce backed Dows, arguing that "there are not enough artists on relief to do our job and maintain the quality for which we stand."[13] Nevertheless, once they realized that Hopkins was going to enforce the relief criteria strictly and that if they did not adhere to WPA guidelines they would lose the funds, both men relented and accepted the WPA's conditions. In an effort to maintain TRAP's reputation as the "Ritz of the relief projects," however, they competed aggressively with the Federal Art Project to secure the "best artists available" for section projects. In the end, TRAP awarded only 289 of its 450 allotted projects for fear of funding art of "substandard quality." This angered many artists. In a letter to Dows, for example, Stuart Davis questioned, "By what authority does the administration of TRAP arbitrarily refuse employment to artists of professional ability?" By failing to use all of its allotted funds, Davis considered TRAP "arbitrary, lacking in realistic understanding of the factors involved, and incompetent in that it failed to carry out the purpose for which the Treasury Art Relief Project was established."[14] Other artists and Federal Art Project administrators voiced similar complaints. For them, the first purpose of the program was to provide relief for all struggling artists of "professional ability," regardless of their aesthetic positions. In 1936, under pressure from the WPA, the Treasury Department slowly phased out its relief projects, and the Federal Art

Project became the dominant vehicle though which the government funded the fine arts.

Unlike earlier federally funded artists, all Federal Art Project participants had to qualify for relief before they were given government jobs.[15] Like those building bridges and roads on other WPA projects, Federal Art Project participants were classified as laborers and were paid a regular wage for their work; therein, they became cultural workers. The idea of the artist as a cultural worker is important to understanding both the Federal Art Project's desacralization processes and its pedagogy of cultural production. While the goal of the treasury art projects was to find the best possible artists to decorate public buildings "in the best possible way," the emphasis of the Federal Art Project was on the artist's livelihood as a worker, akin to the farmer and the bricklayer.

The primary architect of the Federal Art Project was Holger Cahill. In many ways his personal philosophies and life experiences were key in shaping the pedagogy of cultural production. Not much is known about Cahill's early life; his biography is full of colorful and often conflicting stories, many of them generated by Cahill himself. He was born Sveinn Kristjan Bjarnarson in Iceland in January 1887. His parents were farmers who emigrated to western Canada sometime in 1889 and then to North Dakota in 1893. The following year his parents divorced and Cahill was sent to live with a local Icelandic family as a hired hand. He ran away and began a series of travels across the United States and Canada working for the Northern Pacific Railroad and then Great Lakes Boats. His early childhood was key in shaping both his identity and the ideology of the Federal Art Project. Cahill was not born into a family of cultural capitalists. He was an immigrant who spent his early years in remote parts of the country, away from the cosmopolitan centers of high culture. Indeed, the project's focus on local participation, regional influences, and ethnic diversity reflects Cahill's early experiences as an immigrant traveling across the North American continent.

By the fall of 1913 he had moved to New York City and changed his name to Edgar Holger Cahill. In Greenwich Village, Cahill found intellectual camaraderie. By night he worked as a short-order cook at the Baltimore Lunch in lower Manhattan. By day he took creative writing and journalism classes at New York University. He became friends with the socialist writer Mike Gold, the playwright Eugene O'Neill, and the painter John Sloan. Cahill moved to Westchester County, where between October 1914 and June 1918 he worked as the managing editor of the *Bronxville Review* and the *Scarsdale Inquirer*. In June 1918, he moved back to New York City, where

he took classes with Thorstein Veblen, Horace Kallen, and John Dewey. Again, Cahill's personal experiences had a direct influence on the Federal Art Project's guiding philosophies. The coexistence of the kaleidoscope and the melting pot within the project's rhetoric, for example, directly reflects the influence of Kallen, whose mix of aesthetic pragmatism, humanism, and cultural pluralism presented a model for maintaining diversity within assimilation. In his seminal essay "Democracy Versus the Melting Pot," Kallen argued that all ethnic and cultural groups had a unique contribution to make to American culture. His calls to preserve ethnic and cultural variety within the melting pot are evident within Federal Art Project policies, in particular within the Index of American Design and the Community Art Center Program.[16] Cahill was also profoundly influenced by Dewey, particularly his stress on the links between art and experience.[17] In a speech celebrating Dewey's eightieth birthday, Cahill applauded Dewey's educational efforts, citing his work as having "the greatest importance in developing American resources in the arts." He was especially impressed with how Dewey's "philosophic ideas [were] translated into action [and] . . . how the thought of the philosopher makes its way into the homey experience of the everyday and the common sense of the man in the street."[18] Indeed, one of Cahill's overriding goals for the Federal Art Project was to integrate the practice of art into the everyday experiences of the American public, to teach the man in the street how to appreciate art as well as to create an environment where future artists would thrive.

In 1920, to avoid being just "a spade and shovel laborer," Cahill invented an art movement called Inje-Inje.[19] John Sloan, Frank Overton Colbert, Malcolm Cowley, and Mark Tobey were all members. Cahill explained the inspiration for the name as coming from "a tribe in that region between the Amazon and the Andes which was so primitive that it had only two words and the rest of their communications were eked out by gestures. The words were Inje-Inje. I said, 'Holy mackerel, this would be a wonderful basis for aesthetics. We've heard so much of the nuance and all kinds of things, how about a little simplicity for a while.' "[20] While Inje-Inje was in large part a game, the idea of an aesthetic movement rooted in simplicity became a key part of Federal Art Project's working ideology.

In 1921, John Cotton Dana, director of the Newark Library and Museum, offered Cahill a job as publicist. Dana believed that museums had a responsibility to educate the public: Instead of sacralizing art, he wanted to make it more accessible to a large and diverse audience. Dana, like Dewey, appealed to Cahill's populist sensibilities. Encouraged by Dana, Cahill be-

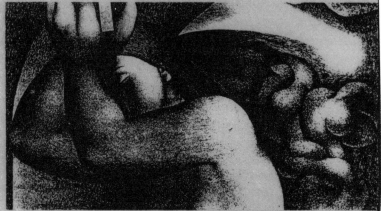

Fig. 3. Program for *Art in Democracy*, June 7, 1938. The relationship between art and democracy was a popular theme for Federal Art Project events. (Archives of American Art.)

came interested in early American folk art. This interest grew as he began collaborating with Edith Halpert at her Downtown Gallery. Together with Halpert, Cahill launched the American Folk Art Gallery, along with a magazine, *Space*, which was devoted to chronicling new talent in American art. In the early 1930s, Cahill began collecting American folk art for Abby Aldrich Rockefeller. His relationship with the Rockefeller family and American folk art grew when he became acting director of the Museum of Modern Art from September 1932 to May 1933. While at MoMA, Cahill organized several exhibitions devoted to the American folk tradition, among them *American Folk Art: The Art of the Common Man in America, 1750–1900*, and *American Sources of Modern Art*. By the mid-1930s, Cahill had become an authority on American art, particularly folk art. It is no surprise, then, that he was at the top of the list to head the Federal Art Project, which from its inception was interested in promoting folk art as uniquely American and inherently democratic.

Like Mumford and other contemporary social commentators, the idea of usefulness was key to Cahill's democratic aesthetic. For example, at a 1938 dinner celebrating "Art and Democracy," he announced to a large audience that through the government-funded art programs which he directed, "The restrictions which made art the special possession of the few, whose patronage fostered it as a luxury enjoyment have been broken down and removed. The public," he exclaimed, "has learned to accept the artist as a useful, producing member of the social family."[21] Cahill's claims are significant for a number of reasons. On the most basic level, they encapsulate one of the guiding impulses behind the New Deal art projects—to integrate artists into American society by paying them a living wage to produce *useful* goods. His stress on art's usefulness rather than on its aesthetic properties is particularly interesting in the context of garnering public acceptance of artists as members of the "social family." By stressing a national familial bond between artists and other citizens, Cahill normalized the role of both artist and patron by attempting to locate them close to home. By focusing on usefulness, he also challenged conventional notions of aesthetic value by privileging the object's present use value over its sacred timelessness.

Cahill's stress on art's usefulness can be seen as part of a larger project to redefine the place of art and artists in American culture. Led in large part by the New Deal cultural programs, but assisted by artists' organizations such as the Unemployed Artists' Group, the American Artists' Congress, and the John Reed Club, throughout the 1930s, a variety of artists,

critics, and administrators directly challenged the idea of the artist as a social outsider by representing him or her as a useful cultural worker. Such redefinitions were tied to New Deal policy and rhetoric, to unemployment relief, and to larger issues of cultural nationalism, as well as to the ongoing quest to somehow link art and democracy in a way that was distinctly American.[22] Yet, while many artists embraced the identity of cultural worker as well as the idea that art was a form of useful work, they maintained that their work was different from that of other workers. For example, in August 1937, the American painter Stuart Davis wrote in his diary that "the artist must seek ways and means to participate in the struggle of the masses which is his struggle. He must make a people's art but that does not mean that he must lower his standards of artistic perception to the level of the artistically uneducated masses." Rather, he continued, "He must ask the workers for support to be an artist, not for the right to betray his art."[23] While Davis identified with the "masses" and saw their struggle as his, he was also committed to the idea that art should foster an "aesthetic experience."[24]

Like Cahill, however, Davis believed that artists were important members of the social family. "The painter," he wrote, "is not only an artist but a member of society."[25] He was committed to the idea of a "people's art," to linking art and democracy. For him this meant making art more widely available. "The fight for democracy," he wrote, "is a fight for more art, not less."[26] Moreover, like Cahill, Davis was also committed to democratizing aesthetic experience through the government art programs. "Socially, politically," he argued, "the task of the artist is to sell the role of the artist to society," to educate the "aesthetically uneducated masses." In another diary entry written in the summer of 1937, he asserted that "the program of the artist should be towards increasing the opportunity of the masses to participate in aesthetic experience and not to eliminate the aesthetic experience from art." For Davis, like Cahill, experience was key. Yet the notion of experience had different referents for the two men. Davis's notion of aesthetic experience was decidedly more auratic than Cahill's. He believed in the power of the original artwork. Nevertheless, like Cahill's, Davis's definition came from Dewey. He strongly believed that "a work of art is a public act, or as John Dewey says an 'experience.'"[27]

Davis's goals were highly politicized. Throughout the 1930s he was active in a number of radical artists' groups. He was the first president of the American Artists' Congress, a founding member of the Artists' Union, and the editor of *Art Front*, an Artists' Union publication. Yet, while he

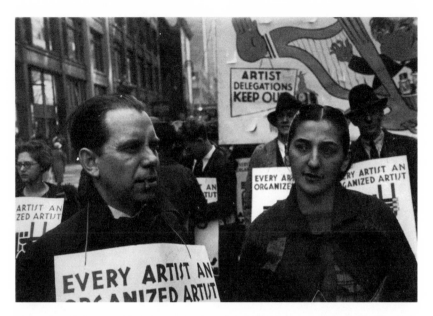

Fig. 4. Ben Shahn, Untitled. Stuart Davis and Roselle Springer among Artists' Union demonstrators at a May Day march, May 1, 1935. Davis's placard reads, "Every Artist an Organized Artist." (Courtesy of the Fogg Art Museum, Harvard University Art Museums, Gift of Bernarda Bryson Shahn.)

believed that American artists should be active in political causes, he did not believe that art should be explicitly politicized. "The idea of changing art to be used as a weapon for correcting economic maladjustments," he argued, "is like trying to change bread into progressive legislation. We want progressive legislation so that we can have bread."[28] Nevertheless, despite his refusal to challenge the idea of art as traditionally defined and his feelings about politicizing art, he did believe that artists should join the fight for workers' rights, so that they could "have bread." The American artist, Davis argued, "has not simply looked out the window, he has to step out into the street."[29] He was committed to supporting the Federal Art Project's pedagogy of cultural production and very vocal about the need to recognize the artist as an important cultural worker.[30]

Davis's role in the cultural politics of the 1930s was important on an aesthetic level as well as a political one. As a committed modernist, Davis fused democratic theory with abstract art. Like Mumford, he saw promise in storefront architecture and mass-produced goods, and through his work

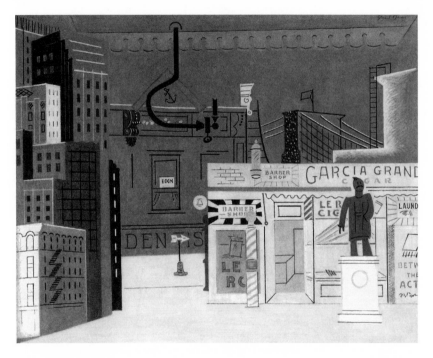

Fig. 5. Stuart Davis, *The Barber Shop*, 1930. Oil on canvas; 35⅛ × 42³⁄₄ in. (Collection of the Neuberger Museum of Art, Purchase College, State University of New York. Gift of Roy R. Neuberger. ©Estate of Stuart Davis/Licensed by VAGA, New York, N.Y. Photo by Jim Frank.)

he advocated for a more democratic modernist aesthetic. For example, his painting *The Barber Shop* (1930) pictures a brightly colored barbershop complete with a striped pole and advertisements for Garcia Grand cigars within a colorful urban landscape. The highly identified commercial space is bigger than the cityscape. Its bright yellow and orange facade catches the viewer's eye and draws it in. Everything in the picture, except for the barbershop, is unnamed—the buildings, the bridge, the neighborhood. An unidentified heroic statue, complete with a gilded laurel on its pedestal, stands in front of the store. But the traditional form of the memorial sculpture is engulfed by the dynamic mass culture that surrounds it. The anonymous great man from the past is encapsulated by the storefront. He is dwarfed by, yet part of, Davis's representation of modern culture.

As the decade progressed, Davis's work became more and more ab-

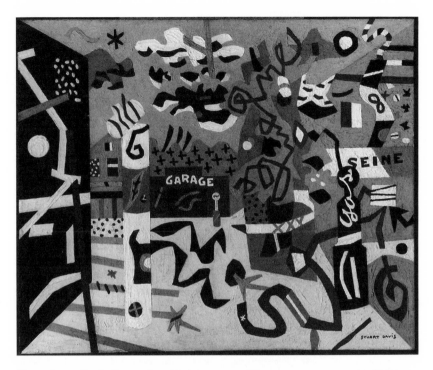

Fig. 6. Stuart Davis, *Report from Rockport,* 1940. Oil on canvas; 24 × 30 in. (Edith and Milton Lowenthal Collection. Bequest of Edith Abrahamson Lowenthal. ©Estate of Stuart Davis/Licensed by VAGA, New York, N.Y.)

stract, yet he maintained his interest in commercial forms and storefront architecture. In *Report from Rockport* (1940), painted ten years after *The Barber Shop*, he represents the coastal town of Rockport, Maine, through an abstract portrayal of an automotive garage. The commercial space of the garage is not given the same primacy as the storefront in *The Barber Shop*. It is folded into the multicolored landscape, not separate from it, so that it does not stand out as identifiably different—hence the need for the text "garage" as a marker. Yet, it is still a concrete landscape within a particular locale—Rockport, Maine, where Davis spent many summers. Davis believed that he was a "realist painter" and that his paintings contained "aspects of the American scene . . . which add up to a total impression of the United States itself." He listed the sources of his inspiration as a mixture of high and low, European and American influences: "American wood and

iron work of the past; Civil War and skyscraper architecture; the brilliant colors on gasoline stations, chain-store fronts, and taxicabs; the music of Bach; synthetic chemistry; the poetry of Rimbaud; fast travel by train, auto, and aeroplane which brought new and multiple perspectives; electric signs; the landscape and boats of Gloucester, Mass.; 5&10 cent store kitchen utensils; movies and radio; Earl Hines hot piano and Negro jazz music in general, etc."

Davis's art was profoundly influenced by jazz music. "Earl Hines' piano playing," he wrote to a friend, "has served me as a proof that art can exist."[31] Since "1928 when I heard him playing in a Louis Armstrong record," he continued, "Earl Hines represented to me the achievement of an abstract art of real order." For Davis, Hines's "ability to take an anecdotal or sentimental song and turn it into a series of musical intervals of enormous variety . . . played an important part in helping . . . to formulate aspirations in painting." Like Hines, through his artworks Davis was trying to use the anecdotal to render pictorially a series of intervals of "enormous variety." The spontaneous and improvisational twisting lines and shapes in his works demonstrate the ways he used jazz to work out formal and structural problems in his painting as well as showing us one of his sources of inspiration and subject matter. Moreover, Davis believed that his art, like jazz music, directly represented early twentieth-century American life in all of its wonderful complexity.[32]

Despite his increasing use of abstract forms, Davis steadfastly maintained that he was not an abstract painter. In 1927 he wrote to Edith Halpert, owner of the Downtown Gallery, that "my purpose is to make realistic pictures. I insist upon this definition in spite of the fact that the type of work I am now doing is generally spoken of as abstraction." People must "be made to realize," he asserted, "that in looking at abstraction they are looking at pictures as objective and as realistic in intent as those commonly accepted as such."[33] "Real Abstract art," he insisted, "exists only in Academic painting, or in the minds of Art critics, historians, and iconographers." His "interest in Abstractions," he maintained, was "practically zero." Instead, he continued in a mixture of Marxist and modernist jargon, "my work is a statement of constant intuitive purpose understood as an Objective Form, consisting of the Relations between simultaneous Precepts of a Subject and a Color-Space logic." As Davis became more interested in radical politics, he referred to this as "the form-content dialectic." For Davis, modern art participated in a dialectical relationship with reality: "In its internal form and in its external relation to reality," he wrote, "modern art could stimulate radical change in the political and economic structure

of America."[34] By making abstract art seem real to the American public, he hoped to demystify it and make it less sacred and more meaningful.

Davis, as a committed modernist as well as a socialist, had to reconcile seemingly incongruous positions regarding abstract art and social change. In the early 1930s, hard-core Communists following the changing Party line maintained that abstract art was a bourgeois convention and had no place in the revolution because it was not easily understood by the proletariat. Davis's insistence that his "abstractions" represented a version of reality was a means of accommodating contradictory theories regarding modernist techniques; it allowed him to democratize the experience of modern art, to be active in radical politics *and* paint abstract pieces. "Modern art," he wrote in his journal, "has created new forms to express a new sense of reality, new objective relations."[35] This new reality, he argued, consisted of "a new sense of spatial relations, color relations which correspond to the world we live in today. The world of modern industrial civilization. The world which is the heritage of the working class."[36] Nevertheless, while Davis believed that both art and artists could be agents for social change, he felt that his work suffered when it became too politicized. Therefore, he repeatedly maintained that artists must act within the artistic community and should not be too dogmatic regarding artistic style.

The tensions that Davis felt over the relationship between modern art and democratic politics divided the American art world in the 1930s and prompted a number of divergent approaches toward the creation of a democratic American art. While other artists shared in Davis's attempt to reconcile progressive politics and the aesthetic principles of modernism, others rejected the latter as elitist. In the context of the Federal Art Project, most artists affiliated themselves with either social realist or regionalist painting. Regionalism, a progressive term employed by early twentieth-century social scientists such as Mumford (and later by Henry Nash Smith) in response to the standardization and dehumanization of the machine age, became codified in the art world as a retreat from the artistic dominance of New York into nostalgic renderings of the localized subject matter of the Midwest. Typified by the work of Thomas Hart Benton, John Steuart Curry, and Grant Wood, regionalist painters located the "American scene" in that area. Farmers, agricultural fairs, and prairie landscapes were their dominant themes. Social realism, in contrast, became politically and stylistically aligned with the radical politics of urban immigrant artists. Following the directives of the international Communist Party, social realists considered

art a "weapon" and used it as a tool to help "educate" the masses and foment worldwide Communist revolution, or at least broad social changes.

Stylistically, the work of social realists and regionalists often looked the same, as both were predominantly realist schools reacting against what they saw as the elite biases of European modernism. The major stylistic difference between the two artistic groups was thematic. Regionalist works, for the most part, contained agrarian subject matter, while social realists depicted more gritty urban scenes. However, this difference was not absolute. Regionalists such as Thomas Hart Benton and Reginald Marsh painted urban settings, and some social realist paintings included rural subject matter. In examining the work of the artists within these two distinct schools of painting, it is difficult to pin down stylistic traits that both unify a school and also set it apart from its rival. Not all social realist paintings look alike. Ben Shahn's *Bartolomeo Vanzetti and Nicola Sacco*, for example, is decidedly different from Stuart Davis's paintings. The same is true of regionalist works. Grant Wood's *American Gothic* has a style distinct from the more modernist works by Thomas Hart Benton. The dividing line between the two schools of painting is largely ideological: The political and social messages of *American Gothic* and *Bartolomeo Vanzetti and Nicola Sacco* differ markedly from one another. The American scene paintings of artists such as Wood celebrate the American land and the fortitude of the farmer, while Shahn's social realist paintings decry the attacks on personal freedoms committed under the rubric of democratic government.[37] Both, however, are political works. By 1930 American leftists had made Sacco and Vanzetti, two Italian anarchists executed in 1927, into martyred symbols of all that was wrong with the American political justice system. Wood's art, and that of his fellow regionalist painters, was also propaganda. "America" for the regionalists was limited to the United States, in particular the Midwestern states. Often xenophobic, their paintings were grounded in populist nostalgia, depicting the United States as a primarily agrarian and small-town nation. Regardless, despite their often profound ideological differences, both schools claimed to be promoting democracy in art.

As is clear from the differences between Davis's approach and that of social realism and regionalism, the meaning of democracy in art became increasingly unclear as the decade progressed. What was evident, however, was that both "art" and "democracy" were contested terms and that something major was at stake in figuring out not only what they meant but also who got to define them.[38] As a publicly funded endeavor, the Federal Art Project was in the middle of this debate and thus attempted to include

artists from all ideological backgrounds to allow for democracy in art as defined by both sides. Artistic autonomy was key, at least in theory, to the Federal Art Project's basic ideology, and so many artists embraced the possibilities offered by the government programs, at least at first. In his painting *Artists on the WPA* (1935), Moses Soyer captures this attitude. The picture plane, seemingly only a part of the room, contains images of six artists at work painting and drawing. Created the same year that the Federal Art Project began, Soyer's painting is optimistic. The artists and their works are each distinct from one another. One man sketches a woman who is sitting in a chair smoking a cigarette an arm's length away from him. She looks slightly bored, oblivious to the activities taking place behind her. Over her shoulder, a man in blue work clothes paints a scene of children playing. Next to him a woman creates a more bucolic, figure-filled landscape. Three more artists work nearby.[39] By portraying these artists alongside one another yet in their own creative worlds, Soyer represents the experience of the government-funded artist as both collective and individual. This dualism—the ability to be simultaneously part of a group yet distinct—was one of the reasons so many artists with different political agendas embraced the New Deal art projects. Of course, the living wage paid to them in the midst of severe economic conditions and the recognition of art work as legitimate work were two other key appeals. But the ability to maintain artistic autonomy, at least in theory, drew many artists to the government projects. It also produced a number of problems for artists and administrators alike as they tried to define the idea of the artist as a cultural worker.

Throughout the 1930s, despite their artistic philosophies, many artists on the Federal Art Project identified themselves as members of the working class. At the end of the decade, for example, the painter and printmaker Rockwell Kent asserted: "I am a worker, in the sense that I earn my living by the work that I do. Whatever might be the nature of that work I would want security, good pay, and reasonable leisure for the enjoyment of life. I have worked lots of trades in the course of my life. If they were organized I joined. If they were not organized I worked to organize them, for I want a good life for myself, for my fellow workers, for the people of America."[40] Kent's statement is especially interesting in the context of the Federal Art Project's pedagogy of cultural production, as well as in the ongoing debate over art and democracy. His definition of what constitutes a worker—someone who makes a living by the work that they do—is straightforward. And, indeed, throughout the 1930s Kent earned a living by creating artworks. Yet for Kent, work also implied security, economic viability, and

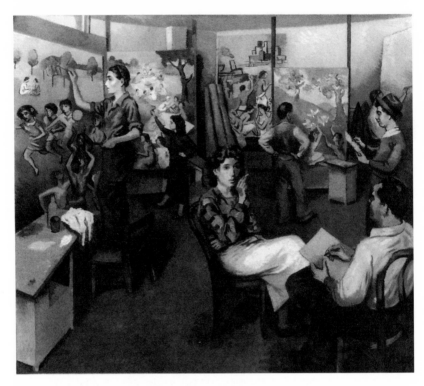

Fig. 7. Moses Soyer, *Artists on the WPA*, 1935. Oil on canvas; 36 1/8 × 42 1/8 in. (Smithsonian American Art Museum. Gift of Mr. and Mrs. Moses Soyer. ©Estate of Moses Soyer/Licensed by VAGA, New York, N.Y.)

access to leisure time.[41] Moreover, his emphasis on the connection between "a good life" and organized labor speaks to the more radical side of the processes of desacralization. Throughout the 1930s, Kent also worked as a labor organizer, actively encouraging artists as well as other tradesmen to unionize.[42]

Kent was not alone in his efforts. By proudly considering themselves workers, many artists joined with him in identifying with the laboring classes. These artists self-consciously challenged elite notions of the fine arts by tying artistic creation to their struggle for workers' rights. Like Cahill, they too considered artists useful and productive members of society. In a 1936 letter published in the readers' forum in *Art Front*, for example, John C. Rogers of Alexandria, Virginia, wrote "More and more the artist is learn-

ing that his art is not a profession that isolates him from classification as a laborer; more and more the artist is learning that he has much in common with those of other trades and professions, the most important and common cause is the struggle to make a living." He continued: "For years the artist has been something apart, something superior to the office clerk, the fish peddler, the ditch digger, the doctor, the movie actress, the student, or the professor. . . . It was only until recent years that the artist became one with the worker, that the artist came down from his ivory tower and stood in the soup, bread and picket line with the rest of his toiling fellowmen and women."[43]

During the 1930s, then, the bread line and the picket line united artists with other laborers, and, the pedagogy of cultural production took root in the Depression reality of the artist as an out-of-work worker. With unemployment at record levels, struggling artists no longer could be looked down on. Artists joined the ranks of other unemployed Americans. As painter Robert Gwathmey recalled, "I got out of art school in 1930. That was the proper time for any artist to get out of school. Everybody was unemployed and the artist didn't seem strange anymore."[44] Similarly, in his 1975 memoir, Harold Rosenberg explained that "the Depression brought forth the novel idea of the unemployed artist—a radical revision of the traditional conception, for it implied that it was normal for artists to be hired for wages or fees."[45] Within the profound crises of the Depression, the type of work that artists were not doing was not under scrutiny. Instead, many artists capitalized on this moment to interrogate what it meant to be a cultural laborer. Perhaps this made it easier for the public as well as for many artists themselves to see the artist as a useful member of the social family. Since they were not producing art, there was no art to evaluate, just the condition of being out of work. By calling attention to their common out-of-workness and advocating for increased artistic opportunities across the country, Federal Art Project administrators attempted to challenge longstanding public perceptions of artists by integrating them into the national workforce.

A number of artists collaborated with the arts project in this process, as throughout the decade many became actively politicized around issues of unemployment relief. Large numbers joined the Communist Party USA, and many became active in its cultural offshoot, the John Reed Club. Named for an American journalist who covered the 1917 Russian Revolution, the John Reed Club was established in 1929 to give "movement in arts and letters greater scope and force" and to bring art "closer to the daily

struggle of the workers." By 1932, it had thirteen branches across the United States. Following the official Communist Party line of "art as a weapon," the club stance was that art had a dual role to play in the revolution. It was both an end (a true workers' art) and a means to that end (a tool to bring about radical change). In that regard, the club put forth six guiding principles "upon which all honest intellectuals, regardless of their background, may unite in the common struggle against capitalism." They included fighting against "imperialist war," fighting for the "development and strengthening of the revolutionary labor movement," fighting against the "influence of middle-class ideas in the work of revolutionary writers and artists," and fighting against the "imprisonment of revolutionary writers and artists, as well as other class-war prisoners throughout the world."[46] By simultaneously fighting for organized labor and against middle-class dominance in cultural affairs, the John Reed Club acted as an important agent in the desacralization process. Like the cultural capitalists they opposed, club members believed that art was a form of cultural (as well as political) capital; they, however, wanted to transform the nature of this capital and make it available to all.

Many artists in the John Reed Club viewed the crisis of the Depression as an opportunity to challenge the idea of art as the province of the cultural elite and to expand the arena for artistic experience to all classes. For example, in the March 1933 edition of *Creative Art,* members of the club issued this statement:

There is a crisis in art as deep, if not as obvious as the economic crisis. The shock of the crash has tumbled the ivory towers. Artists are beginning to realize that they are as a group possessing interests in common with other groups, and not the isolated individualists they once pictured themselves. The present period demands a new art, not necessarily new in form, but new in expression. We are face to face with a field of untold artistic experiences which will give art new life and new vigor. Though unclear in many respects, as all beginnings must be, there is already the promise of a vital art which will function and thrive.[47]

What this "new art" would look like was open to debate. In the early days of the John Reed Club there was room for differences of opinion. Many followed Davis's call to maintain aesthetic standards and avoid heavy-handed political commentary, while others embraced the Communist Party line that all art should function as a form of propaganda.[48] One thing that most liberal- and left-leaning artists working during the 1930s embraced, however, was the need to establish a government-funded art

project. Not only would public funding create a "new and vital art," but many hoped that it would also revolutionize artistic production by removing the patronage system from the marketplace, thereby establishing new standards for determining aesthetic value.

In the summer of 1933, members of the John Reed Club began to meet informally to discuss banding together to demand government patronage. Calling themselves the Unemployed Artists' Group (UAG), they issued a manifesto declaring that "the State can eliminate once and for all the unfortunate dependence of American artists upon the caprice of private patronage."[49] In October 1933, the UAG, in conjunction with the College Art Association, held a symposium on unemployed artists. Again, their focus was on securing government relief for artists as out-of-work laborers. That December, they presented a formal proposal to Harry Hopkins detailing a plan for creating jobs for all unemployed artists. The plan included jobs in teaching, in mural and easel painting, and in the commercial and applied arts. Hopkins was receptive to the idea, and in 1934 the government began funding out-of-work artists through the Public Works of Art Project (PWAP), its first art relief program. As the government projects began to put artists to work, the group changed its name from the Unemployed Artists' Group to the Artists' Union. The name change was significant on a number of levels. Clearly, many of the artists involved were no longer unemployed, but they also now saw themselves as members of the working class. According to Robert Jay Wolff, a member of the Artists' Union in Chicago, "By calling itself a union the organization identified itself with the underprivileged. This shattered the old illusion of the lofty position of the artist and publicly put him in the ranks of the unemployed."[50] The change in nomenclature signaled a change in policy as well. Not all of the artists involved in the Artists' Union were members of the Communist Party. The main goal of the Artists' Union was no longer revolution, per se, but rather securing the rights of its members as trade workers.

Not everyone in the art world embraced the idea of an artists' union. Peyton Boswell, the editor of *Art Digest*, found the idea of unionization antithetical to the artistic impulse. The artist, he argued, is not a "group man. . . . The very nature that leads him to be an artist makes him intensely individualistic. To such men the very thought of unionization is distasteful. They are not the same as coalminers. The loss of personal initiative means the loss of creative spirit."[51] The issues raised by Boswell—of communal identity versus individualistic spirit, as well as those regarding artistic standards—mirrored those with which the art project was wrestling and would

plague union leadership. In the August 1935 edition of the *American Magazine of Art*, for example, Stuart Davis responded to other members' complaints that "we can't have everyone in a union who calls himself an artist. We have a standard." By asserting that "art comes from life, not life from art," Davis argued, "the question of the quality of the work of the members of the Artists' Union has no meaning at this time." Like Kent, Davis believed that artists should organize to secure basic rights as human beings. "An artist does not join the union merely to get a job," he wrote; "he joins to fight for his right to economic stability on a decent level and to develop as an artist through development as a social human being."[52]

Like other trade unions, the Artists' Union held weekly meetings and published a monthly magazine, *Art Front*. From its inception, the Artists' Union stressed its ties to the government art projects. For example, an editorial in the November 1934 edition announced, "*Art Front* is the crystallization of all the forces in art surging forward to combat the destructive and chauvinistic tendencies which are becoming more distinct daily. A new frontier is being created [by the PWAP.] Help to extend it."[53] Similarly, the January 1935 cover declared that "Jobs for the Artists + Municipal Art Center = Art for the People or a Federal Art Bill."[54]

The relationship between the Artists' Union and the Federal Art Project was not one-sided. By 1936, the Artists' Union had become the de facto bargaining agent for artists on the WPA. Audrey McMahon, head of the Federal Art Project in New York City, regularly met with representatives from the union. McMahon was sympathetic to the idea of the artist as worker. In fact, she saw it as inherently democratic. For example, in a 1938 radio address entitled "Art in Democracy," she asserted that "the artist has emerged to see himself as a worker and to recognize his identity in the light of a worker producing art for the American people."[55] Although many of the union's demonstrations were directed against her as an agent of the government, McMahon repeatedly defended artists' right to demonstrate as organized labor. Moreover, she would often suggest to friends in the union how best to present problems so that she could help them. In return for her continued support, union artists would find ways to notify McMahon of demonstrations in advance—and the Artists' Union demonstrated on a regular basis.

Despite loose affiliations with government representatives such as McMahon, Artists' Union demonstrations often turned violent, and artists were often arrested. Some saw this as a learning experience. Harry Gottlieb, who became president of the Artists' Union in 1936, depicted his experi-

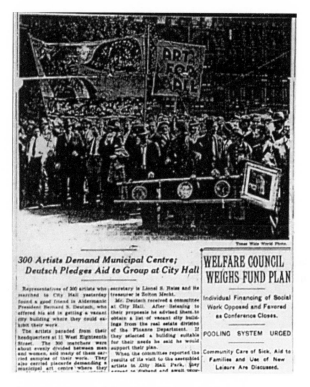

Fig. 8. Front page of the *New York Times*, May 10, 1934.
Members of the Unemployed Artists' Group
demonstrating in front of City Hall. The UAG, which
became the Artists' Union, demonstrated on a regular
basis, and their activities were often documented in the
popular press.

ences on the union's picket line in his 1939 silkscreen *Nor Rain Nor Snow*,
and Philip Evergood, a Federal Art Project supervisor and an Artists' Union
leader, credited the emotional success of his painting *American Tragedy*
(1935) to a beating he received while on a picket line. "They beat me insensi-
ble . . . my nose was bleeding, blood was pouring out of my eyes, my ear
was all torn down. . . . I don't think that anybody who hasn't been really
beaten up by the police as badly as I, could have painted an *American
Tragedy*."[56] Despite the threat of violence, throughout the 1930s many
American artists followed Davis's directive that the American artist "step

Fig. 9. Harry Gottlieb. *Nor Rain Nor Snow,* 1939. Silkscreen; 10 3/8 × 13 7/8 in. Gottlieb, who was president of the Artists' Union in 1936, draws upon his experiences on the union's picket line in this image. The title, a play on the post office slogan, highlights the dedication of the many artists who regularly braved the elements to broadcast their demands. (Syracuse University Art Collection.)

out into the street." They deliberately entered public spaces, painting and picketing for social democracy.[57] They regularly marched to assert their right to organize; to protest cuts in the budget; to demand that fired artists be reinstated; to complain against cases of censorship. They carried placards and joined picket lines. They assembled in front of government buildings. They organized boycotts. Moreover, they continued to identify with other laborers. In July 1935 the Artists' Union attempted to join the American Federation of Labor (AFL). A spokesperson for the union explained the decision on the front page of *Art Front*, claiming that "although we have no apologies to offer for having existed as an independent union . . . by joining the AFL, we can achieve unity, and be enabled to carry on a stronger fight for trade union wages and conditions on the projects." Although the AFL merger failed, the Artists' Union joined the Congress of Industrial Organizations (CIO) two years later.

The public activities of members of the John Reed Club and the Artists' Union demonstrate the active role that many artists played in desacralizing art in the 1930s. They also illustrate the centrality of the idea of the artist as worker to the government's pedagogy of cultural production. According to legend, the New Deal arts projects had their genesis in a 1933 letter from the artist George Biddle to the newly elected president, Franklin Delano Roosevelt, his classmate at both Groton and Harvard, prodding him to help struggling artists. Roosevelt, who had provided aid to artists while governor of New York State, then supposedly complied and created the first of the New Deal art projects, the PWAP.[58] While Biddle did write a letter to Roosevelt urging him to consider providing government funding for artists to decorate public buildings, and Roosevelt was supportive of artists throughout his political career, the process of recognizing the artist as a legitimate worker was not one-sided nor premised solely on the trickle-down theory of cultural dissemination. Throughout the decade, many artists with different political and aesthetic positions were involved directly in negotiations among themselves, with government officials, and with critics and other members of the public about how to promote the idea of the artist as a useful and producing member of the social family. Likewise, Federal Art Project officials and administrators with different political motivations were also fluid in their desacralization efforts. For Holger Cahill, instituting "democracy in art" meant arriving at a series of compromises. He walked a tightrope between dueling definitions of the artist as producer and the artist as genius; he tried to strike a balance between the idea that all Americans could be artists and the idea that artistic production was limited to a special few; he attempted to make modernism accessible while not favoring one movement over another. In so doing, he both desacralized ideas of art and democratized traditional notions of artistic production as sacred. As a result of Cahill's negotiations, artists on the Federal Art Project were considered workers, yet they also were seen as different from other workers and were given privileges based upon these differences. Most could work in their own studios and on their own time. Nevertheless, they were still considered government wage laborers, and the government was firm regarding the ownership of their artworks. Plans and sketches required approval, and in extreme cases artists were not allowed to sign their works or take them home. Their experience thus paralleled that of the farmer or the bricklayer in that the work they produced became anonymous, not affiliated with the producer. Yet these were extreme cases. In most instances

artists on the Federal Art Project retained their unique status as cultural workers, again as a result of Cahill's negotiations.

In order to recognize different levels of artistic talent and include as many "artists" as possible on the relief rolls, Cahill classified project artists into four categories ranging from "professional" and "technical" workers to "ancillary" positions such as gallery workers and handymen, based on an evaluation of the applicants' practical skills. On the most advanced level (A) were the professional and technical workers. These were "artists who are experienced in their skill and capable of producing creative work of a high standard of excellence." Level A workers provided leadership, supervision, and training on the projects. In addition to painters, sculptors, and graphic artists, "others such as highly skilled craftsmen, photographers, teachers of art, lecturers, and research workers" fit in this classification. The inclusion of teachers, lecturers, and research workers in the most advanced category highlights the project's larger goals of cultural desacralization through education and the importance of teachers in carrying out the Federal Art Project's goals. The next level (B) comprised the skilled artists. These were artists "able to produce work of recognizable merit but not of a quality equivalent to A." On level C were less skilled and experienced artists, craftsmen, and apprentices. And finally, there were the unskilled workers (D), who fulfilled ancillary functions such as gallery attendants, handymen, messengers, and office help.[59] This multi-tiered classification system allowed for maximum participation in the project's relief roles. Indeed, by including technical workers and craftsmen in their criteria, project officials challenged longstanding notions of the artist as a genius in a secluded garret; they shifted the focus from the idea of art through inspiration to art as a useful form of labor. Handymen, messengers, and office staff helped art reach the public and were paid the same wage as artists, teachers, and craftsmen. But the hierarchical nature of the categories also suggests that there was some resistance to completely doing away with the artist's special status. While handymen and technical workers were a key part of the relief program, they were not on level A.

Artists on the Federal Art Project worked 96 hours a month. This included the hours spent working on the actual projects as well as the supervised time spent in preparing work. It did not, however, include *unsupervised* time spent researching or preparing work, which caused the issue of supervision to become a major source of tension between project artists and administrators. Again Cahill played middleman, arguing that "it should not be necessary for artists to leave their work to make formal ap-

pearances before timekeepers. This kind of interruption seriously interferes with creative work and is entirely unreliable as a check on the time the artist has worked." Instead, Cahill proposed an "automatic time checking arrangement" whereby artists submitted "time reports" projecting a "tentative estimate" of the hours necessary to complete their work, based on regular consultations with "the supervisor in charge of the specific project." This arrangement was initially approved by both artists and administrators.[60] According to sculptor Robert Cronbach, though, "Such a system [was] very open to abuse." But, he continued, "the striking thing . . . is not that such abuses did not occur—of course they did—but that they occurred so seldom." On the contrary, he continued, "when an artist became deeply involved in a major project, he completely disregarded the [mandatory] 15 hour rule and worked 40–60 hours a week."[61]

While the Depression was certainly a time of crisis, it was also a moment of possibility for many artists who were habitually out of work. Journalist Suzanne LaFollette wrote in a 1936 article for the *Nation* that "the Depression of 1929–? may prove to be the best thing that ever happened to American art. The government relief projects have not made the artist rich but they kept him alive and given him what he sorely lacked, opportunity. He used to be poor and discouraged. Now he is poor and encouraged."[62] Many artists agreed with LaFollette. For example, Thaddeus Clapp declared that on the Federal Art Project the artist was "no longer an exotic, but an individual functioning freely within a society that has a place for him, no longer in an ivory tower but in contact with his time and his people."[63] And, according to Cronbach, the project artist "felt that he was part of an important art movement; that his project would be seen by, first, his peers and also by a fair section of the public and the art world."[64] For artists, critics, and Federal Art Project officials alike, the expulsion of artists from the ivory tower and their integration into the larger community was something to celebrate. The public nature of the project demanded a new relationship between artists and the marketplace. Instead of creating for collectors and consumers, project artists could now, at least in theory, create on their own terms. Like the artists in Soyer's painting, artists on the WPA were part of a group but still autonomous.[65]

For many artists, the Federal Art Project provided the first opportunity to paint what they wanted without the expectations of a private patron. Indeed, for artists such as Cronbach, the government art projects were revolutionary in that they provided opportunity "when there were no other equally valid outlets or markets for his work at this time."[66] The Federal

Art Project's emphasis on the artist as a worker and art as a form of work challenged previous systems of patronage by removing the need for market-driven production. Instead, the initial emphasis was producer-driven. According to Gwathmey, the best thing about the projects was that "artists for the first time . . . had a patron—the government—who made no aesthetic judgements at all. . . . You were a painter: Do your work. You were a sculptor: Do your work. You were a printmaker: Do your work. An artist could do anything he damn pleased."[67] Similarly, Jacob Kainen wrote of his experiences in the Graphic Division of the project that "no pressures were placed upon the artist to work in any specific direction. He was free to select his own subjects and to treat them in any manner he chose."[68]

This freedom was particularly important for black artists. Although the Harlem Renaissance had brought the work of many black artists to national attention a decade before, the term also suggested white notions of "art" and elite systems of patronage. And while Harlem in the 1920s had fostered an environment in which black creative expression was encouraged and rewarded, it was often defined by or for white patrons.[69] Philanthropic organizations such as the Harmon Foundation rewarded black painters who got in touch with their "primitive heritage," and black scholars such as Alain Locke looked to Africa for aesthetic traditions in which to place black artistic achievements.[70] Many Harlem artists, however, did not consider themselves African but rather American. Langston Hughes, for example, recalling a patron's "it's not you" response to one of his works, asserted, "She wanted me to be primitive and know and feel the intuitions of the primitive. But unfortunately, I did not feel the primitive surging within me." Hughes maintained that his art was not dependent upon African traditions but rather upon "Chicago and Kansas and Broadway and Harlem."[71]

Government-funded art projects provided an alternative form of patronage to the race-conscious Harmon Foundation and the dwindling numbers of Harlem Renaissance patrons. Within the WPA, the art of black artists was evaluated according to the same aesthetic criteria as those used for white artists; every artist received the same weekly pay of $23.80 regardless of race. In a 1970 interview, artist Robert Blackburn recalled that employment on the government art projects in the 1930s "was how artists survived and it was very good because it made all artists equal so the black artist got a chance to work—got a chance to paint."[72] Similarly, Jacob Lawrence maintained that the Depression in Harlem "was actually a wonderful period . . . there was a real vitality in the community."[73] Furthermore, while

Fig. 10. Negro artists protesting. Gwendolyn Bennett (*center*) and Norman Lewis
(*striped shirt*) are shown among those rallying for the creation of a Federal Art
Project community art center in Harlem. (Photograph. Archives of American Art.)

black Americans generally had been denied union membership until after the founding of the CIO in 1935, black artists were members of the Artists' Union from its inception. According to Romare Bearden and Harry Henderson, during the Depression, black artists "were suddenly no longer outsiders, but participants in American cultural life. Their world changed, and they looked at themselves, their tasks as artists, and their people in a new way."[74]

Nevertheless, the success of artists' groups such as the Artists' Union and the government art projects in integrating artists (both black and white) into the "social family" as useful and productive workers led to a backlash—almost from the very start. In September 1935, less than one month after the Federal Art Project was inaugurated, the *Sunday Mirror* identified a group of Federal Art Project artists as "Hobohemians . . . chiselers . . . and boondogglers biting the hand that feeds them." Conservative newspapers, led by the Hearst Press, regularly attacked the government art projects for producing "bad art." Calling the artwork "full of tripe," "inane," "disgusting," "botches of color just smeared together," and "not art of any kind," critics of the project did not evaluate the artworks in terms of relief; rather, they steadfastly adhered to traditional aesthetic criteria in their denunciations. Once the formerly unemployed artists began to work, their artwork, not their productivity, became a source of critique. For example, in 1940 the *Chicago Tribune*, an anti-Roosevelt paper, ran a series of articles that attacked local WPA art projects as "wasteful, ugly and communistic." In particular the author of the articles signaled out the work of the muralists Edward Millman and Edgar Britton as "un-American in theme and design" and warned readers that their murals would "exert an alien effect upon children and adults who view them."[75]

To counter such charges, government officials attempted to shift evaluative criteria away from aesthetic judgments back to the pedagogy of cultural production by focusing instead on issues of patronage and the idea that the artist was a useful worker. For administrators such as Cahill, artistic usefulness was not merely aesthetic, it was social, economic, and political. Moreover, Cahill's notions of usefulness were both forward and backward looking. He regularly tried to link the government art projects both to the glories of past civilizations and to the future success of American democracy. In a letter to Federal Art Project administrator Ellen Woodward, he announced that "the United States government in setting up its art programs has returned to the healthy tradition of art patronage which existed during the Renaissance and Middle Ages when thousands of artists were

given an opportunity to work by patrons who believed in a living art."[76] Cahill made regular allusions to the government's patronage as being part of a long and noble tradition. In a 1936 speech to the Southern Women's National Democratic Organization, he declared that "the U.S. government has become the greatest art patron in the world. . . . and government support for the arts is no new thing. Governments in every age and in every part of the world have employed artists. Egypt, Greece Rome . . . China and other oriental countries . . ."[77]

Cahill repeatedly used the language of *renaissance* to describe the success of the government art programs in reaching the American public. For example, in a 1939 WPA Federal Art Project pamphlet he wrote, "When art historians of the future record this country's achievements in the late 1930s they will be able to offer tangible evidence of this country's renaissance in the mural paintings of the period." In another art project manual Cahill applauded mural painting as a "heritage to the future . . . created in our own time."[78] For Cahill the future retrospective value of the artwork was key. He regularly urged the public to save evaluative criteria for "historians of the future," who would validate the democratic impulse behind desacralization. The idea of the future retrospective value of the artwork, its "heritage to the future," marks the Federal Art Project's concept of renaissance and again speaks to the central tension within the project's ideology of cultural production. By alluding to the timelessness of art through repeated references to an American renaissance and validation by future generations, Cahill endorsed the idea of art's sacred nature. At the same time, however, arts project officials measured artistic value not by future standards but in terms of its function in contemporary daily life. For example, Thomas Parker, head of the Community Art Center Program, announced in a speech to the Art Reference Round Table that "the WPA Federal Art Project has based its work upon the belief that in a democracy all artists should have an opportunity to work and to do their best and that the ultimate judgment as to permanent values must be left to posterity." Likewise, in another speech, he asserted, "Historians will some day describe our era as a period of gigantic forces changing with blinding rapidity."[79] The deferral of judgment to historians in future generations—generations who grew up with the Federal Art Project—was an important component of the desacralizing process. Ultimately, the primary concern for Cahill, Parker, and other art project staff was to address what they saw as the aesthetic as well as the practical needs of contemporary America. An ethos of "paint, don't debate" informed the daily activities of the project. While this dulled some of the

ideological edge of their endeavor and was certainly a way of dodging criticism for the work being done, it was also a way of making art part of contemporary experience. By making more art more available to a wider public, Cahill felt that art became more democratic.

He felt this was particularly so in the case of mural painting. For Cahill, murals were inherently democratic in that they became an integral part of the communities they occupied. By painting murals in spaces that did not traditionally have art—post offices, courtrooms, hospitals, and jails— art reached more diversified audiences composed of individuals who were not traditionally patrons or consumers of the arts. In this way, murals aided in the desacralization process by bringing art to everyone who entered their space. For example, muralist Lucienne Bloch, writing of her experience painting a Federal Art Project mural at the Women's House of Detention in New York City, claimed that, before they met her, many of the inmates felt that "Art—[w]as something highbrow." For Bloch, their attitude indicated "to what extent art had in the past been severed from the people and placed upon a pedestal for the privilege of museum students, art patrons, and art dealers." Bloch, like Cahill, intended her art to reach a broader audience: "To combat this antagonism it seemed essential to bring art to the inmates by relating it closely to their own lives. Since they were women and for the most part products of poverty, I chose the only subject which would not be foreign to them—children—framed in a New York landscape of the most ordinary kind. . . . This proved to be a huge success, for in the inmates' make-believe moments, the children in the mural were adopted and named." For Bloch, such a response "clearly reveal[ed] to what degree a mural can, aside from its artistic value, act as a healthy tonic on the lives of all of us."[80]

Yet murals also raised questions about the nature of the public they served and often directly challenged traditional notions of aesthetic value. In February 1936, for example, Lawrence J. Dermondy, a white administrator at Harlem Hospital, rejected a series of mural sketches by several well-known black Harlem artists. The sketches had already been approved by the Municipal Art Commission and the necessary Federal Art Project officials. In his letter to Charles Alston, the supervisor of the project, Dermondy claimed that the murals were rejected because they contained "too much Negro subject matter." Furthermore, Dermondy asserted that "Negroes may not form the greater part of the community twenty-five years hence" and that the "Negroes in the Community would object to Negro subject matter" in murals for a hospital that "is not a Negro Hospital."[81]

Fig. 11. Lucienne Bloch at work on her mural *Cycle of a Woman's Life* for the Women's House of Detention, New York, N.Y., December 1936. (NARA RG69-3-13265-C.)

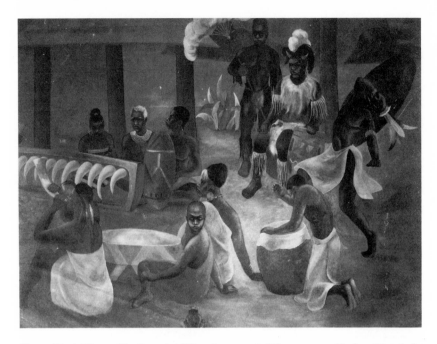

Fig. 12. Vertis Hayes, *The Pursuit of Happiness*, 1936. Oil on canvas. Harlem Hospital. This early frame from Hayes's mural depicts Africans in their native land making music and dancing. The image is one of the first in a sequence that traces the history of African Americans living in Harlem, from health ceremonies in Africa to the halls of Harlem Hospital. (Art Commission of the City of New York.)

In a letter to Audrey McMahon protesting the rejection of the murals, Alston noted that designs for murals in the hospital's boardroom had been made by white artists. These designs, he commented, "being executed by white artists and containing no colored figures, have been readily approved by Mr. Dermondy. Obviously the predominance of white subject matter in a hospital located in a predominantly Negro community causes Mr. Dermondy no concern. All that matters is that there is danger in too much Negro subject matter."[82]

The mural's artists, members of WPA Project 1262, and members of the Artists' Union all united to protest the hospital's decision. They wrote letters of complaint and sent them to President Roosevelt, Harold Ickes, Harry Hopkins, Mayor Fiorello LaGuardia, Holger Cahill, Audrey McMahon, the Academy of Medicine, the Manhattan Medical Society, the

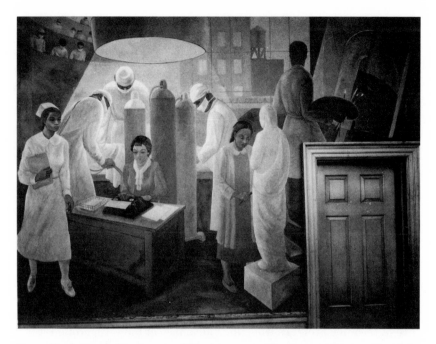

Fig. 13. Vertis Hayes, *The Pursuit of Happiness*, 1936. Oil on canvas. Harlem Hospital. In this frame of the mural, Hayes depicts a variety of African American hospital staff at work under the bright glare of an operating room light. The collagelike style of the work, with its overlapping images as well as its subject matter, the glorification of work, is in keeping with the modernist aesthetics of the day. (Art Commission of the City of New York.)

NAACP, and a number of local and national newspapers. The letters claimed that the rejection of the mural sketches demonstrated "a chauvinism which cannot be tolerated." The artists used the incident as a flash point for further political action. They did not blame Dermondy alone. Rather, they asserted that such discrimination was the "logical result of such segregation of Negro artists into an all Negro project" and, among other things, demanded that the "policy of segregating Negro artists into any jim-crow project such as the Harlem Hospital . . . be abandoned immediately." The letter concluded with the assertion that "Negro achievement, culture and progress are indisputable facts which should be known and respected by all races as part of the great body of our city's culture." As Harlem residents, they asserted that Harlem was a distinct and important

part of New York City and should be recognized as such. In addition, the artists hoped that this event would serve a national purpose and would "bring these facts to the attention of other races so that they might better understand the Negro and by this means break down the thing we all abhor—discrimination." As a result of their campaign, the rejected murals were painted in Harlem Hospital (and are still there today).

The Harlem Hospital murals trace the development of medicine from the practices of African witch doctors to the discoveries of scientists such as Louis Pasteur and Wilhelm Roentgen, inserting blacks into the history of medicine. Black doctors and nurses treat patients and work in laboratories. Yet, despite their "Negro subject matter," the murals are painted in a high modern style. They closely recall the works of the Mexican muralists José Clemente Orozco, David Alfaro Siqueiros, and especially Diego Rivera. Alston knew Rivera personally and would have been familiar with his 1933 mural for Rockefeller Center, *Man at the Crossroads*.[83] Indeed, Alston's sketches contain some of the same visual motifs as Rivera's piece. The giant microscope in the middle of the sketch, like the atom splitter in Rivera's mural, places technological advances at the center of this historical narrative of scientific progress, while the individuals in the work ground it in a real time and place. Compositionally, the two murals are similar as well with their multiple story lines working in the service of a larger didactic narrative. Alston, like Rivera, was aware of the public nature of murals and intentionally crafted his works to speak to a large number of people. Through his work he combined a progressive historical narrative with political activism and modernist artistic mastery.

In a sense, the Harlem Hospital controversy resulted from the nature of the artistic medium under debate. Because murals become an organic part of the spaces they occupy, their value is measured by the constituents as well as the custodians of the spaces. Moreover, murals financed by the Federal Art Project were, theoretically, public property. In the case of the Harlem Hospital murals, however, white administrators and members of the black community both claimed ownership of the hospital's public space, and they had different ideas of what the federal government should finance as public art. As Alston pointed out, the rejection of the mural sketches illuminates one of the major problems inherent in models of democracy by inclusive invitation: those doing the inviting define the norm. In the case of the Harlem Hospital murals, the use of black subject matter in a predominantly black community was considered "political," while white subjects were seen as apolitical, even natural. Yet the mobilization of the

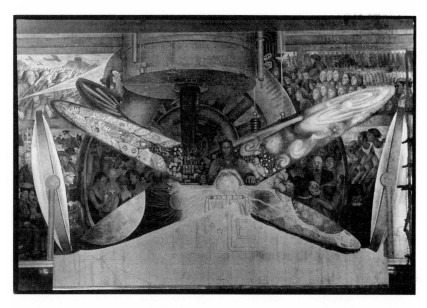

Fig. 14. Lucienne Bloch, photograph of Diego Rivera's unfinished mural, *Man at the Crossroads,* for Rockefeller Center, 1933. Bloch, who worked for Rivera on the mural, took one of the only photographs of the work before it was destroyed. Both Charles Alston and Vertis Hayes were aware of Rivera's work, and their works for Harlem Hospital bear its direct influence in both style and subject matter. (Courtesy of Old Stage Studios, Gualala, Calif.)

artists who designed them to demand inclusion in the national cultural laboratory, on its members' own terms, demonstrates their success in challenging this notion of democracy and working toward a more inclusive definition.

By simultaneously acting as a form of political, social, and cultural capital, works such as the Harlem Hospital murals successfully bridged the tension between desacralizing art and democratizing the sacred. The rejection of the sketches galvanized the murals' artists as well as members of local and national communities to take action: as artists, as workers, and as part of the American public. Art provided the means for them to enter into public debate. The artists on the project used their ties to the government projects to directly advocate for larger social change and to fulfill their artistic vision. They followed Stuart Davis's directive to step out into the street and in so doing became members of Cahill's social family. But they did not sacrifice style for politics: Their murals combine modernist

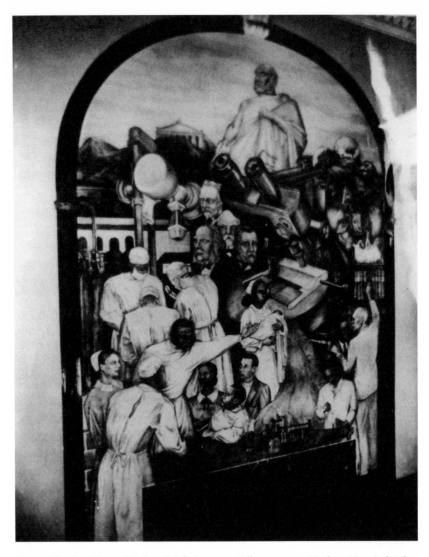

Fig. 15. Charles Alston, *Modern Medicine*, 1936. Oil on canvas. Harlem Hospital. Like Hayes and Rivera, Alston combined images from the past with those pointing to the promise of a better future. A statue of Hippocrates, the "father of modern medicine," towers over the composition, which also contains images of actual Harlem Hospital doctors and nurses. Dr. Louis Wright, the supervising physician at the hospital, is depicted at work in the large operating theater, which gets its light from a giant microscope. As in Rivera's *Man at the Crossroads,* technology plays a crucial role in this visual journey. (Art Commission of the City of New York.)

aesthetics with political commentary. By focusing on their rights as cultural producers, these artists embraced the Federal Art Project's pedagogy of cultural production and presented a model for the social usefulness of art both on their own aesthetic terms and within a national cultural context; in so doing they created a compelling example of a more democratic American modernism and made artistic experience available to a much more diverse audience.

Chapter 2
Future Citizens and a Usable Past

On September 5, 1938, *Time* ran a cover story celebrating the successes of the Federal Art Project. Appropriately enough, a photograph of Holger Cahill wearing a fedora and a pinstriped suit and standing in front of a mural depicting muscular workers excavating a majestic mountainscape graced the magazine's cover. The dapper, smiling bureaucrat, the monumental mural, the overall-clad workers: these were all visual symbols of the Federal Art Project.[1] Yet administrators regularly stressed that there was more to the project than these visual cues. In an interview inside the magazine, Cahill identified the project's primary goal as "break[ing] up the big city monopoly on art by getting people all over the United States interested in art as an everyday part of living and working."[2] Art education, he explained, was a crucial component of this process. For many Americans, elite definitions had obscured the idea that art was something that they could create and enjoy. Through wide-reaching educational programs the Federal Art Project attempted to dismantle such notions and make artistic production more tangible for the mass public. As shown in the previous chapter, while a large part of the project's operating philosophy was concerned with making work for out-of-work artists, another major emphasis was on teaching the American public how to appreciate and make art themselves. Both, however, shared similar ends: to challenge the idea of art as something sacred and to democratize it by providing access to a wider segment of society. While the project's philosophy about artists placed a premium on their autonomy, its approach to the public was much different. Massive publicity campaigns in the mainstream media, such as the article in *Time*, were part of the process. Two other major components of the government's democratization project—as Cahill put it, to "get people all over the United States interested in art as an everyday part of living and working"—were carried out through the Community Art Center Program and the Index of American Design. Through the former, the government directly funded over four hundred art centers that offered a variety of

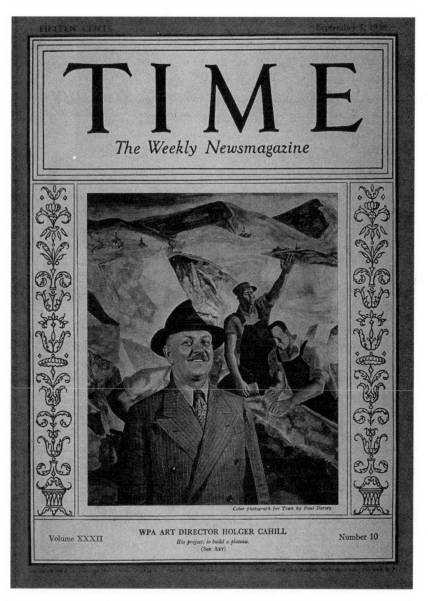

Fig. 16. Holger Cahill on the cover of *Time*, September 5, 1938. (© Time Inc. Photo by Paul Dorsey/Getty Images. Reprinted by permission.)

classes to children and adults across the country. The latter employed over three hundred commercial artists to catalog American decorative arts from the colonial period to the Gilded Age in a massive national salvage project. From the activities in the Harlem Community Art Center to the detailed sketches of antique quilt designs and weather vanes, these two projects invited the American public to participate in creating a new national art form and, in so doing, challenged and transformed longstanding ideas of what constituted value in American art.

The inclusion of the community art center movement in the Federal Art Project resulted from the efforts of Daniel S. Defenbacher, state supervisor of the North Carolina Federal Art Project. Defenbacher felt that the appreciation of art reached beyond the gallery and affected the general welfare of individuals at home, at work, and in the community. "We must know," he asserted, "that most men can get personal pleasure . . . from conducting their lives with some degree of artistic sensitivity." In his first year as state supervisor, he established three art centers within the state. Each art center had a gallery, provided lectures and demonstrations, and offered art classes for adults and children. Defenbacher believed that "art must be seen for what it is and what it does in community life." The uses of art, he maintained, could be taught: "We have established leadership for health, social welfare and science," and now, he argued, "we must follow the same course for art."[3] Cahill recognized that the creation of community art centers across the country could address the tension within the Federal Art Project's ideology between true desacralization, the destabilizing of an artwork's sacred aura, and democratization, providing access to the artwork's aura. Defenbacher's contention that artistic value came from what it did in community life fit nicely within the Federal Art Project's efforts to root artistic value in production. His emphasis on teaching also dovetailed nicely with Cahill's efforts to provide creative outlets for those living in remote areas of the country, away from spaces traditionally defined as cultural centers.

Early in 1936, Cahill appointed Thomas Parker, a member of the national staff in Washington, to the position of director of the art center program. Parker toured the country, looking for areas in which to establish art centers. His initial emphasis was on the South and the West. By December 1936, twenty-five new art centers had been created in these two regions, and over one million children and adults were reported to have participated in activities sponsored by these centers. With the zeal of missionaries, Cahill and Parker preached their doctrines of desacralization and democratization.

In speech after speech, Parker exclaimed that the primary goal of the program was "to make art an expression of the people to broaden its meaning through mass participation as well as appreciation and to assiduously avoid the imposition of preconceived ideas of what is best."[4] Similarly, Cahill repeatedly explained that "in every art the need is for demonstration to ordinary people that they can participate. The road to appreciation is to do, not only to watch. Whenever art becomes more than a spectator activity, the quality of life is immeasurably improved."[5] Cahill's and Parker's repeated emphasis on doing rather than watching, as well as their assiduous efforts to avoid imposing evaluative criteria based on aesthetics, was quite radical in their time. Indeed, by encouraging "ordinary people" to participate ("to do not only to watch"), they challenged contemporary conceptions of artistic worth and posited an alternative valuation system based on production rather than on consumption or spectatorship.

Between June 1936 and October 1937, Parker, Cahill, and Defenbacher collaborated on a manual that outlined how to establish community art centers across the country. In addition to establishing guidelines for selecting staff members, deciding upon classes, organizing administrative duties, and physically arranging the sites, the manual contained the philosophies behind the art center movement. "In the arts, as in many other phases of American life," the opening sentence declared, "there has been in our time a development of professionalism without a corresponding development of community participation."[6] The Community Art Center Program attempted to rectify this seemingly oppositional division and merge notions of artistic professionalism and community participation by encouraging members of the local public to get involved in running the centers. In order to receive government funds to establish a WPA art center, each community first had to raise a certain amount of money and, ideally, provide a suitable venue for the center. These were the tasks of the sponsoring committees. In addition to raising initial community interest, sponsoring committees cooperated with the hired staff in overseeing the finances and planning events in the region. Through the work of local committees the government hoped to integrate community art centers directly into local community life. Such integration was key to the program's success. As Parker explained, "The art center should be as indispensable as the public library . . . in developing opportunities for sharing in the experience of art and in the development of taste in both personal and civic matters." Moreover, he continued, "The center endeavors to bring order, design and discrimination into the pattern of environment created by human society."[7]

In keeping with the "order, design and discrimination" of local communities, community art centers were racially segregated. Separate "Negro centers" were set up across the South as well as in Harlem. Rather than viewing segregated centers as discriminatory, however, Cahill and Parker felt that Negro art centers were progressive and mentioned them proudly in their speeches. For example, in 1938 Parker told a group of librarians that "an unusual feature of Community Art Center work has been the establishment of galleries for Negroes both in the South and in New York City." "In this phase of its program," he continued, "the Project has been very successful in giving expression to the rhythmic and artistic instincts of the Negro heretofore confined primarily to music and the dance."[8] While some blacks participated in non-Negro art programs, Negro art centers were created specifically to recognize the "traditions" customarily denied to black artists as well as to cultivate black artistic talent. In a July 1938 speech in Tuskegee, Alabama, Parker exclaimed that "Negro art has always been attuned to the rhythmic expression of a people deeply sensitive to the poetic values of life." The Negro, Parker asserted, "is, in general, instinctively an artist. He has, however, like other racial groups, needed an opportunity to participate in a rich national culture." The government aimed to provide such an opportunity. According to Parker, the creation of Negro art centers across the country "endeavored to give full expression to the contributions of the Negro" while "integrating the fabric of [the] national cultural pattern." Through the Community Art Center Program, he explained, "Negro artists have been given new opportunities to realize their vital role" in the national "esthetic melting pot."[9]

Although the essentialist racial assumptions in Parker's speech may seem prejudicial today (and in many ways smack of tokenism), the establishment of Negro art centers was often the result of intense lobbying from within black communities. For example, in December 1935, a Mrs. E. P. Roberts wrote to Cahill on stationery embossed with the slogan "Harlem's Aim is a Permanent Art Center." In her letter she described the success of a 1935 exhibition of "works of Negro artists at the West 137th branch of the Y.W.C.A." sponsored by a group of Harlem citizens known as the Harlem Arts Committee. The local community's response to the show, Roberts argued, "pointed up in the minds of the artists and of the sponsoring committee the need for a permanent art center in Harlem." As chairman of the committee, she concluded, "I am writing you to ask you to make a direct Federal grant to finance this project."[10]

The activities of the Harlem Arts Committee surpassed Cahill's and

Parker's criteria for community art center sponsoring Committees as out-lined in their manual. Its members raised money for local art exhibitions and provided free art classes to neighborhood children, and their efforts repeatedly were met with large numbers of participants and positive reviews in the local and national press.[11] Moreover, the committee seemed to em-brace the aesthetic value system employed by the Federal Art Project, which highlighted the relationship between art and productivity, between artists and the community, and between education and experience. Yet they were still not rewarded with a government art center, although community art centers were springing up almost overnight in other parts of the country. In February 1937, the Harlem Arts Committee sponsored another exhibit at the 137th Street YWCA In the foreword to this show's catalog, the commit-tee again made a direct appeal to the federal government to establish an art center in Harlem, stating, "This exhibit is Harlem's response to the ques-tion, Does New York need a city art center?" Interestingly, there were other Federal Art Project art centers in New York City as well as a number of government-funded programs in Harlem itself. Harlem residents, however, wanted a proper community art center like those being set up across America, not another after-school workshop in a church basement. The Harlem Art Committee's use of the term "New York" to define Harlem acted as a reminder to government officials that Harlem was outside of the big-city monopoly of midtown Manhattan yet part of New York while at the same time building upon notions of Harlem as a distinct community in need of both professional and public participation in the arts.

After two years of heavy lobbying, on December 20, 1937, First Lady Eleanor Roosevelt opened the Harlem Community Art Center on the site of a formerly empty lot on the corner of 125th Street and Lenox Avenue. The building, a 7,200-square-foot space, comprised a central gallery flanked by a number of studios for study and practice. The Harlem Community Art Center became a source of enormous pride for many members of the local community, as well as for government publicity officers. Despite the fact that it took two years of pressure from local citizens before the WPA opened an art center in Harlem, once it did, the government flaunted its achievements. The Harlem Community Art Center received mention in almost every weekly report from the New York City office to the national office in Washington.[12] Celebrities such as Albert Einstein and Paul Robe-son visited the center to much fanfare. Weekly reports noted other interna-tional and national guests as well. In many ways, the praise and attention lavished upon the center recapitulated the slumming activities popular dur-

Fig. 17. Children lined up to register for free art classes at the Harlem Community Art Center. (NARA, RG 69-N-20841-C)

ing the Harlem Renaissance—there were few reports of international visitors to other community art centers.

The combination of its location in Harlem and the minorities who participated in its activities was what made the Harlem art center a popular site for cultural tourism. Unlike the slumming of the 1920s, however, at the Harlem center blacks were in control of their artwork. Government money allowed them a freedom of expression previously denied. Moreover, the center reached a broad-based local public and enjoyed widespread community support and enthusiasm. Realizing this, the federal government presented the Harlem Community Art Center to the world as an example of racial harmony and government benevolence, arguing that its activities conveyed a sense of shared citizenship rather than otherness. The following year the WPA funded a Negro Community Art Center in Chicago, again meeting with great enthusiasm from the local black community. Despite the contemporary desire to view Negro art centers as paternalistic and patronizing, both the lobbying that local residents did to get these centers established in their communities and the enthusiasm with which they received them demonstrate a high level of engagement in local politics as well as a strong desire to enter into national debates over the role of the arts in a democracy. For the participants in Negro centers, art became a form of political as well as social and cultural capital. The creation of Negro art centers also became a way for the government to fuse theory and practice by publicly demonstrating the democratic and color-blind nature of its cultural mission and directly challenging the idea of art as sacred and timeless by positing its social value firmly in the present.[13]

The Federal Art Project's ideal of cultural desacralization rested in large part upon the redistribution of artistic opportunity in the United States. Again, this was tied directly to notions of usefulness. In an address to the Art Reference Round Table Group of the American Library Association, Parker lamented that in the recent past artistic opportunities had "all been confined to the metropolitan areas." The result, he argued, was that "the vital relationship between the artist . . . and his public [had] rapidly declined . . . undermining the contribution of the artist as a valuable member of society."[14] One reason for this decline, he argued, was that in the past many artists had left their local communities to find camaraderie and acceptance in metropolitan areas, which led to the separation of artists from society as a whole. The government, by providing artistic opportunities for artists in their hometowns, hoped to rectify this problem and keep local talent local. They aimed to reintegrate artists and their "valuable contribu-

Fig. 18. Jerome Henry Rothstein, *Hundreds Are Receiving Free Instruction*. Poster for Federal Art Project–sponsored classes at the Harlem Community Art Center, 1936–38. (Works Progress Administration Poster Collection, Library of Congress, POS-WPA-NY, R68, no. 10.)

Fig. 19. Student sculptor. One of many publicity photographs depicting children's art classes at the Harlem Community Art Center. The activities at this center were a popular topic in Federal Art Project publicity campaigns, as were images of children at work, since both testified to the "usefulness" of the art project's programs. (NARA, RG69-55-23329-D.)

tions" into local communities across the United States and root artistic value in the contemporary production of art in everyday life rather than in rarefied and separate environments. Community art centers played an important part in this process by providing spaces in which artists could work and by creating venues that would accept and encourage artistic production. Ideally, staff was chosen from the region. This was not always possible, however, since all Federal Art Project personnel had to qualify for relief in order to be hired, and often local communities did not have the artists on relief needed to staff their art centers. Moreover, in New York City and other large urban areas there were often too many artists for the budget. In an attempt to rectify geographically and financially the unequal distribution of artists on relief, Cahill instituted a policy of "loaning" New

York artists to communities that lacked the artistic talent necessary to staff a community art center. Loan artists worked the same number of hours as they did in New York City and were given vouchers to cover their travel expenses and phone calls.

While this sounds good in the abstract, the loan artist program did not always run smoothly. In a 1938 memorandum to art center directors, Cahill instructed that "any failure of the artist to harmonize his work with that of the resident staff will be grounds for immediate return to New York." Confidential reports on the loan artists' attitudes and cooperation were filed regularly. For example, Frederick Whiteman, acting assistant to the WPA in North Carolina, sent this confidential report to Defenbacher on December 30, 1938, regarding WPA loan personnel: "Ernest Crichlow, Negro, has given us every reason to believe that he is in full accord with our own ideas and plans for a Negro community interest in such a project. He is also cooperating with the other Negro workers in their class work and we feel he is generally making improvements in this direction." Regarding loan artist Sarah Murrell, however, Whiteman wrote, "We are as yet undecided as to her true status. We feel that she has real artistic ability and should have good teaching qualifications. However," he continued, "her unsympathetic spirit toward the South and her un-willingness to mingle with the proper people in the Negro community" made her seem "aloof" and "antagonistic." And, he concluded, "Some have expressed the idea that she has made them feel that she considers herself much above the community Negroes."[15]

Many loan artists responded like Sarah Murrell. They resented being treated as common laborers who could be moved about like cogs in the machine; they wanted to retain their special status as artists and disliked being displaced from their home communities and forced to fit into government-determined roles of how artists should function in an ideal community. Moreover, loan artists often thought rural residents ignorant and were unable to establish the necessary personal and professional ties needed to interact with their host communities. In other instances, however, the discrimination was reversed. Racial and ethnic prejudices were often stronger, or at least more visible, outside of metropolitan areas. For example, in a letter to Cahill regarding the appointment of a loan artist to the Ojai Valley Community Art Center in California, the project director and abstract artist Stanton McDonald-Wright queried Cahill, "Is Mr. Morris of Levantine, Near Eastern, Karate or Ishkanian lineage? To you, is he Jewish? They do not want any of our chosen brethren in that locality." Cahill re-

sponded, "Carl Morris is a fine fellow . . . but his wife is very and emphatically one of the progeny of Rachel."[16] Due to local anti-Semitism, another artist got the job.

Despite the Federal Art Project's repeated calls for an "aesthetic melting pot," racial and ethnic differences were often closely scrutinized by local residents, who in many cases were still distrustful of artists. Nevertheless, community art center administrators tried to include a diverse range of ethnic and racial traditions within their programs. As part of their efforts to demystify artistic production and redefine the place of art in America, when possible, they included lessons in regional crafts and the use of local materials. By focusing on the familiar, they hoped to include a diverse group of participants in their programs. In order to cast their nets as wide as they could and include as many Americans as possible in their democratic artistic communities, the Federal Art Project was divided into forty-two administrative units. New York City and New York State constituted two separate units. Cahill, as national director, was officially based in Washington, D.C. Below him were the field directors; they floated nationwide and supervised the regional and state art directors, who oversaw the district art supervisors and local advisory committees. There was constant interaction between the regional and local committees and the national office. For example, surveys and questionnaires were sent regularly from Washington to regional centers asking about relationships with the local population and attendance at the centers. Regular memos encouraged local art administrators to consider incorporating the major industries in their communities into art center activities. In addition, the national staff asked regional directors to be on the lookout for indigenous crafts and when possible to "revive old and neglected patterns of design that are found in works of art produced by members of the community in the past." By incorporating regional differences and specialties into its programs, the Federal Art Project challenged the power of a primarily metropolitan elite to determine what constituted a work of art and, in so doing, expanded the definition and role of art in America.[17]

By today's standards, the efforts of Cahill, Parker, and other art center staff seem folksy and their goals quaint and naïve. But their dedication and the strength of their convictions about the power of art to communicate to vast and diverse audiences as well as their broad-based definition of what constituted a work of art are worthy of revisiting. Despite their often normative goals, community art centers encouraged tolerance and diversity. Their art education programs aimed to teach the public not just about art

but also about the importance of education and public participation for a functioning democracy. Following Dewey, Cahill considered art a vital teaching tool. He consciously tried to redefine art education to address a broad range of social issues. Cahill believed that education was an active process and that there were direct links between knowledge and experience and between education and citizenship. One of his pedagogical goals was to reconnect art and experience in Depression-era America to energize the educational process. In a 1936 speech, Cahill lamented, "To many people education is a dull word. It suggests the musty smell of the classroom blackboards, chalk dust, and the routine of trying to learn a lot of things that are supposed to be good for us. Those of us who have this childhood hangover find it hard to imagine that education can be as enjoyable as a movie or a football game."

In part, Cahill was reacting to the cultural practices of contemporary museums as agents of cultural sacralization focusing on what he called "dead art." He encouraged Americans to think differently about the place of art in everyday life. When asked why "such slight attention is given to the fine arts in our educational programs," Cahill answered, "Isn't it because in our thinking about art we have sold ourselves down the river to the melancholy doctors of esthetics? These doctors have split art in two, calling the one part—the part which they admire—ideological and expressive, and the other part, which is supposed to be very inferior, indeed utilitarian."[18] One of the goals of the Community Art Center Program was to collapse the boundaries between the expressive and the utilitarian, to challenge these binaries as false distinctions, to simultaneously destabilize the sacred aura that surrounded most art at the time and provide access to this aura to those not traditionally included in its purview. One of the ways that project staff attempted to do this was through the employment of what they called "artist-teachers." The idea of the artist-teacher was central to the Federal Art Project's larger ideology of desacralization through cultural production. Artist-teachers had dual identities: As artists they represented the "expressive," while as teachers they understood the "utilitarian." Their primary job was to demystify art to make it accessible to the layperson. Project staff argued that artist-teachers inherently understood the "need to create," which all people felt. Moreover, they were well suited to offer instruction on how to satisfy that need. According to one Federal Art Project official, "Artist-teachers know that a fundamental creative impulse has been common to humanity since the time when primitive people decorated the caves . . . and though civilization progresses, deep instincts remain unchanged."[19]

Such essentialist notions of art—as something primal rather than rare-
fied—contributed to the government's larger desacralization efforts by
endowing all Americans with artistic instincts. It also marked a transforma-
tion in the ownership of cultural capital from the hands of a small elite to
those of a more democratic public. Indeed, for Cahill and staff, the job of
the artists-teachers was to integrate the universal "need to create" into
modern American society and "give healthy corrective to the predomi-
nantly mechanized amusements and values of the contemporary world."[20]

Cahill's agenda was larger than just making education as enjoyable
as commercial entertainment and resuscitating the arts in contemporary
America, however. He wanted to transform how aesthetic value was cali-
brated across the United States by destabilizing art's aura and locating its
value in the everyday life of local communities. Through the Federal Art
Project, he advocated for a way of life centered upon an idea of community
that was rooted in abstract notions of a mythologized small-town past.
Nostalgia for preindustrial society permeated the educational literature of
the Community Art Center Program. For example, at a 1939 conference
designed to garner continued support for the project, Cahill complained
that "America no longer has the rich community life of its early days. It no
longer has the corner grocery store and its sewing circles, its domestic
drafts, its looms by the hearth and its itinerant painters, its town meetings
and Sunday school picnics, its traveling Uncle Toms and Little Evas, Local
Ballad sings and Virginia reels."[21]

By lamenting the disappearance of these mythic constructs—the sew-
ing circle, the church picnic, the minstrel show—Cahill highlighted what
he saw as the spiritual and emotional poverty of life in the Depression-era
United States and warned of the horrific effects such bankruptcy would
have on American culture. Stories such as this one abounded nationwide
in which a WPA teacher "asked a six year old in her class to paint a still life
of the vegetables she eats. The little girl painted a can of baked beans."
"Like most Americans today," the story continued, "the little girl is the
product of a ready-made world where milk is something that is left in
bottles at the door; subways and automobiles take the place of legs, and
even creation is passive; we listen to radio programs and look at motion
pictures instead of creating our own diversions."[22] While today one might
consider the young girl a visionary, incorporating Duchamp's concept of
the readymade and prefiguring Warhol's soup cans by twenty years, at the
time her painting was viewed as tragic—a manifestation of individual and
national crises.

In contrast to some of the Federal Art Project's support of artists who were incorporating modernist aesthetics into their work, the rhetoric of the community art center movement contained strong strains of antimodernism as well as nostalgia. The fear that twentieth-century Americans were becoming merely passive spectators and idle consumers in the face of modernity frightened many progressive educators. For example, in a 1937 speech Cahill complained that "the radio, the movies, and the Sunday supplement seem to determine our standards and control our lives." Furthermore, he asked in another speech, "is the progress that can be measured in terms of automobiles, movies and the radio giving us anything to take the place of the values that are being lost? . . . [Can] the heritage of the past be revitalized and brought into the daily experiences of ordinary people? Can America learn to use its new tools to enrich its community life as well as to extend its scientific and productive forces?" The community art center, he answered, "is proposed as one step that is within our reach. It answers our basic needs."[23]

But what exactly were these basic needs? And how were they related to the myths and symbols—both real and imagined—of American life? For Cahill and other project staff, there were direct links between desacralized artistic practice and democratic citizenship, and both were tied to issues of prescriptive public behavior. The Federal Art Project's emphasis on mass cultural production presented art as a corrective tool for addressing the inequalities and problems inherent within modern life. Initially, community art centers were set up in rural areas and small towns to stem the flow of cultural talent away from local communities. However, once staff saw how successful their programs were in these areas, they began establishing urban art centers (often with prompting from local citizen's groups such as the Harlem Arts Committee). Indeed, the establishment of urban art programs soon became a primary goal of the Federal Art Project administration in its attempts to redefine artistic value across the United States. Stressing the participatory value of the programs and employing the language of social usefulness and efficiency, they used the rhetoric of desacralization as a tool for the cultural assimilation of "future citizens." In a 1938 report summarizing the project's first three years, Cahill boasted that the community art center movement had "reached hundreds of thousands of adults and children from the slums of Manhattan . . . where art was hitherto an unknown language." In New York and its vicinity, "a widening area of *social usefulness* has been created by the classes for underprivileged children who have been taken off the street and provided with fresh and natural

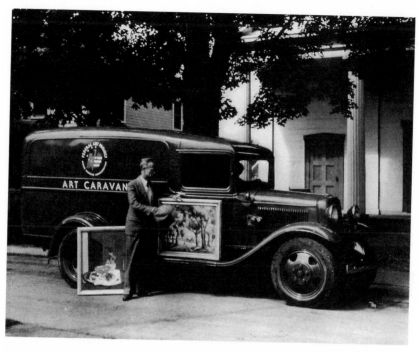

Fig. 20. Art caravan. The Federal Art Project often sent artists to areas where there were no art classes to set up traveling workshops in art caravans such as this one. (NARA, RG 69-3-20901.)

outlets for expression." Unsupervised after-school hours, Cahill asserted in another speech, "spent sometimes in perilous street play, sometimes in pursuits which began careers in crime, have been turned instead into *constructive* play with paints, clay and craft tools" (emphasis mine).[24]

Cahill made the same point in more colorful language in yet another 1938 speech:

Boys and girls in greater Manhattan who receive no nurture from the stereotyped education of a large public school system and then seek excitement in the gang life of the slums constitute a special problem. . . . city children are over-stimulated by the color, drama, and excitement of modern urban life. They have lost their racial traditions. They have no place to play except the streets. Their high energy needs both emotional expression and physical outlet.

Federal Art Project classes, he claimed, directly addressed these issues and, he excitedly exclaimed, "have abundantly demonstrated that many young-

sters . . . are as eager to join together in painting a mural as to rob a nearby grocery store."[25]

To paint a mural or to rob a grocery store: Cahill presented the options as a melodramatic choice between stark contrasts. Nevertheless, fears of juvenile delinquency resulting from lack of supervision and the loss of ethnic traditions were widespread in urban areas, and they escalated during the Depression. Supporters of the Federal Art Project promoted art activities as a means of both addressing and rectifying these problems by providing constructive outlets for the "over-stimulated color palettes" and reserves of energy that many project personnel and educators believed if left untapped could result in a life of crime or ill repute. Articles on the positive effects of art education and the social value of art in disciplining children abounded in the popular press, in government publications, and in medical journals. For example, in an essay entitled "The Artist as Social Worker," Irving J. Marantz wrote of his experiences teaching for the New York City Art Project at the Community Boys Club. "Boys of the toughest type," he recalled, "many already with police records came in and actually put in time away from the anti-social training of the streets. . . . Ragged, undernourished and in many cases extremely brilliant lads were in a short while handling paint brushes as deftly as they threw stones or stole apples from the peddler, or penknives from the '5 and 10.'" In addition to engaging the boys' dormant creativity and getting them off the dangerous streets, Marantz argued that their artwork had positive effects on the community. "The hanging of the outdoor exhibit of the paintings by these boys," he noted, "was the first time in the history of the neighborhood that there had been a display of creative work. The boys stood proudly by and guarded the exhibition from any vandals from other neighborhoods." This, he argued, "was the beginning of a large movement and a sharp change in the attitude of the entire neighborhood."[26]

Throughout the 1930s, prominent educators, settlement workers, and psychiatrists repeatedly testified that community art center activities helped to prevent juvenile delinquency. In 1936, educator Samuel Friedman wrote, "Psychiatrists at hospitals and schools for juvenile delinquents study paintings to discern the emotional and mental development of their young charges."[27] Similarly, an article entitled "Art and Medicine" in *Hygiene Magazine* (May 1939) claimed, "While the exact relationship of art to medical science is still a debatable question, the experiments with art in the medical world in the past two years have proved so valuable that even the most literal-minded physician cannot fail to be aware of its therapeutic

benefits."[28] One of the valuable experiments mentioned in the *Hygiene* article and widely celebrated elsewhere was the cooperation between the Harlem Community Art Center and Bellevue Hospital, which culminated in the 1938 exhibition *Art and Psychopathy*. Gwendolyn Bennett, director of the Harlem Community Art Center, described this show with pride and highlighted the social value of art when used as a teaching tool. "Exciting," she wrote, "has been the experience of watching delinquent and maladjusted children sent to the center from psychiatric wards of the city hospitals become stable material with which to build future citizens."[29]

The show, held at the Harlem Community Art Center from October 24 to November 10, 1938, contained paintings and drawings by "normal" children and adults from Harlem alongside those done by Harlem children and adults with a wide variety of psychological problems. For example, exhibit 32 was by "7-year-old Leroy, an illegitimate colored boy who was left down South by his mother without much of the good things in life. He came to New York in the past four months, and everyone complained that he did not know how to act, with other children, at school, on the streets, at home, with a new step father, etc." Exhibit 54 detailed the work of "a 14-year-old colored girl—very aggressive and with homosexual tendencies who chooses her topic according to her aggressiveness." The text continued, "The technical ability of the artist is obviously limited, and the shortcomings in technique really appear as shortcomings and not as primitively as in pictures of children."

The deliberate differentiation between patient 54's "unhealthy" technique and the scribblings of "healthy" children seen elsewhere in the exhibition normalized the diagnostic process so that visitors to the exhibition could participate in identifying the patient's problems and in comprehending the value of art in treating them. Moreover, these brief descriptions alerted viewers to the host of "misbehaviors"—homosexuality, nonsocial conduct, aggressiveness—that could result from unregulated environments. In addition to brief analyses of each patient's artwork, case histories similar to this one were included throughout the exhibition and cited in the popular press:

One sensitive, introverted boy, who began by working on a small corner of his paper and who revealed a deep feeling of inferiority by never completing a piece of work and by expressions of deep dissatisfaction with it, delighted his teacher and his physician by a gradual change that culminated, finally, in free broad paintings. Instead of subjects from his own unhealthy fantasy, he began to paint the things around him, discarding somber hues for pastel tints. During this period, lasting

more than a year, he began to mingle with his fellows, to talk and to have moods of lighthearted gaiety with increasing frequency.

The report concluded, "His art work may or may not have been an instrument in his return to normalcy and a social outlook. It did, however, record his psychological trend, and, in his own words, 'It makes me see everything twice as interesting.'"[30]

Such case histories attested to the successful uses of art in both diagnosing and treating illness and were part of the broadening definition of art and aesthetic value employed by Federal Art Project personnel to promote their programs. These expanding notions legitimated the government art projects by demonstrating their social importance. By presenting situations and individuals with problems that most viewers could recognize, then testifying to the positive benefits of art projects in alleviating these problems, exhibitions such as *Art and Psychopathy* made art seem relevant to individuals who may not have cared about aesthetic issues. Moreover, such shows concretely demonstrated how art was being used for social purposes. The most valuable by-product, however, was not the art produced by participants but the effect that artistic production had on participants themselves. By making art, they in effect became the valuable products produced.

The idea that community art centers were helping to shape the "citizens of the future" dominated the rhetoric of project staff. Moreover, they repeatedly emphasized the idea that shaping citizens was a more important goal than aesthetics. In this way, the Community Art Center Program contributed to the Federal Art Project's ideal of its future retrospective value—that historians would one day hail it as "great." Yet the project's notions of value were also backward looking and were in tension with its support of more experimental artists. Cahill, like many in the 1930s, was actively looking for a "usable past."[31] In many ways his mission was to capture, and in some cases salvage, America's artistic heritage for use in the future, before it was too late. Tied to the nostalgia and antimodernism of the Community Art Center Program was the idea that American folk traditions were slipping away. The integration of local crafts and ethnic traditions into community art center activities was one way in which project administrators hoped to maintain an awareness of the past.

Perhaps nowhere, however, was the urgency of this quest more evident than in the Federal Art Project's Index of American Design. Under the index, over three hundred artists made hand copies of more than twenty-

two thousand objects from America's craft heritage. These included weather vanes in the shape of the angel Gabriel, Pennsylvania-Dutch whirligigs, woven coverlets, crewel bed valances, fire marks, and painted chests. The index had a major salvage component: It gave priority to "material of historical significance not previously studied which, for one reason or another, stood in danger of being lost." The ideology guiding the Index of American Design contained the same central tension as the other Federal Art Project programs between desacralizing and democratizing art in America. Yet its notions of both were different from those guiding the projects created to provide unemployment relief for out-of-work artists and the public outreach programs of the community art centers. Through the Index of American Design, art project administrators and participants attempted to expand the notion of artistic aura to objects not traditionally considered artworks. Moreover, the project retroactively broadened the category of the artist in American history, since most of the individuals who made the goods being cataloged were not technically artists in their day but were other types of workers—farmers, bricklayers, tradesmen, and housewives. Thus, the index directly challenged the notion of the artist as genius, since most of the producers, as well as the goods they produced, were anonymous.

The Index of American Design was not part of the original Federal Art Project plan. It was the brainchild of Romona Javitz, head of the New York Public Library's picture collection, who "had recognized for some time the need for a comprehensive source record of American design." In the spring of 1935 Javitz teamed up with Ruth Reeves, a painter and textile designer and, according to Cahill, "the missionary of the Index idea." Reeves approached Frances Pollack, director of Educational Projects for the New York City branch of the Emergency Relief Administration, to suggest that government-funded artists carry out the project.[32] Cahill and other Federal Art Project staff were receptive to this idea and later that year initiated the index with Reeves as the national coordinator and Constance Rourke as the national editor.[33]

Rourke's interest in American vernacular culture made her an excellent fit for the project. Like Cahill she was interested in defining a national character and searching for America's cultural roots.[34] Regarding the Index of American Design she wrote: "Fresh light may be thrown upon ways of living which developed within the highly diversified communities of our many frontiers, and this may in turn give us new knowledge of the American mind and temperament. . . . If the materials of the Index can be widely

Fig. 21. Gentleman recording a 1770 coverlet for the Index of American Design in Coral Gables, Florida, February 1940. Artists employed by the Index of American Design worked directly from the object they were recording and were meticulous in their copying. (NARA, RG69-5-22577.)

seen they should offer an education of the eye, particularly for young people, which may result in the development of taste and a genuine consciousness of our rich national inheritance."[35]

Rourke's idea of an "education of the eye" nicely complemented Cahill's desire for a usable past. Both highlighted the experience of looking as an important educational process. The index also fit nicely within the Federal Art Project's desacralization mission, in particular within its stress on cultural production. In an essay detailing the history of the index, Cahill explained, "Here was a job that needed doing. The doing of it would maintain and improve skills." Cahill's "just do it" pragmatism aimed to get people working in both the public and the private realms. He saw the index as a way of putting less talented artists to work while redefining notions of

Fig. 22. Index of American Design studio, Coral Gables, Florida, February 1940. As in many Federal Art Project studios, artists worked on their individual projects in a common space. (NARA, RG 69-5-22579.)

artistic production in America to include the country's craft heritage. He
hoped that the index would educate the public about America's folk past
by providing a detailed visual history. According to Cahill, "The basic di-
rective of the whole WPA program was the maintenance of skills," a timely
directive given the mass unemployment of the Depression. However, the
Index of American Design had a larger value as well:

Its most obvious value is historical. The Index, in bringing together thousands of
particulars from various sections of the country tells the story of American hand
skills and traces intelligible patterns within the story. In documenting the forms
created by the tastes, skills and needs of our ancestors it brings a new vitality and
warmth into their everyday history, whether they were the founders of colonies and
states, or political, religious or economic refugees who came here to find a new free
way of life, "a chapter of harmony and perfection" in the relations of men.[36]

For Cahill, examining its material culture was a key to understanding
the country's past. He considered the index "a kind of archaeology" de-
signed to help "correct a bias which has tended to relegate the work of the
craftsman and the folk artist to the subconscious of our history where it
can be recovered only by digging." By excavating this history and making
it public, the index contributed to the Federal Art Project's larger pedagogy
of cultural production by highlighting the work of past cultural producers
as a teaching tool about the past but also about the present and the future.
Take the American ax, for example. For Cahill, work done by the index
challenged Eurocentric arguments such as those advanced by Dr. Henry
Chapman Mercer, a historian of carpenter's tools. Mercer argued that
American tools were primarily "European heirlooms." On the contrary,
Cahill argued, the American ax, "both as tool and as design," had a "form,
neatness and precision of weight" that made it superior to the Euro-
pean ax.[37]

The American ax had many lessons to teach the public. Cahill urged
Americans to remember "the inventiveness that reshapes forms in response
to the needs of a changing environment." He wrote: "We are surrounded
by so many and such powerful evidences of mass-production technology
that we are apt to forget that this technology was born in a handicraft
tradition. The forgetfulness may be an expression of our passion for obso-
lescence. It is one of the accidents of our history that modern design in the
United States has developed in almost complete isolation from traditional
craftsmen skills." Cahill hoped that the index would play the role of "inter-
preter, calling our attention to the unique and irreplaceable contribution

which these skills have made, and still make, in our culture."[38] By including objects such as hand tools, the index challenged aesthetic hierarchies by attempting to integrate the anonymous craftsman into American art history as an important cultural producer. It also aimed to make a broader public aware of this history by hiring contemporary artists to preserve it within the present moment. The index's larger goal of maintaining skills operated on a number of levels. Employing artists to copy allowed them to maintain their technical skills. However, the index also aimed to maintain the skills that produced the original objects. The copies were one way of preventing those skills from becoming obsolete: It made them a part of history while simultaneously keeping them from becoming merely historical artifacts.

In January 1936, the Federal Art Project's central office in Washington, D.C., issued a preliminary manual for the index outlining the scope of its activities and its larger purpose. The preliminary manual contained a broad plan of organization as well as suggested methods for doing research and recording information. Initially there was no standard documentary technique that artists were expected to use. Instead, "what was insisted upon was strict objectivity, accurate drawing, clarity of construction, exact proportions, and faithful rendering of material, color and texture so that each Index drawing might stand as a surrogate for the object." Despite the desire for objectivity and clarity of detail, index staff derided photography, since they felt that "the camera, except in the hands of its greatest masters," could not "reveal the essential character and quality of objects as the artist can."[39] According to index administrators, a photographic reproduction could not act as a surrogate for the object. While color photography could come close to capturing the object's essence, it was expensive and, more important, did not maintain skills in the same way as hand copying could. In many ways, the index's documentary techniques fetishized handicraft along the same lines as the project's larger ideology. In the age of mechanical reproduction, copying itself became a type of handicraft in danger of becoming obsolete.[40]

In March 1936 the national office issued a supplemental manual outlining different techniques for documentation. The officially favored method was one based on the teaching of Suzanne Chapman, who had been "loaned to the Massachusetts Index project by the Boston Museum of Fine Arts." Chapman was an expert at the "Egyptologist's technique," a meticulous transparent watercolor method worked out by Museum of Fine Arts curator Joseph Lindon. The Egyptologist's method was painstakingly detail oriented and, for many artists, painstakingly boring to do. According

to Cahill, "Many felt that the Index was dead copying. . . . They could not express themselves through the free use of form and color and so felt cheated of the creative assignments they had expected from the Federal Art Project." Indeed, one artist, after documenting a textile piece for the index, claimed that "he'd rather starve than do another." Yet, again according to Cahill, many artists "discovered that documentary art may become a free creative activity even within severe discipline and limitations." He believed that this change in attitude "was brought about by the steady improvement of project standards and the missionary work of supervisors."[41] Much like the community art center organizers, index staff and administrators saw themselves as missionaries preaching and proselytizing an alternative notion of art and artistic value in the name of cultural production as well as aesthetic democracy.

The index's primary focus was on regional and local crafts. Architecture was not included in the index, since two other government projects, the Historic American Buildings Survey and the Historic American Merchant-Marine Survey, were "already concerned with it." Despite the language of the aesthetic melting pot found elsewhere in the Federal Art Project, in the case of the index, the regional and the local were composed almost entirely of objects of European origin. According to Cahill's history, "It was felt that Indian Arts should be left to the ethnologists who had been making pictorial records in that field. The Index was limited to the practical, popular and folk arts of the peoples of European origin who created the material culture of this country as we know it today."[42] This included the Spanish influence on colonial Mexico found in much handicraft work in the American Southwest, but it did not include the "Negro traditions" celebrated in the community art center movement.

Along with the other branches of the Federal Art Project, the Index of American Design had a central office in Washington, D.C., a larger research office in New York City, and regional offices across the country. Again, this tentacle approach allowed for the inclusion of a diverse range of expertise within the project and challenged the boundaries of what constituted American art and design. Perhaps more than any other component of the Federal Art Project, on the Index of American Design the qualifications for expertise were wide open. According to the index manual, state projects could be "of any size made up of persons familiar with the history of American craft or expert in some particular field." Despite this vagueness, there was a fairly detailed chain of command. Field offices were responsible for surveying local material and selecting the objects to be recorded, as well as

for verifying the authenticity and history of these objects. Issues of authenticity were key on the index. As Cahill explained, "Before an object was assigned to an artist for recording it was examined by the research supervisor and all information concerning it entered on the data sheet—pasted on the back of the completed drawing." The Washington staff then checked on the quality of local project work and coordinated research to avoid duplication. The desire to avoid duplication is curious, for it seems to contradict one of the fundamental ideals behind craft work—that each object is unique. Instead, index supervisors seemed more interested in recording genre than in documenting particular instances of artistry and craftsmanship.

Like other Federal Art Project programs, the Index of American Design was both forward and backward looking. For Cahill the craftsman was the "bearer of folk memory in the arts." One of the ways that the index publicized this "folk memory" was through collaboration with museums such as the Metropolitan Museum of Art in New York City. Although the Metropolitan was, and continues to be, an important institution for sacralizing culture, it held two shows and published two brochures that showcased work done on the index. The first, *I Remember That: An Exhibition of Interiors of a Generation Ago*, consisted of drawings of nineteenth-century interiors, focusing on the "bric-a-brac, the curious trifles, the moveable ornaments and the gew-gaws." The show's curator wrote that the drawings in the book were "amusing but . . . not intended to ridicule. Rather, they record and give remembrance to a time and place."[43] The second, *Emblems of Unity and Freedom*, also evoked a time and a place; in this case, one that was decidedly patriotic. Painted cast-iron banks depicting Uncle Sam, Constitution Hall, and the Liberty Bell, bald eagles carved into headboards and woven into tapestries, and busts of George Washington were among the items included in the collection. These emblems of freedom and unity were meant to instruct the public about the nation's past as well as to inspire "artists and writers who are placing their skills at the service of the national war effort, to familiarize themselves with this traditional material . . . to know the popular symbols which have been created to express and transmit the historic meanings of democracy."[44]

According to Cahill, the index was to be "more than a backwards look. There is in it also the Davy Crockett 'go ahead principle' [which] tells the story of creativeness and inventive change when traditional design failed to met new problems." This creative inventiveness was key during the crisis of the Depression. Index administrators hoped that artists, manufacturers,

and members of the public would take advantage of the index as "a store-house of the technical and symbolic innovations of the past" as a way of preparing for "new developments" in the near future. Moreover, they also hoped that American manufacturers would draw inspiration from this heritage as well and reproduce some of the goods recorded by the index in mass quantities for the public to purchase. By providing access to the country's "democratic" artistic past, index administrators saw themselves as performing a public service. In theory, the index "would not compete with private enterprise but would . . . benefit private enterprise though providing it with a reservoir of pictorial and research material on American design and craftsmanship."[45]

Cahill's desire to foster cooperation between the craftsman of yesterday and modern industry marks a significant shift in the Federal Art Project's pedagogy of cultural production. As the decade progressed, Cahill and other project staff began to modify their focus on artistic production and address issues of consumption in their plans and projects. In part these changes stemmed from attacks by conservative critics. While the operating budget of the Federal Art Project underwent financial and personnel cuts from the moment it commenced, the program itself became a target for anti-Roosevelt forces during the economic slump that began in mid-1937. The conservative press, led by William Randolph Hearst, along with numerous reactionary citizens' organizations, repeatedly condemned the project for producing "bad art" and encouraging "bad" citizenship by employing political subversives and social deviants. For example, Ralph M. Easley, chair of the National Civic Federation, which by this time had become a conservative citizen's watchdog group, wrote a series of letters to Roosevelt during the summer of 1937 detailing Communist activity in the WPA cultural programs. "Communist influence," he argued, "is predominant on the white-collar and professional projects." Easley included Cahill and other art project staff in his list of de facto Communist government administrators. In addition, he charged that the government's work projects contained "men repeatedly convicted for the sale of obscene literature, habitual drunkards, former bootleggers and Communist salesmen of questionable goods, moral perverts, and similar types."[46] Easley's accusations conflated alcoholism, homosexuality, and Jewishness as "communist." In the New York art projects, he complained, blacks, Jews, women, and homosexuals were not merely employed; in some cases they were supervisors. This alone, he argued, was cause for the project's closure.

The racial and sexual integration of New Deal projects such as the

Negro art centers also became fodder for anti-Roosevelt forces. In her 1936 self-published pamphlet *The Roosevelt Red Record and Its Background*, red-baiter Elizabeth Kirkpatrick Dilling accused the New Deal projects of implementing a Communist plot to promote racial intermixture and encourage black discontent. While Dilling might seem like a crank, she attracted a number of followers who agreed with her allegations that "it remained for Karl Marx to insist that agitation must not cease until the races and sexes be poured into one melting pot to be molded into one mass, as planned by Marx, not by God."[47] Dilling and her followers viewed the Federal Art Project's goal to create an aesthetic melting pot as a Communist conspiracy in direct opposition to the dictates of God. Moreover, they attacked the basic tenets of the pedagogy of cultural production for producing a worker mentality among artists. Widespread fears of an encroaching Marxism forced project administrators to reframe their pedagogical goals and once again recalibrate the ways in which they measured aesthetic value.

As attacks on the project grew, its administrators changed their approach to promoting their art programs. Instead of focusing just on producer-centered experiential notions of art, they began to employ more market-value-based definitions. In addition to stressing the role of the American public in making art, they also began to encourage the public to consume it. For example, in 1939, with attacks on the New Deal increasing and major cuts being made in the budget for the Federal Art Project, Cahill published *Supplement to the Community Art Center Manual*. The supplement contained a list of suggested themes to explore in the community art centers.[48] The first new theme was the "Consumer in America."

The Federal Art Project's move toward consumption in the late 1930s was not, however, merely a capitulation to redbaiters and critics of the New Deal. Nor was it merely rhetorical. Cahill's and Parker's desire to teach the American public how to "consume art as a useful and vitalizing commodity of their daily lives" reflected their larger hopes to "correct [the] unequal distribution of cultural advantage" and democratize art in America.[49] Adjusting their programs to accommodate the increasing importance of consumption in American life fit both within their larger goals and within the particular historical moment.[50] During the 1920s and 1930s, the United States moved from a primarily production-based to a consumption-based society.[51] This shift was not limited to major urban centers; mass culture invaded the entire country. For example, in *Middletown*, their landmark study of Muncie, Indiana, in the late 1920s, sociologists Robert and Helen Lynd detailed the emergence of a new consciousness centered around pecu-

niary goals. Work, for most of the people they encountered, was merely a means of gaining purchasing power. Many of the Middletowners they interviewed spoke of a "decrease in the psychological satisfactions formerly derived from the sense of craftsmanship." "Frustrated in this sector of their lives," the Lynds continued, "many workers seek compensations elsewhere." They sought fulfillment not through work but through movies, radio shows, and glossy picture magazines.[52]

Throughout its tenure, the Federal Art Project's many programs attempted to address this shift directly by stressing the importance of a continued awareness of America's craft heritage and the centrality of aesthetic experience for participatory democracy. Its key administrators attempted to integrate the reality of an increasingly consumer-centered ethos in the project's working ideology as well. For example, as a way of addressing the increasing importance of consumer rights, the art center supplement suggested holding forums on "the problems of consumption" and "honest advertising," having speakers from consumer groups, creating "representations of pre-industrial industry," making movies on the sales tax, staging living newspaper performances featuring the "poor little consumer," holding exhibits focusing on "value for your money," developing "industrial and government scholarship," exposing "consumer fakes," and developing consumer research and testing methods. It also recommended that community art centers hold "make it yourself demonstrations" and establish outside tie-ups with the National Consumer Federation and the Fair Advisory Committee on Consumer Interests.[53] Yet this move toward consumption did not veer dramatically from the Federal Art Project's central emphasis on promoting individual aesthetic experiences. Through their expanded educational efforts, art project staff still encouraged the American public to actively participate in the creation of aesthetic meaning and value. In May 1937, Parker appealed to an audience of settlement workers to rethink the benefits of the Federal Art Project. "May I remind you," he began, "that the Federal Art Project has not only given artists and craftsmen the opportunity to create art but it has given large numbers of people in America their first real opportunity to appreciate art; to consume art as a useful and vitalizing commodity of their daily lives." He presented cultural consumption, like cultural production, as a means of providing increased access to artistic experiences. For Parker, this was inherently democratic, since teaching the American public how to make as well as consume would "correct [the] unequal distribution of cultural advantage" across the country. It "should be obvious," he argued, "that the general circumstance is not

over-production but rather under-consumption; comparatively few people own art, yet the potential audience for American art is extremely wide. As new publics for art develop—as they seem bound to—our supply of artists may actually prove to be too small."[54]

Echoing the move toward a more Keynesian model in the New Deal economic programs, by the end of the decade both Parker and Cahill were claiming that the government art projects were actually helping to jump-start cultural consumption by alerting the American public to new types of commodities and creating new marketplaces through the establishment of localized art communities. Nevertheless, despite the inclusion of an increasingly consumer-centered philosophy in their pedagogical models, they never gave up on the importance of cultural production as a means of desacralizing and democratizing aesthetic experience and making art available "for the millions." Through the community art center movement, over two million students attended classes in more than 160 venues. This included such future art world luminaries as Jackson Pollock, Jacob Lawrence, and Mark Rothko. On the Index of American Design, artists and administrators expanded notions of American art to include the craft heritage of diverse communities and ethnicities. As a result of the efforts of the Federal Art Project, the leatherwork of cowboys in Texas and the drawings of African American children in Harlem became part of the country's aesthetic melting pot, shifting frames in the national kaleidoscope.

The Federal Art Project was not the only institution focusing on the links between consumption, the fine arts, and the creation of democratic communities. Almost immediately after it began advocating an art for the millions, a number of public and private institutions across the country, from fine arts museums to department stores, began appropriating the language of desacralization and democratization for their own purposes, which were often quite different from those of the Federal Art Project. This is the subject of the next two chapters.

Chapter 3
Democracy in Design

On January 15, 1930, Sarah Carr, editor of Marshall Field and Company's semiannual publication *Fashions of the Hour*, wrote to Alfred Barr, director of the newly opened Museum of Modern Art in New York City, to request an article for the publication.[1] "It occurred to us as an interesting fact," she began, "that a great many people who still shudder at the very mention of 'modern furniture' have unconsciously capitulated to the modern spirit in the way they furnish the more informal . . . parts of their home." Therefore, she wrote, the editorial staff in the advertising department of Marshall Field's "would be delighted to have any comments you might care to make . . . about general trends in the use of design of modern furniture and fabrics." Carr concluded her appeal by distinguishing the store's financial gains from its role in promoting good design. "Anything we print along these lines," she claimed, "is really just a *crusade* on our part, as the store has relatively little modern furniture." Nevertheless, she informed Barr that she hoped to be able to dig up "three or four good pieces" for sale in the home furnishings department of the store "to photograph for the page opposite your article."[2] In a letter to Carr a week later, Barr responded that it would be his pleasure to write a short article. "You must understand," he cautioned her, "that I am in no sense an authority, but have considerable interest in furniture, as an important part of the modern movement." "I shall, of course," he concluded, "try and make it readable and interesting" and not "refer specifically to American designers and manufacturers" but to "design principles in general."[3]

Barr began his article, entitled "The Modern Chair," by stating that "modern furniture in the manner called most unpleasantly *modernistic* can no longer be considered a mere snobbery or fashion." He differentiated between two "sources" for modern furniture, which he called the "decorative" and the "constructional." For Barr, the "decorative" in furniture design was both "absurd" and "unfortunate," since, he asserted, "furniture is essentially a utilitarian problem," and "when it is designed along principles

Fig. 23. The Modern House. Illustration from *The Store Book, Marshall Field and Company.* Such an image accompanied Alfred Barr's essay for Marshall Field's catalog, *Fashions of the Hour.* The caption reads, "This is one of the stunning rooms in the new Modern House recently erected on the eighth floor, adjoining the attractive budget house." (Wolfsonian Museum.)

other than functional, it tends to become impractical." Instead, Barr applauded architects such as Walter Gropius and Marcel Breuer "for developing forms of furniture based entirely upon utilitarian and structural requirements" and for regarding each piece of furniture as a machine with a special purpose.[4] Following their lead, Barr hoped to merge aesthetics with practicality for an American audience. He saw democratic possibilities within the machine aesthetic, but he also saw potential problems caused by the confusion of modern design with what he called the "pseudo-modern," the "modernoid," and the "modernistic."[5] MoMA's role would be to distinguish between these categories for the broad public and in so doing to help desacralize and democratize high modernism.[6]

Barr's essay for Marshall Field's highlights the increasingly close relationship between institutions of high culture such as MoMA and American department stores, and American commercial culture by extension, in the early twentieth century. While historians such as Neil Harris and William Leach have demonstrated how nineteenth- and early twentieth-century department stores borrowed display and advertising techniques from museums, the reverse is also true. From the museum's beginnings, MoMA staff forged close relationships with department stores and other commercial venues around the country. Their modern marriage of art and life was often rooted in the marketplace. Marshall Field's was not the only department store to actively follow the aesthetic dictates of Alfred Barr and company. Giant New York retail firms such as Macy's and Lord and Taylor, as well as smaller department stores across the country, made direct reference to MoMA shows and to museums in general in their advertising campaigns and their display techniques.[7] The increased cooperation between museums and department stores during the 1930s demonstrates not only how these institutions blurred art and commerce but also how they collapsed the lines between education and consumption. Through MoMA design shows, learning about "art" became, in essence, learning about what to buy.[8]

Indeed, throughout the 1930s, with the sagging sales of the Depression as a backdrop, the Museum of Modern Art and department stores across the country sought to help American consumers define the place of "art" in everyday life by encouraging increased private and individual consumption in the home. Through museum exhibitions, department store displays, and a host of other educational tactics, modernist crusaders such as Barr and Carr attempted to stretch the boundaries of art to include mass-produced, machine-made goods and thus make art accessible to a broader constituency. By repeatedly highlighting the use value of the goods they

chose, they contributed to the desacralization process I outlined earlier. Like Cahill and Dewey, Barr believed that a democratic art would be experiential and grounded in widespread public participation, but his notions of both experience and participation were often quite different from Cahill's and others on the Federal Art Project staff. While anyone could potentially paint, sculpt, or take a photograph on the Federal Art Project, the only access average Americans had to design was through consumption. Through what I am calling the pedagogy of cultural consumption, MoMA staff attempted to teach the public how to become "collectors" of high-quality modern products by educating it on how to recognize items of good design and then buy them and use them wisely. The pedagogy of cultural consumption highlighted the active role that American consumers could play in fusing art and life to create a democratic aesthetic. In this way, by employing the language of democracy and equality in the marketplace, MoMA advocated for its own brand of cultural desacralization by locating cultural capital in individual aesthetic experience.

Barr's design categories contained an implicit gender division. He considered "modern" design in terms of a traditional marriage based on essentialized gender roles in which women were more "ornamental" and men were more "practical." Female consumers, he feared, would favor the "decorative" over the "constructional" because, "their eyes are trained in the judgment of pattern and color." Further, he assumed that male consumers would be able to recognize the "constructional" in design because "the aesthetic judgment of the American man is most highly developed in the matter of deciding whether the 1930 Buick is better than the 1930 Chrysler. Let his wife buy the curtains; let him buy the chairs!"[9] For Barr, truly modern design resulted from the intimate merger of the decorative and the constructional. With MoMA's help, Barr hoped to encourage domestic co-operation between what he saw as the wife's ability to judge pattern and color and the husband's knack for appreciating form in the modern art of living; he also hoped that the increased cooperation between MoMA and venues such as Marshall Field's would strengthen the marriage between use and beauty to promote what he called "democracy in design."[10]

As his letter to Carr makes clear, Barr believed that American men had more finely tuned aesthetic sensibilities than women.[11] His directive—"let his wife buy the curtains"—points to outright gender divisions not only in the marketplace but also in the dissemination of "culture." Rather than enforce these gendered divides, however, Barr hoped to erase them through "modern" design. Together, he argued, husband and wife should

choose the refrigerator, "the only honest furniture in most American homes." "For some reason," Barr mused, "the makers of the new electric refrigerators have ignored both the period styles and modernistic decoration and have produced one of the finest examples of modern furniture—a machine for keeping food cold, but also to the eye a beautiful and perfect object."[12] By using such loaded gendered language and playing with the idea of a modern marriage between beauty and use, Barr challenged long-standing associations in which consumption was gendered "female" and the machine, artistic creation, and "work" were all gendered male.[13] In reconfiguring art as a commodity, Barr and his associates at MoMA reshuffled these divisions and challenged now-classic dichotomies between production and consumption as well as masculine and feminine notions of culture. The truly modern was neither, or both.

While most histories of the Museum of Modern Art focus on the ways in which members of the museum's staff acted as agents of sacralization, anointing an intellectualized high modernist (read formalist) aesthetic, in the museum's early years, this formalism was not as rigid as many have presumed. In early planning documents, Barr repeatedly referred to the museum as "an experimental laboratory." He also regularly stressed the importance of the American public in the successful implementation of his plan.[14] Barr, as well as others involved in the museum's creation, very consciously tried to create a new type of art institution, one that included not only the traditional fine arts of painting and sculpture but also posters, photographs, and cups and saucers. By blurring the lines between high and low culture and stretching the parameters of art to include mass-produced, machine-made goods, the museum, in many ways, attempted to make art more democratic and more accessible to a wider public. Yet the blurring of cultural boundaries was also a way for the museum to delineate new aesthetic categories based on its own formulations. The ways in which the museum transformed cultural capital, on one hand desacralizing it and on the other resacralizing it, produced a number of tensions in MoMA's formative years—tensions that are often overshadowed by its postwar embrace of Greenbergian formalism. Exploring these early tensions, however, offers important insights into both the history of modernism and the ways in which artistic value has been determined in the United States.

The Museum of Modern Art opened on November 7, 1929, just one week after the stock market crash devastated the American and world economy. The museum was founded by a female triumvirate of artistically progressive art patrons—Lillie P. Bliss, Mary Quinn Sullivan, and Abby Aldrich

Fig. 24. Alfred H. Barr, Jr., ca. 1929–30 (PA39). (Digital Image © Museum of Modern Art/Licensed by SCALA/Art Resource, New York, N.Y.)

Rockefeller—for the purpose of "encouraging and developing the study of modern arts and application of such arts to manufacture and practical life, and furnishing popular instruction."[15] MoMA was a decidedly elite venture from the start; the three women came up with the idea of creating a modern art institution in New York City while traveling abroad. Despite the growing tolerance of European modernism since the New York Armory show sixteen years before, modern art was still considered foreign in most of the country. Educating the American public about the principles of modernist aesthetics and redrawing artistic boundaries in the United States were key parts of MoMA's founding mission. While in the planning stages, Bliss, Sullivan, and Rockefeller enlisted the aid of modern art collector A. Conger Goodyear, who had just been forced from the board of the Albright Museum in Buffalo for purchasing a Picasso painting for its collection.[16] Goodyear, who became MoMA's first president, helped the women to assemble an advisory board and to choose staff. All four shared an interest in European modernism, and the early shows featuring the works of Gauguin, van Gogh, Cézanne, and Seurat reflected their interests.

Perhaps the most important person in the early history of MoMA, however, was its first director, twenty-seven-year-old Alfred Barr. Barr, the son of a Presbyterian minister, worked with a missionary's zeal to educate the American public to accept the tenets of modernism as an aesthetic style as well as a way of life.[17] In the fall of 1929, shortly after assuming the directorship, Barr set forth his vision for the institution in a brochure entitled *A New Art Museum*. Known as the 1929 plan, *A New Art Museum* contained a "multi-departmental plan" to govern the museum's growth. In his original draft Barr forecast that "in time the Museum would probably expand beyond the narrow limits of painting and sculpture in order to include departments devoted to drawings, prints, and photography, typography, the arts of design in commerce and industry, architecture . . . stage designing, furniture, and the decorative arts. Not the least important collection might be the *filmotek*, a library of films."[18] Barr's early vision of a multidepartmental modern museum played an important role in the cultural desacralization processes taking place in the 1930s. He consciously worked to redefine what constituted aesthetic value by rooting it in personal experience. Moreover, he deliberately aimed to make MoMA "truly representative of modern art" by including in its shows and collections examples of "the practical, commercial and popular arts as well as . . . the so-called fine arts."[19] The museum's early shows simultaneously questioned what constituted the modern while defining it for American audiences. In

this way, Barr, as well as other MoMA staff, intentionally blurred the lines between high and low, between art and everyday life.[20]

Barr's training in modern art was both formal and autodidactic. When he took the job at MoMA he had just finished coursework for a doctorate in art history at Harvard, having received both his B.A. and his M.A. in art history at Princeton. While at Princeton, Barr was profoundly influenced by Charles Rufus Morey, a professor of medieval art. From Morey, Barr learned how to synthesize often divergent scholarly viewpoints. He was also influenced by Morey's focus on historiography—an influence that would affect his own efforts to place modernism firmly within an established cultural tradition. By the time he assumed the directorship of MoMA, Barr believed in the existence of a "pure art" without social or political implications, and he defined modern art in terms of formal criteria such as geometric/nongeometric and representational/nonrepresentational painting. While at MoMA, Barr famously created a number of diagrams that charted the history of modern art in broad, sweeping strokes. Much of this he learned from Morey. For example, in 1936 he published a chart that traced the development of abstract art. In mapping modernism in this way, Barr placed such disparate objects as Japanese prints, Near Eastern art, "the machine aesthetic," and Negro sculpture alongside Western movements such as cubism, surrealism, and futurism. Barr's notion of art history proceeded along a formal continuum; he measured artistic development in terms of stylistic innovation. He based his formalism on "absolute" concepts of beauty and functionality, which he claimed were divorced from any social, historical, or moral context.[21]

Barr's commitment to formalism can be read as both a move toward desacralization and a move away from it. The object's functionality rather than its economic worth or historical aura was the key signifier of aesthetic value for Barr. His ideology was also divorced, in theory, from cultural hierarchies and traditional notions of artistry. By placing mass-produced goods such as refrigerators and automobiles alongside ancient calligraphy in terms of artistic importance, Barr claimed that the modern transcended the means of production. Yet his formalism also relied on personalized evaluative standards, which were heavily laden with racial, historical, and geographical values.

Barr's training also reflected his time at Harvard, which had a different approach to the study of the fine arts than Princeton.[22] According to Barr, "aesthetic Harvard" had "more music and a gentler atmosphere."[23] During Barr's tenure at Harvard, the art history department still reflected the ideol-

Fig. 25. Alfred Barr, The Development of Abstract Art. This is one of the many charts that Barr created to delineate the history of modern art along a formal continuum. (Digital Image © Museum of Modern Art/Licensed by SCALA/Art Resource, New York, N.Y.)

ogy of its founder, Charles Eliot Norton. Norton, a close friend of John Ruskin's, believed in the intimate merger of art and life on moral, social, and ethical grounds. Harvard's art history department also bore the influence of Bernard Berenson and his focus on the art object as a formal text, as the basis for connoisseurship. For Barr, however, the most important influence at Harvard was Paul Sachs, who taught a course entitled "Museum Work and Museum Problems" at the university's Fogg Museum. Sachs's method focused on creating productive links between museums and art historical scholarship. Barr was a frequent visitor to Sachs's course, and in his tenure at MoMA he adopted Sachs's credo that "in America the museum is a social instrument—highly useful in any scheme of general education."[24] Indeed, for Barr, MoMA's primary aim was not merely to display but to educate. Perhaps Barr's faith in the museum as a pedagogical tool stemmed from his own experiences learning about modernist art. He was largely self-taught in this area. For Barr, learning about the modern was rooted in personal experience. He traveled throughout Europe, meeting artists and visiting galleries and schools. Following Dewey, Barr aimed to make experience a central part of MoMA's pedagogical program. Each show reflected his belief that "words about art may help to explain techniques, remove prejudices, clarify relationships, suggest sequences and attack habitual resentment through the back door of intelligence. But the front door to understanding is through experience of the work of art itself."[25]

The key to MoMA's early success rested on building an audience for modernism in the United States. Barr hoped that MoMA's shows would demystify modern art for the American public by making his formalistic categories comprehensible through a variety of educational programs, informational catalogs, and didactic exhibitions. From the start, Barr hoped to enlist the aid of the American public directly in the museum's pedagogical endeavors. In a 1932 MoMA Bulletin entitled *The Public as Artist*, for example, Barr proclaimed that "art is the joint creation of artist and public. Without an appreciative audience, the work of art is stillborn." Therefore, he announced, the public "shares equally with the artist the exciting responsibility of carrying on the great tradition of living art."[26] Barr's use of domestic, reproductive language to differentiate between "living art" and art that is "stillborn" pointed to the need for a new kind of marriage—between the museum and the public, between art and modern life. Education played a key role in this relationship.

Although the museum did not formally create an education depart-

ment until 1937, it worked to educate the public from the start. One way that it did this was through the use of explanatory text. Barr used catalogs and exhibition labels as didactic tools to present his particular way of understanding what was on view. According to Barr's wife, Margaret Scolari Barr, "The labels that my husband used to write were not only labels for each picture, but they were general intellectual labels, to make people understand what they were seeing."[27] Barr also ventured outside of the museum to educate the American public. In 1934, for example, he collaborated with Holger Cahill on a series of radio programs entitled *Art in America in Modern Times*. The hour-long program, which ran from October 6, 1934, through January 26, 1935, was broadcast on Saturday nights by a "coast-to coast network through the facilities of the National Broadcasting Company."[28] That same year Barr and Cahill published a book under the same name. Included in the program and book were segments entitled "American Art Since the Civil War," "Stage Design in the Modern Theater," "Houses and Cities," and "Photography in America." Through radio programs and publications such as *Art in America in Modern Times*, MoMA brought its multidepartmental definitions of modernism and art to a broader public. It successfully used the modern media to integrate modern art into modern life.

In 1936, at the suggestion of Nelson Rockefeller, the museum hired Artemas C. Packard, a progressive art historian and the head of the department of art at Dartmouth College, to help the museum "aid in the development of aesthetic values in American life." Like Dewey, Packard encouraged "the study of Art as immediate experience (deriving its validity from its direct impact on the consciousness rather than indirectly through an understanding of its relation to a series of stylistic developments called Art History)." Packard's year-and-a-half-long examination of MoMA's educational needs confirmed the role that most museums were playing in the sacralization of culture. In 1938 he wrote, "Art museums at the present time serve the interests of the expert and the connoisseur far more than they serve the interest of the public." However, since "'Popular instruction' is one of the major objects for which the institution [MoMA] exists," he concluded that the museum needed to establish an autonomous educational program in order to combine the study and promotion of modernism in America: "What we are really confronted with is the need for two quite consciously and deliberately different kinds of enterprise; on the one hand, the search for what is best in Art according to the highest standard of critical discrimination and on the other, the provision of facilities for

popular instruction in accordance with the public need. These two objectives might at times seem mutually antagonistic, but in the long run I am convinced that they will be found to complement and reinforce one another."[29] Packard identified the same major tension within his art educational programs as Cahill found in the Federal Art Project's; a tension between the ways to democratize sacralization, or provide access to "the best in art," and desacralization, or how to redefine the practice of art to meet "public need." Packard, like Cahill, also recognized the potential of this tension, or antagonism, in determining alternative notions of aesthetic value, and he recommended that the museum address it head-on.

In 1937, in part as a result of Packard's report, Barr hired Victor E. D'Amico to head MoMA's new Education Project. Like Packard, D'Amico was also profoundly influenced by Dewey's educational philosophies. Before joining the MoMA staff he taught art in settlement houses in Manhattan and the Bronx, and from 1926 to 1948, he was head of the art department at the progressive Ethical Culture Fieldston School in the Bronx. D'Amico translated his work in progressive education to his work at the museum. He created special shows on modern art and architecture to bring to schools across the city; he also brought the schools to the museum. In 1939, D'Amico created a Young People's Gallery "to provide a place for children in an adult museum to communicate the ideas and activities of the Department, and to bring new experiments in art education to parents, teachers and the general public." Exhibitions in the Young People's Gallery included "works selected and hung by student juries from material assembled . . . from the permanent galleries of the Museum and loan exhibitions from private collections and art galleries." Regarding these shows, art historian Carol Morgan has argued that the "the practice of inviting high school students to organize shows of original work speaks to the informality and spirit of exploration that dominated the Museum in its formative years."[30] Indeed, this spirit of exploration and informality was key to the idea of art education at MoMA and a crucial part of the museum's guiding mission.

Barr, along with Bliss, Sullivan, Rockefeller, and Goodyear, hoped to make MoMA "the most important modern art collection in the world" and New York an international art capital.[31] Detractors of MoMA, at the time and since, have criticized the museum and its staff for their embrace of European high modernism. This is not an entirely fair critique: While MoMA's much-publicized inaugural show of the postimpressionists Cézanne, Gauguin, Seurat, and van Gogh set the tone for many of its subse-

quent exhibitions, its second exhibit, and Barr's first choice for the opening show, was *Paintings by Nineteen Living Americans*, which included work by Thomas Eakins, Winslow Homer, and Albert Pinkham Ryder. Today MoMA's early shows of American art are often overlooked; but by 1932, just two years after the museum opened, it had held seven exhibitions of work by American artists. MoMA was one of the first major museums to seriously examine American art and the first to place it within the history of modernism.[32] According to Goodyear, "Our aim here has been to offer a fair measure of the value of American art today."[33] In addition to works by Picasso and Matisse and other European masters, Barr's experimental laboratory and multidepartmental plan included numerous examples of American modern art. Writing in 1940 to Dorothy Miller, MoMA's first curator of American painting and coincidentally Holger Cahill's wife, Barr attempted to correct the misconception that the museum was only concerned with "foreign art." "I think that statistics will show that we have been more concerned with the American art than with the art of all foreign countries combined. . . . No other Museum in the country has done as much to further the interest of American photography, American films, American architecture and American industrial design."[34]

In 1932, Barr took a leave of absence from the museum, and Holger Cahill took over as acting director. Under his guidance MoMA held a variety of shows focusing on contemporary work by American artists as well as shows historicizing American aesthetic traditions as sources for modern art. Cahill may seem like an odd fit for a museum dedicated to the promotion of modern art. In many ways he was, but his belief in the experiential nature of art fit nicely within Barr's experimental plan. Moreover, like Barr, Cahill was interested in creating a uniquely American-flavored modernism. In lectures and catalogs he repeatedly linked European modernism and American art, writing in one that "modernists have exerted a powerful and vitalizing influence upon contemporary American art. They have given American painting and sculpture a wider range of knowledge and a broader basis in tradition."[35]

To this end, in 1933 Cahill curated an exhibition entitled *American Sources of Modern Art*. In it he displayed stone carvings of Aztec goddesses, ancient Incan jewelry, and Peruvian feather headdresses alongside the work of modern artists such as Diego Rivera, Jean Charlot, Max Weber, and William Zorach. Lenders to the show included the American Museum of Natural History in New York, Harvard University's Peabody Museum of Archaeology and Ethnology, and the Museum of the American Indian, as

well as a number of New York galleries that represented contemporary art. In *American Sources of Modern Art* Cahill attempted to blur the lines between anthropology and fine art and to engage American audiences in a new way by encouraging them to see parallels between often dissimilar movements.[36] Yet his parallels were not absolute and, like Barr's, were dependent upon personal evaluative criteria: "There is no intention here to insist that ancient American art is a major source of modern art. Nor is it intended to suggest that American artists should turn to it as the source of native expression. It is intended simply to show the high quality of ancient American art, and to indicate that its influence is present in modern art in the work of painters and sculptors some of whom have been unconscious of its influence, while others have accepted or sought it quite consciously."[37] Like Barr, Cahill was interested in linking Western and non-Western art along a formal continuum. In this way, by creating a narrative for seemingly nonnarrative forms, he too attempted to make modern art more accessible to a wider American public and to encourage people to make connections between the past and the present as well as between the sacred and the quotidian.

Cahill used his time at MoMA to develop many of the ideas that he would later implement while head of the Federal Art Project. For example, his text for the 1932 exhibition, *American Folk Art: The Art of the Common Man in America, 1750–1900*, prefigures the rhetoric of the Index of American Design. Writing in the catalog for the show, Cahill argued that the exhibition represented "the unconventional side of the American tradition in the fine arts. . . . It is . . . a straightforward expression of the spirit of a people." Moreover, he continued, "this work gives a living quality to the story of American beginnings in the arts, and is a chapter intimate and quaint in the social history of this country."[38] Again, a show focusing on American folk art may seem like a strange event to be staged at a museum dedicated to exhibiting the modern. But, like the *American Sources of Modern Art* show, which came after it, the *American Folk Art* exhibition highlighted the presence of an American vernacular within the historiography of the modern. By emphasizing the relationship between form and function as well as the ways in which "folk artists tried to set down not so much what they saw as what they knew and what they felt," Cahill was able to argue that weather vanes and folk paintings prefigured a modernist ethos in which contemporary artists represented what they knew and felt rather than what they literally saw. He highlighted feeling as a basis for determining value.[39] By stressing the inherently "democratic" nature of the objects

Fig. 26. *American Sources of Modern Art*, May 10–June 30, 1933. The vibrant orange and red cover of this exhibition catalog depicts exotic Mayan hieroglyphics; the text inside the catalog traces their connection to the "complex heritage" of modern art. (Digital Image © Museum of Modern Art/Licensed by SCALA/Art Resource, New York, N.Y.)

on display, created by the anonymous common man, Cahill directly challenged traditional artistic hierarchies as well as the meaning and form of modern art in America.

MoMA's most direct challenge to artistic hierarchies and appeals to democracy in art, however, took place in the museum's industrial design shows. From the beginning of his tenure as director, Barr included examples of the industrial arts (American as well as European) in the museum's collections. In addition to merely collecting examples of "good design," Barr believed that the museum should engage in defining standards and writing histories for industrial objects similar to the standards and histories used to evaluate painting and sculpture. In 1932 MoMA formally created the Department of Industrial Design to do just this. Barr and the department's young curator, Philip Johnson, made sure to choose objects that would differentiate between the traditional decorative arts and the industrial arts. They defined industrial design as "mass-produced useful objects made to serve a specific purpose" and stressed two main criteria for including such objects in their exhibits—the quality of design and the historical significance of the product.[40]

Above all else, however, Barr and Johnson viewed utility as the most important quality in designating a product as "modern." Both men were appalled by the widespread use of what they termed "modernistic" design to sell products. "It is unfortunate," Johnson wrote in a 1932 essay, that the word "'modern' as applied to buildings, furniture and decoration should have become so identified in the public mind with 'modernistic.'" This "confusion of terms," he argued, "must be cleared up if people are ever to overcome their hesitancy in accepting the modern style." Much like Barr's "Modern Chair" article, Johnson's piece assigned gender to style by claiming that trends in interior decoration "follow one another like styles in women's clothes." Just as Barr equated female consumers with the "decorative," Johnson linked the "modernistic" with the fickle world of women's fashion, which changed seasonally according to a mixture of advertising and whim. True modern design, according to Johnson, did not depend upon changing fashions but "goes beneath the surface to fundamentals." The "modernistic," in contrast, "with its zig zags, set backs and tortured angles," he argued, "merely redesigns the surface of furniture and rooms." For Johnson, the modern room was "a background for living." Therefore, "it must be both simple in appearance and efficient in service." Thus, governed by "utility," he argued, it will be "homogeneous and harmonious," not a superficial, uneconomical revamping of an old style.[41]

It is important to note that both Barr and Johnson deeply believed that there was a profound difference between the "modern" and the "modernistic" and that this distinction transcended semantics. Their definitions of these terms, however, were vague and unstable. They defined "modern" through essentialized appeals to universal standards of beauty, functionality, and absolute formal properties; the "modernistic" encapsulated everything else. For both men, the "modern" was "timeless" and "true," while the "modernistic" consisted of applied decoration often arbitrarily affixed to machine-made goods to make them conform to the fashions of the times. Yet their notions of timelessness and truth were divorced from the sacred aura of the past and tied instead to use value in the present moment. Because their definition of "modern" was so abstract, both Barr and Johnson fortified their explanations by using numerous examples of what they considered good "modern" design. But despite their insistence on the important distinction between "modern" and "modernistic," rarely did either man actually point to concrete examples of the "modernistic." Rather, they showcased the products they considered "modern" in the design shows and repeatedly warned that "modernistic" products were out there.[42]

The museum's mission was not only to point out good modern design but also to convince the consuming public that buying modernistic goods was indeed a mistake, although one that it could overcome with the help of MoMA staff. Barr and Johnson felt that they were doing more than just endorsing products; in many ways they saw themselves as aestheticizing capitalism by weeding out inferior products in order to ensure the successful future of industrial civilization during the crises of the Great Depression.[43] The design shows at MoMA thus became crusades, not only for Barr's and Johnson's aesthetic categories, but also for what they considered the "American way of life" as rooted in mass-market consumer capitalism. Yet MoMA's democratization of modern design was not merely an advertising campaign for selected industrial goods. Rather, its ideological foundation was rooted in the ideals of progressive European design movements, such as the British Arts and Crafts, Dutch De Stilj, and German Bauhaus schools, whose work the museum also showcased. These European design schools emerged in response to increased industrialization under capitalism across Europe at the turn of the century.

Although the same influences were behind much of MoMA's design ideology, there were profound differences between industrial design in Europe and industrial design at MoMA. Most European design ideologues had strong socialist inclinations. For both William Morris and Walter

Gropius, for example, the desire to reunite the worker with the fruits of his labor was central to their aesthetic philosophies. Morris, following John Ruskin, advocated a return to handiwork as a means of forging this link, while Gropius, Schlemmer, and other Bauhaus innovators believed that machines could produce beautiful goods in which workers could take renewed pride. A handful of small-scale utopian communities, such as Elbert Hubbard's Roycrofters in East Aurora, New York, were modeled directly on these European ideologies, and a few homegrown groups, such as the California Mission school and Frank Lloyd Wright's Prairie school, bore their influence as well. The goods they produced, however, were tied to the producer in terms of value and were generally expensive and primarily limited to specialized audiences.

MoMA's design shows attempted to broaden the audience for industrial design in the United States by making anonymous, machine-made, "modern" goods available to all Americans. Through its industrial design shows, MoMA staff essentially erased the role of the worker by emphasizing instead the role of the machine in producing the goods. Rather than locating value in production, however, they placed the determination of aesthetic value in their own hands. The design shows highlighted the work of the museum's expert staff in choosing the objects on display and the work of the viewer in then buying them. In so doing, MoMA staff used consumption to legitimize the museum's cultural authority. Through MoMA's design shows, choosing the goods to buy became a form of "work," while mass consumption became elevated to an art form in itself.

MoMA's early design shows, in particular *Machine Art* (1934), *Useful Objects Under Ten Dollars* (1937), and *Useful Objects Under Five Dollars* (1938), exemplified the museum's pedagogical goal: to educate the public in how to recognize and consume "good design." By stressing cost ("under five dollars"), MoMA staff yoked economy to aesthetic quality. Such a move was crucial at this particular historical moment, inasmuch as the fine arts, and modern art in particular, were still primarily the province of the intellectual and economic elite. Furthermore, during the Depression, many Americans did not have the expendable income with which to buy art, let alone consumer goods such as the household appliances on display at the museum. By highlighting the inexpensive nature of the goods on display in their industrial design shows, MoMA staff members attempted to broaden the consuming audience for their exhibitions as well as for their pedagogy of cultural consumption.

Both Barr and Johnson stressed function as the most important mea-

sure of good design. "It is not possible," Johnson wrote in an early departmental publication, "to define function as if it were an attribute of an object itself, when in reality it is a complex of relationships between habits and accidents of use, techniques of fabrication and symbolic meanings."[44] Both men believed that functionality was inherent in the object's design and could not be superimposed. The absolute merger of function and design was what made a piece modern and therefore truly beautiful. For Barr and Johnson, the promotion of good design rested on educating both the manufacturers and the potential buyers of industrial goods in how to recognize the truly modern. They commended the programs of the Bauhaus, as well as Le Corbusier's "designs for living," because they not only designed goods with both function and beauty in mind but also explained to their public why these goods were superior to others on the market. The industrial design shows at MoMA attempted to replicate these European designers' ideologies on a far grander scale in the United States and simultaneously to challenge elite conceptions of modern art and design.

One of the major differences between Bauhaus and MoMA design ideology was that Bauhaus designers either collaborated with the makers of industrial goods to produce the products they endorsed or made them themselves, while this was not the case at MoMA. Although Barr and Johnson maintained close relationships with manufacturers and industrialists, they did not help them design their products. Theirs was a free-market aesthetic model, in that they let the market produce without directly interfering. They evaluated products that were already made and available for purchase in the marketplace. This is a key distinction for a number of reasons. First, it bespeaks an inherent faith in the American marketplace to produce at least some quality goods on its own. Second, it highlights the need for Barr, Johnson, and other MoMA staff to act as cultural experts. Collaborating with manufacturers would have necessitated defining their standards. Once defined, the museum would, in effect, be irrelevant. In order to make "good design," industrialists would need only adhere to MoMA-endorsed guidelines. Without precise instructions, however, MoMA staff was needed to evaluate the products. While on one hand MoMA's shows promoted a democracy of goods and challenged cultural hierarchies by including photographs and toasters in its collections, on the other hand they perpetuated the need for experts to distinguish between what was modern and what was not.

By choosing certain products over others based on their often vague aesthetic categories, Barr and Johnson maintained such a position of cul-

tural authority. In collecting and displaying painting and sculpture, Barr and staff may have stretched the boundaries of the modern by including work by American artists and other unknown modernists, but for the most part they followed traditional collecting practices and displayed the pieces as sacred masterpieces imbued with timeless auras that would ensure their value in the future. In the industrial design shows, however, they challenged traditional standards for determining, collecting, and displaying art by focusing instead on the temporality of the pieces—their value was rooted in their contemporary usefulness. In a way, such practices further legitimized the cultural authority of the MoMA staff by stressing its ability to sift through the detritus of modern industrial culture and affix an aura of "greatness" to anonymous machine-made pieces.[45] By locating aesthetic worth in mass-produced industrial objects and identifying it for all Americans, MoMA staff members created new standards for determining artistic value. By extending high modernism to new objects, they not only transformed the forms cultural capital could take, they also transformed how it was accrued. While this can be seen as a form of resacralization rather than desacralization—those who mastered MoMA's new aesthetic codes would become the new class of cultural capitalists—their emphasis on function rather than exchange value presented a new type of aesthetic experience rooted in the quotidian and tied to everyday life. MoMA's staff was not advocating that the public purchase the goods it highlighted to place on a shelf to accumulate value over time; on the contrary, an object's value was linked directly to its use in the present.

MoMA's design programs were thus grounded in the idea of educated consumption, which the curators, in particular Barr and Johnson, believed resulted from an aesthetically informed public. The museum's catalogs repeatedly warned viewers that the marketplace was flooded with products being sold as "modernistic" or "modernoid," and that these labels were not evidence of high-quality design but rather sales techniques designed to fool the consumer. MoMA's shows and catalogs claimed that the museum was teaching the American public how to distinguish good design from packaging. In many ways, MoMA staff members assumed the role of consumer advocates, policing the marketplace as a public service for their audience. Yet there was little or no explanation of their often arbitrary aesthetic categories in the museum shows and publications; rather, MoMA design curators told the consuming public which objects to choose, not how to choose them. Nevertheless, it would seem that the American public did learn one of the lessons the museum was pushing: all design was not equal,

and they, as consumers, had a choice in the American marketplace. Perhaps many already knew this as consumers of industrial goods, but not as collectors of "art."

For the most part, Barr's and Johnson's formalism was new to the American public—or at least their aesthetic categories were new. "The only collections of industrial design seen by the public," Barr explained, "are those on the display counters of local stores." Few Americans in the 1930s, however, regarded these goods as art. Nevertheless, Barr continued, "the advertisements and show windows of New York's Saks Fifth Avenue Department Store, have accomplished more to popularize the modern mannerism in pictorial and decorative arts than any two proselytizing critics."[46] While Barr, Johnson, and other museum staff cooperated with department stores across the country to educate both producers and consumers in the principles of good design, their bottom line was not to sell individual products but to sell an ideology: modernism as a democratic way of life. While their ideology of aesthetic democracy was rooted in buying, it transcended the merely commercial. The marketplace was not a precondition but rather provided the conduit for modern aesthetic experience.

Often Barr and Johnson took their cues directly from the "modernistic" sales techniques against which they repeatedly reacted. Indeed, the museum's design galleries resembled department store showrooms with case after case filled with industrial products. Furthermore, the museum's design catalogs looked very similar to the mail-order catalogs sent out regularly across the country by companies such as Sears Roebuck and Wells Fargo. Indeed, comparing the photography of Marshall Field's *Fashions of the Hour* with the objects photographed in the *Machine Art* catalog, it is hard to tell which came from the museum and which from the store. The objects in the MoMA exhibition catalogs were photographed in black and white, head-on with little or no artistic embellishment, and with the product's name, manufacturer, and price underneath or alongside the photograph, much like the objects for sale in mail-order and department store catalogs. In fact, the objects in mail-order and department store catalogs often were more stylishly photographed than those in MoMA catalogs, again explicitly blurring the lines between art and consumption.

Perhaps the objects in MoMA industrial design shows were photographed in such a manner to stress that MoMA design catalogs were meant to be educational tools, not souvenirs or decorative books. Such straightforward photography aligned the catalogs more closely with "five-and-ten" companies than with big urban department stores. It differentiated them

from highbrow commercial publications like *Fashions of the Hour* and thereby pictorially reaffirmed MoMA's decree that all Americans, even those with limited budgets, had access to modern goods. By using more generic, or lowbrow, forms for highbrow purposes, MoMA appropriated a mass-market aesthetic in an attempt to appeal to a wider American public than just the art world elite. In addition, each MoMA design catalog contained detailed informational essays. MoMA's catalogs were a key tool in the pedagogy of cultural consumption, since they helped the museum in its mission to reach a broader audience.

Another way that they attempted to do this was through traveling exhibits. Both the *Machine Art* and *Useful Objects* shows were created specifically to travel. They were first shown in New York "to bring to the attention of New Yorkers the availability and low price of household articles of good modern design"; they then went on the road, where they were shown in a variety of museums, colleges, libraries, private and public schools, women's clubs, Junior League clubrooms, and department stores. In a 1938 MoMA report detailing the year's activities, Barr announced that at present the museum had sixty circulating exhibitions, "which have been shown 622 times in over one hundred cities in the United States, Canada and Hawaii."[47] Barr repeatedly stressed the idea that MoMA's collections were not limited to the New York avant-garde. The museum's mission was much broader: It included all Americans. MoMA staff hoped that their traveling shows would alert the public across the country that "some of the handsomest glassware and other articles are from the five-and-ten cent stores" and that they had a choice between the modern and the modernistic.[48] The idea of choice was important. MoMA staff asserted the need for active public participation in winnowing out the modernistic by voluntarily selecting the right products in a sort of marketplace natural selection. The process of selection, however, was far from natural; it had to be learned.

The 1934 exhibition *Machine Art* was MoMA's first attempt to recruit the American public directly in the merger of art and life and was also the first MoMA industrial design show to go on the road. MoMA's *Machine Art* contained more than four hundred pieces, consisting of machines, machine parts, scientific instruments, and "objects useful in ordinary life." The show was organized "for the convenience of the *reader* and the visitor" into six categories: industrial units, household and office equipment, kitchenware, house furnishings and accessories, scientific instruments, and laboratory glass and porcelain. Philip Johnson, the show's curator, maintained that no "purely ornamental objects" were displayed in the exhibition. Rather, he

MUSEUM OF MODERN ART

MACHINE ART

Fig. 27. Cover of *Machine Art* exhibition catalog, March 5–April 29, 1934. This photograph highlights the artistry of such mundane machine-made goods as this ball bearing. (Digital Image © Museum of Modern Art/Licensed by SCALA/Art Resource, New York, N.Y.)

stated, "the useful objects were . . . chosen for their aesthetic quality." Some will claim, he continued, "that usefulness is more important than beauty, or that usefulness makes an object beautiful." The point of view behind the *Machine Art* show, however, was that "usefulness is an essential," but that "appearance has at least as great a value."

For Barr and Johnson, use and beauty could not be separated, because they were part and parcel of the modern. Moreover, through the *Machine Art* exhibition, Barr and Johnson attempted to establish a set of aesthetic standards for industrial goods on a historical continuum while simultaneously challenging the sacred aura that traditionally surrounded art objects by placing use value firmly in the present. They attempted to consciously write MoMA into the history of design and legitimize what they were doing. For example, one MoMA press release announced that "instead of going back a thousand years for beautiful pottery vases and dishes used by the Chinese or five thousand years to household objects found in the tombs of the pharaohs, this exhibition presents well-designed objects in general use today." In their essays for the exhibition catalog, Barr and Johnson stressed links between classical ideals of absolute beauty and mass-produced objects of the mid-twentieth century. These historical relationships were emphasized throughout their exhibits. In the entryway to the *Machine Art* exhibition's galleries as well as on the inside front page of the catalog, for example, there were three quotations that explicitly linked the art of antiquity and the goods on display in MoMA showrooms. The first was from Plato's *Philebus* and was written in both Greek and English:

By the beauty of shapes I do not mean, as most people would suppose, the beauty of living figures or of pictures, but to make my point clear, I mean straight lines and circles, and shapes, plane or solid, made from them by lathe, ruler, and square. These are not like other things, beautiful relatively, but always and absolutely.

The second quote, from Thomas Aquinas's *Summa Theologia*, was written in both Latin and English:

For beauty three things are required. First, then, integrity or perfection: those things which are broken are bad for this very reason. And also a due proportion of harmony. And again clarity: whence those things which have a shining color are called beautiful.[49]

The pairing of English with classical languages such as Greek and Latin and the choice of two well-known metaphysical philosophers alluded to the

universal quality of these "truths." Moreover, providing such an esteemed genealogy for the show legitimized MoMA's project. If Plato included straight lines and solid shapes made by lathes and rulers in his definition of absolute beauty, then perhaps the industrial goods on display in the museum's galleries were indeed beautiful, thereby justifying Barr and Johnson's formalist criteria and simultaneously safeguarding them from critical attack. Since Plato and Thomas Aquinas justified simplicity and utility as aesthetic determinants, they lent a sense of *gravitas* and historical authenticity to MoMA's desacralization efforts.

While a strong formalist ideology was inherent in the first two quotes, the final quote placed the exhibit in a contemporary social context. It was taken from L. P. Jacks's book *Responsibility and Culture*: "Industrial civilization must either find a means of ending the divorce between its industry and its culture or perish."[50] While today the warning of the dangers brought on by increased industrialization sounds rather melodramatic, in 1934, in the midst of the Depression, people literally were perishing due to a lack of work, and fears that machines would replace workers were widespread. Like Jacks, Barr and Johnson believed that forging cooperation between industry and art could help mend the economic and aesthetic schisms that began with the industrial revolution and were being made worse by the Depression. For example, Barr concluded his introduction to the exhibition catalog with the assertion, "Today man is lost in the far more treacherous wilderness of industrial and commercial civilization. On every hand machines literally multiply our difficulties and point to our doom." "If . . . we are to 'end the divorce' between our industry and our culture," he continued, "we must assimilate the machine esthetically as well as economically. Not only must we bind Frankenstein—but we must make him beautiful."[51]

Barr directly blamed "the machine" for multiplying hardships and prompting a split between art and production; yet the machine, he asserted, could also facilitate an alliance between aesthetics and economics, between the universal and the temporal. Similarly, Philip Johnson wrote in his essay in the *Machine Art* catalog that in the nineteenth century "technics and design were divorced."[52] He continued, however, that "the twentieth century is gradually rectifying this anomaly and is returning to the more reasonable principle of designing tools and useful objects with reference to the latest technique, out of the most durable material, and as economically as possible."[53] Interestingly, like Jacks, both Barr and Johnson used the concept of divorce to stress the traumatic effects of an unholy partnership between art and industry. Nevertheless, they all believed that the marriage

Fig. 28. Carl Zeiss telescope. Object 329 in *Machine Art* exhibition catalog, March 5–April 29, 1934. This telescope was one of the most expensive items featured in the show, which, according to Philip Johnson, focused on the "aesthetic merit of certain industrially manufactured objects, those created without artistic intention." (Digital Image © Museum of Modern Art/Licensed by SCALA/Art Resource, New York, N.Y.)

Fig. 29. Installation photograph from *Machine Art* show, March 5–April 29, 1934. *Art Digest* described the transformation of the galleries as follows: "The entire floor plan of the museum and surfaces of the walls have been changed by factitious muslin ceilings, movable screens, panels and spur walls of aluminum, stainless steel and micarta, and by coverings of oilcloth, natural Belgium linen and canvas painted pastel blue, pink and gray" (March 15, 1934, p. 10). (Digital Image © Museum of Modern Art/Licensed by SCALA/Art Resource, New York, N.Y.)

could be saved by a return to the design principles of premodern times, by reconnecting form with function and use with beauty and reconfiguring the relationships between aesthetics and experience.

According to both Johnson and Barr, increased cooperation between the American consuming public and the manufacturers of industrial goods would help repair the split between art and industry. For them, making the monster beautiful meant providing more democratic access to high modernism through increased public participation in their aestheticized version of consumer capitalism. They worked closely with manufacturers in putting together their industrial design shows. Indeed, the list of contributors to the *Machine Art* show reads like a manufacturing index, with selec-

Fig. 30. MoMA Bulletin for *Useful Objects Under Five Dollars* exhibition, September 8–October 28, 1938. The *Useful Object* shows received much publicity in both MoMA and non-MoMA publications. (Digital Image © Museum of Modern Art/Licensed by SCALA/Art Resource, New York, N.Y.)

tions from companies such as Westinghouse, United States Steel Corporation, Yale Lock, and Revere Copper, to name just a few. All of the items on display in the exhibition were identified by brand name and price, and the places where they could be purchased were listed as well. For example, Object 73 was the Silver Streak Carpet Sweeper by the Bissell Carpet Sweeper Company. In 1934 it was listed for five dollars and could be bought in department stores and furniture and hardware stores. Likewise, the Wear-Ever food containers from the Aluminum Cooking Utensil Company cost between $.93 and $3.55 and could also be purchased in department stores. Higher-end products were included in the exhibit as well. Object 329, the Carl Zeiss 80mm telescope, sold for $1,166.25; according to the *Machine Art* catalog, it could be found in specialty stores or ordered directly from the company. Such listings prompted more than one reviewer of the exhibition to recommend that visitors to the show "take a notebook . . . when you go, for the shadow of Christmas is already falling . . . and you will soon find good use for the little list you can compile at Modern Museum's little exhibition." Another reviewer claimed that "you couldn't possibly agree with the merits of its different pieces [but] . . . you'll certainly find enough there to fill your whole Christmas list no matter how formidable."[54]

The American public may not have been buying MoMA's artistic categories, but they were, it appears, buying the goods that MoMA endorsed.

After visiting the *Useful Objects Under Ten Dollars* show in December 1938, for example, Mr. Samuel Kootz of New York City wrote to the museum that "while at the Museum on Sunday, I . . . was very much impressed by a small glass vase sold by the Southern Highlanders, Inc. I went in today to purchase one of these vases for myself and was told that they were completely sold out as a result of hundreds of visits from people who had seen this isolated item at the Museum."[55] Other goods sold out as well. In December 1939 a representative from Gorham Company Silversmiths wrote to Barr and the "Gentlemen at the Museum of Modern Art," asking them to return the Dolly Madison–patterned spoons and forks they had lent to the *Machine Art* exhibition; as a result of the show, they informed them, the silverware was completely out of stock.[56]

Many manufacturers were excited by MoMA's brand of modernist proselytizing; the inclusion of their products in a New York museum certainly glamorized their individual products as well as their company names. Some companies used their links to the museum to directly market their goods—"As seen at MoMA." Manufacturers' enthusiasm often manifested itself in both financial and verbal support of the museum. In his October 1933 welcoming address at the New England Conference of the American Association of Museums in Worcester, Massachusetts, John Woodman Higgins, president of the Worcester Pressed Steel Company, exclaimed to his audience that "industry looks forward to the day when fine art museums will choose, own, and exhibit machine products with the same good taste and loving care, if and when these mediums express qualities of art, as acceptably as canvas and oil." Regarding the *Machine Art* show, Higgins continued, "The Museum of Modern Art will hold an exclusive *Machine Art* exhibition of their own initiative. They are making their own shapes from raw materials to demonstrate art to us manufacturers. We can now look for the restoration of that lost profession, the artist-artisan, which the art school seems to have divided."[57]

In addition to becoming patrons of the arts through MoMA design shows, industrialists now had the potential to become "artist-artisans" as well. Just as the consumers of industrial products, with the guidance of MoMA staff, could become connoisseurs as well as patron-artists, the manufacturers of industrial goods now controlled production not merely as managers but as artist-artisans. Of course, they were still dependent upon MoMA to validate their work; they needed the museum staff to legitimize their mass-produced, machine-made products as art. Such a relationship led to an interesting reversal of the traditional dependence of the museum

on the industrialist as financial patron. Through MoMA design shows, the museum became the patron, the industrialists became the artists, and the consuming public became the discerning connoisseurs.

Perhaps MoMA's motives transcended the simple encouragement of good design. The museum certainly capitalized on industrial manufacturers' enthusiasm for their new role as artist-artisans to solicit merchandise for its permanent collection. At least one contemporary critic noted this connection. The headline for the March 17, 1934, *Boston Transcript* review of the *Machine Art* show exclaimed, "Gyration About a Ball-Bearing," and the accompanying article noted that the lengthy list of contributors read like the "register of space takers in an industrial exposition." "Here then," the author concluded, "is a mass endeavor to interest industry in art and, perhaps industrialists in museums."[58] A form letter sent to hundreds of potential lenders to the show claimed that "there is a great deal of interest in this exhibition from manufacturers and local distributors as well as the casual gallery visitors." Moreover, museum staff directly stressed the advertising bonuses the MoMA could provide. "Visitors who neglected to buy the catalog or take down information at the exhibition continue to write us for the addresses of . . . shops where particular items may be purchased." But, the staff announced, this financial gain was not the only reason for contributing to the show. In the long run, they claimed, these companies would be doing a major service for the history of design in the United States. "We hope that through this and similar exhibitions sales may be stimulated for articles of particular merit in design and manufacture."[59] Like form and function, art and commerce were intimately linked.

In return for such favorable publicity, especially at a time of decreased consumer spending, manufacturers continued to support MoMA shows. After requesting their silverware back, Gorham executives, "feeling that you are doing missionary work that is appreciated by both the public and manufacturers," voided "the memorandum charge covering these pieces." Gorham concluded its letter with the hope that the museum would accept the silverware as its "contribution to [the museum's] efforts." Companies such as Gorham directly benefited from Barr's missionary work on behalf of modern design. Through MoMA design shows, Barr and company were not preaching to the converted; on the contrary, theirs was a proselytizing mission designed to attract and educate new audiences and perhaps new consumers.

It was not enough, however, for MoMA to cooperate with manufacturers to be able to reach the public. The museum had to draw audiences

on its own in order to legitimize its position as a cultural authority; otherwise the museum was merely an advertising agency, and its experiential notions of aesthetic value became directly tied to the mass market rather than to individual experience. In order to popularize the museum's shows and attract more diverse audiences to its exhibits, MoMA held contests designed to draw in the public and foster widespread participation in its programs. For example, on the opening day of the *Machine Art* show, Amelia Earhart, John Dewey, Charles R. Richard (director of the Museum of Science and Industry in New York City), and Frances Perkins (secretary of labor) participated as celebrity judges in selecting the three most beautiful objects on display in the show. A later MoMA press release, quoted in a number of national papers, declared that Amelia Earhart recognized the links between good design and living by reporting that she had "recently added to her achievements by becoming a designer of clothes that are both beautiful and appropriate to the age we live in." In judging the contest, however, the report continued, Earhart had trouble choosing between a ball bearing and a piece of spring. She chose the spring and explained her decision as such: "In designing clothes I made a buckle for a belt out of a ball bearing. And I have on my desk as an ornament an intake valve from an airplane because it is beautiful." Earhart publicly praised MoMA's efforts on behalf of industrial design, stating, "I think that the exhibition as a whole is a great step forward in that I believe people may see beauty in machines which, so often we think of as only crude or lacking individuality, which isn't the case at all for anyone who has eyes to see."[60]

Despite celebrity endorsements and high attendance at MoMA design shows, not all Americans believed that industrial goods constituted art. Many viewers were reluctant to accept the museum's new artistic categories and held fast to traditional aesthetic standards of beauty and definitions of fine art; they wanted to keep the machine out of the garden and machine-made goods out of the museum. They resisted Barr's and Johnson's claim that their new aesthetic categories were "democratic" and instead viewed them as merely another transformation of cultural capital held only by those who had mastered the new code. Barr's and Johnson's position was often reflected in the press. Some reviewers of the MoMA design shows responded like Edward Alden Jewell in the February 26, 1934, *New York Times*, who argued that *Machine Art* "promises to demonstrate the progress that is now being made in the matter of evolving truly native expression." Many others, however, shared Arthur Miller's view in the March 25, 1934,

Los Angeles Times: "Is Beauty the same thing in Auto's lines and in sunset?" Miller's review pitted William Morris against Plato:

When you see a new car or the new Union Pacific speed train and exclaim: "Gee what a beauty!" do you mean the same kind of beauty you see in a sunset? Looking at the intricate mechanism of your watch opened by the jeweler, you admire the beauty of all those coiled springs, cogs and levers fitted so closely together. . . . But is it the same kind of beauty as a pretty girl?

—An airplane is a beautiful thing, isn't it? Then how about a beautiful picture? Is it the same kind of beauty and can it be judged by the same standards as the airplane?

Similarly, the March 14, 1934, *Springfield* (Massachusetts) *Republican* reported that a piece of spring "won first prize in the exhibition of beautiful objects of the machine age at MoMA." "Note carefully," the reviewer instructed his readers, "that it was a piece of spring not a piece of Spring. It was not a blue-eyed maiden tossing flowers from her apron. It was not a flock of lambs gamboling on the lea. It was not lilacs in the front yard growing." It was a piece of steel spring "such as one might use to swing back the kitchen door."[61]

One of the ways that museum staff attempted to persuade the public that machine-made pieces could be beautiful was by playing to female audiences, the traditional keepers of the decorative. Barr may have wanted men to buy the furniture, but he was banking on female consumers buying more than just the curtains. In an attempt to rectify doubts over the legitimacy of their design shows, MoMA staff embarked on a major outreach program to convince female viewers that the goods on display were not just art, but useful pieces of art. Regular press releases, reprinted in hundreds of national newspapers, announced not only the aesthetic but also the practical benefits of buying the products included in the shows. Under the headline "Hostess Makes Entertaining Easy," the *Roswell* (New Mexico) *Dispatch* reported that "designed with an eye to beauty as well as convenience, these household gadgets fit into the modern home as smartly as any accessory should." For example, "Many new rubber gadgets make cleaning a pleasure and guard fine china from chipping or breaking. New bottle openers bring the hostess a happy sigh of relief." Similarly, the *Buffalo Courier Express* announced, "You have modern art in bathroom, kitchen . . . ," and the *New York Times Magazine* instructed readers that "a wire batter beater or a metal tea kettle show evidence of the serious consideration given to attaining a convenient shape which is at the same time attractive."[62] By using the lan-

guage of fashion advertising and highlighting the pragmatic, MoMA staff targeted female viewers in much the same way as the makers of the goods targeted female consumers in their advertising campaigns. In daytime lectures and radio shows, representatives from the museum stressed the myriad benefits buying such products would bring and made direct appeals to convenience and beauty. But the museum added another dimension to their sales techniques. By choosing the goods MoMA staff had highlighted, they argued, women could enter into "the fine art of living" as collectors. It was a fine line indeed between art and life.[63]

Despite initial mixed reviews, the *Machine Art* show traveled unchanged around the country for ten years, from July 1934 to May 1944. It was displayed in major museums, local colleges, and high schools. By the end of the 1930s, the museum was no longer legitimizing the existence of its design shows. Displays of industrial goods had not only become normalized; they had become quite popular. *Machine Art* was followed by yearly *Useful Object* shows. The first, *Useful Objects Under Ten Dollars,* and the second, *Useful Objects Under Five Dollars,* were, like the *Machine Art* show, aimed at awakening American consumers to good design, and in particular female consumers, to the inherent beauty and convenience of the seemingly banal objects they used every day, as part of MoMA's project to merge art and life. More than the *Machine Art* exhibition, the *Useful Object* shows attempted to include visitors from all economic classes as potential collectors. Art, MoMA staff argued, was no longer available only to the rich; it could be purchased by anyone with five dollars, thus prompting *Retailing magazine* to announce the "triumph of democracy in design."[64]

Like the *Machine Art* show, the *Useful Object* shows identified products by brand name, price, and where they could be bought. In many cases, the "where-to-buy" part was made even easier because the exhibits often traveled to department stores that stocked much of the merchandise on display. As the shows became more popular, the need to justify the products on display as art became less important, for the public had begun to accept industrial design as an aesthetic category. As a result, MoMA curators began to include examples of the "modernistic" in their publications. In a 1938 MoMA Bulletin, John McAndrew, who had replaced Johnson as the director of the Department of Industrial Design in 1937, included photographs of modernistic or "pseudomodern" objects for sale across the country. Perhaps museum staff began to identify examples of the modernistic in their publications and shows in an attempt to maintain their role as cultural authorities. Their industrial design exhibitions may have succeeded too

USEFUL OBJECTS UNDER FIVE DOLLARS

An exhibition arranged and circulated by The Museum of Modern Art, N.Y.

CHECK LIST *See also Receipts Volume VIII.*

Mus.No.	Manufacturer or Retailer	Name of Object	Price
38 .2751	Allen Metal Products Co. Yonkers, New York	adjustable towel rack	$3.50
" .2734A-3	Aluminum Cooking Utensil Co. New Kensington, Pa.	aluminum tea kettle	3.00
" .2566A-3	Aluminum Goods Mfg. Co. Manitowoc, Wis.	salt and pepper shakers	.10
.2565A-0		mirro combination pan	1.79
.2670A-3		aluminum and cork mats	.10 ea.
.2765A-3	Amerith, Inc., New York	comb and brush set	1.95
.2752	Ann Zell Specialty Mfg. Co. Brooklyn, New York	travelling mirror	2.50
" .2683	Artwire Creations, Inc., N.Y.	rubber covered dish drainer	1.19
.2660	Assoc. Attleboro Mfrs., Inc. Attleboro, Massachusetts	colored measuring spoons	.10
.2616A-3	Braquette, Inc., New York	two chrome Braquettes	2.00 ea.
.2647A-3	P.W. Buchhart, New York	spun aluminum screen top ash tray	1.50
.2756	Cambridge Glass Co. Cambridge, Ohio	glass pitcher	1.50
.2654	Cavitt-Shaw, East Palestine, Ohio	1 soup plate (pale yellow)	.30
.2655A-D		4 dinner plates " "	.35 ea.
.2655E-7		2 bowls	.60 ea.
.2655G		1 cover	.35
.2651	Chase Brass & Copper Co. Waterbury, Connecticut	chrome plate	.75
.2716		copper tray	.75
.2717		chrome tray	.75
.2731	Christy Co., Fremont, Ohio	steel pocket knife	1.00
.2572A-3	Corning Glass Works Corning, New York	sauce pan with chrome handle	1.40
.2573A-3		double boiler	3.95
.2729	Dennison Mfg Co., New York	brandy glass	.59

Fig. 31. Partial list of contributors to *Useful Objects Under Five Dollars* exhibition, September 8–October 28, 1938. The show not only displayed objects of good modern design, it also told the visitor who created them and how much they cost. Checklists such as this one accompanied the exhibit as it traveled across the country. (Digital Image © Museum of Modern Art/Licensed by SCALA/Art Resource, New York, N.Y.)

well. As the 1930s progressed, manufacturers and department stores across the country had begun to use MoMA's categories to sell the goods in their showrooms. But unlike Marshall Field's at the beginning of the decade, many of these retailers felt they were no longer dependent upon MoMA's endorsements or advice; they began to give their own design advice, using MoMA's design categories and language. They too were playing with the idea of desacralization, but for most fostering aesthetic experience was secondary to selling goods.

Initially it was important for department stores to maintain close ties with fine arts museums as an advertising tactic. In 1928, R. W. Sexton noted that recently "merchants have been brought to realize that art has selling value" and that "the key competition amongst stores and shops . . . has already been responsible for the maturing of this appreciation of the commercial value of a beautiful thing." Indeed, at the turn of the century, the use of "art" became a way of differentiating individual stores from one another. Stores like Saks Fifth Avenue, Macy's, and Lord and Taylor employed industrial designers to create their window tableaus and internal displays in an attempt to define their store's signature style.[65] MoMA was not the only museum to recognize these links between the fine arts and department stores. In 1930 Robert W. deForest, president of the Metropolitan Museum of Art, told a group of department store executives that "you are the most fruitful source of art in America." The department store's influence, he continued, "was far greater than that of all the museums combined," and stores should be used as "missionaries for beauty."[66] While the relationship between department stores and museums was not new, what was new in MoMA design shows was the direct cooperation among industrial producers, retail stores, and MoMA in choosing which products to promote.

In order for their modernist crusades to work not merely as marketing devices or advertising campaigns, MoMA staff had to maintain close ties not only with industrialists but also with the stores selling the approved products. Many department stores saw rich opportunities in promoting these ties, and trade journals such as *Retailing Magazine* regularly described industrial design shows at the museum and urged stores to stress the relationship between MoMA and their inventory. In addition, Frederick Kiesler, in his influential "how-to" book on department store displays, *Contemporary Art Applied to the Store and Its Display*, not only encouraged increased cooperation between museums and department stores but also asserted the national importance of forging these links. Following World

War I, Kiesler argued, the United States had gained leadership in everything except art. Americans, he believed, were unable to compete with European artistic movements. According to Kiesler, the department store was "the true introducer of modernism to the public at large," since it "revealed contemporary art to American commerce."

Like Barr, Kiesler believed that consumer capitalism could be aestheticized through the cooperation of department stores and the manufacturers of industrial goods. This partnership, he asserted, was in the best interest of the American people because "THE NEW ART IS FOR THE MASSES . . . THAT IS: IT WILL BE OF THE MACHINE." The cooperation of art and commerce, he claimed, would bring about a democratic American artistic renaissance. "If ever a country has had the chance to create an art for its people, through its people, not through individuals and handicraft, but through machine mass production," he wrote, "that country is America today." Machine-made products, according to Kiesler, were tied directly to increased democratic access to art. Positive links could be forged between the masses and mass production. "The expression of America," he announced, "is the mass, and the expression of the masses, the machine." Therefore, Kiesler announced, the department store must act as "the interpreter for the populace of a new spirit in art . . . by simply planting its creations in the commercial marts."[67] Kiesler advocated selling art for the masses, in masses.

Art journals also embraced this idea. For example, the April 15, 1937, issue of *Art Digest* reported that "art students who find the usual artistic pursuits in the commercial world overcrowded are finding a new outlet for their talents in show window display." The article quoted Mrs. Polly Petit, founder of the New York School of Display, who argued that whether "for a painting or a window display . . . the rules of lighting and composition are the same." The *Art Digest* article blamed "the Depression years for the upheaval in store-window technique and progress."[68] Whatever the cause, by the late 1930s, more and more department stores had "artists" on their payrolls. And with good reason, their window displays and showrooms were received well by the art community, often better than the displays of their museum counterparts. An article in the December 1936 *American Magazine of Art* entitled "Art in Display," for example, applauded a sample bedroom display for Macy's in New York, stating that "it has a feeling of trueness to life missing in many period installations in art museums."[69] But art in department stores was not limited to displays. During the 1930s, many retail firms created galleries within their stores in which they sold original art. In 1939 Macy's even went so far as to hold its own "Macy's

Mexico in Manhattan" festival to correspond with MoMA's *Twenty Centuries of Mexican Art* show. The rush for department stores to include "fine arts" in their merchandise prompted a staff writer at the *New Yorker* to remark that soon "Macy's and every other store will . . . [turn] us into a city of retail museums." This cultural renaissance, he continued, "will probably work out fine for everything except for the general merchandise, which will be forced to take refuge elsewhere. People who start out in search of an electric toaster will end up at the MoMA, aisle 4."[70]

Often department store personnel attempted to bypass the museum entirely, casting their store in the role of cultural educator. For example, in 1933 Macy's published a booklet entitled *Forward House: "The Men Who Made the New York Skyline Have Designed a House for You."* In this publication and the accompanying exhibition in Macy's Herald Square store, Macy's anthropomorphized itself and took credit for making art available to all Americans through the goods in its showrooms. "A great New York store," the preface to the booklet announced, "conceived the idea of an elaborate exposition in the new art of living." Macy's claimed that the store's products were being sold as part and parcel of a way of life. This was hardly a new approach to selling goods; afer all, promising happiness and life improvements was the bread and butter of the advertising industry.[71] Appeals to higher standards of living were not new, either. What was new, however, was the stress on the institution rather than the individual products as the means of achieving happiness. This was quite similar to the approach taken by MoMA. The major difference, however, was that all of the goods on display in Macy's showrooms were available for purchase right there. Unlike the MoMA design shows, which merely pointed to the goods, Macy's and other department stores actually sold them.

Macy's saluted the efforts of MoMA curators and then trumped them by building an environment in which to actually place the goods. The "things" might "make the rooms," but Macy's did not stop there. Following MoMA, Macy's engaged in architectural design. They made the houses in which to place the rooms in which to place their goods. Despite their emphasis on the relationship between "use" and "beauty," MoMA shows often displayed goods out of context. A spring by itself was just a spring. Macy's and other department stores not only showed the spring at work in the toaster but also placed the toaster in a room inside the house. The "thousands who come to see this exposition," they reasoned, "will want to know what sort of houses might well contain these rooms." Macy's asked the staff of *Architectural Forum* to help them choose architects from whom

to solicit plans for their show. Indeed, the *Architectural Forum* staff cooperated with the store in planning both the exhibition and the book, lending an air of legitimacy to the entire exhibit. (Most likely the journal cooperated because the show encouraged viewers and readers of the book to "consult your own architect when you decide to build or remodel.")

Not only did Macy's plug the architectural profession, which was in a slump due to the building slowdowns of the Depression, but the store also encouraged shoppers to "add new zest" to their determination "to build now," claiming there were "definite savings to be made by doing so . . . whether your home is to be modest or mansion-like." Chief among these benefits was the long-term savings that employing a "competent architect" would bring: "His services will actually cost you nothing . . . [because] the mistakes he will save you from making will more than pay his modest fee." This was not buying on speculation; this was investing in the future, a lesson many Americans had learned firsthand over the past few years. But more important than that, the book asserted, "he will design a house for you that will be a joy to you and a source of pride to your neighbors." This joy was a crucial selling point. "Choosing a house," Macy's asserted, "is the second most important decision in your life (choosing the wife to live in it comes first)." By emphasizing the process of choosing an individual architect (much like choosing a spouse), Macy's personalized the design process. It was no longer an anonymous endeavor; rather, it involved real people making real choices.

Interestingly, Macy's *Forward House* booklet looked just like a MoMA architectural publication, with biographies of the individual architects consulted, sketches of their plans, and a list of objects included in their decoration (all available, of course, in Macy's "living" showrooms). Macy's avoided charges of self-promotion by donating "every penny above the cost of this book . . . not to the store, nor to the architects who designed these houses—but to the treasury of the Architect's Emergency Committee, an unselfish and official bureau for the relief of New York architects out of employment." The Depression had a serious effect on both architectural building and consumption of durable goods. Macy's, with the help of the American public, aimed to correct these problems through events such as *Forward House*.

The following year, MoMA followed suit with an exhibition that specifically addressed housing problems in the United States, *America Can't Have Housing*. The *America Can't Have Housing* show, like the *Forward House* exhibition, directly debated the place of art in everyday life. In this

Fig. 32. *America Can't Have Housing* exhibition, March 15–November 7, 1934. This installation photograph from the third section of the show contains models, drawings, and graphs of "successful" housing projects. (Digital Image © Museum of Modern Art/Licensed by SCALA/Art Resource, New York, N.Y.)

case, however, the entire home was aestheticized. MoMA had already devoted a great deal of energy to aestheticizing private architecture. One of the museum's first shows (still considered a signature event) was Philip Johnson and Henry-Russell Hitchcock, Jr.'s, 1932 exhibition, *International Style*. The *International Style* show followed many of the same tenets of the museum's early design shows; functionalism ruled.[72] Held in conjunction with the New York State Housing Authority and Columbia University, the *America Can't Have Housing* show was in part a reaction to criticisms of the *International Style* show. The exhibition (and accompanying catalog) aimed to "arouse public interest and foster a better understanding of the housing problem," as well as to "discuss the radical changes which must be made in our social philosophy and public policy in order to improve the housing condition of masses of American people."[73] But theory and practice were not always the same. The catalog, edited by Carol Aronovici, di-

rector of the Housing Research Bureau of New York City, accomplished something very different from the exhibition itself.

The catalog consisted of seventeen short essays by internationally recognized housing experts. The advice of these experts varied greatly. German Bauhaus innovator Walter Gropius essentially endorsed Johnson and Hitchcock's International Style architecture (which was basically a celebration of Bauhaus principles) as a solution to housing problems in American cities such as New York. He argued that with the proper amount of "air, light, warmth and elbow room . . . human beings, biologically speaking, need only a very small space to live in." By enlarging the windows and providing accessible grass plots where children could play, Gropius believed that the New York "apartment house of the future will not resemble the squalid, cramped tenement houses of the past." Abraham Goldfeld, executive director of the Lavanburg Foundation (one of the show's sponsors), favored a more paternalistic model of housing reform. He suggested that enforcing "rigid checks" and "careful selection of tenants" in the housing projects would ensure that the buildings were being occupied by "those for whom they were designed." Lewis Mumford, in contrast, called for the necessary social and economic changes that "would make housing available to every income group." The "objective in modern housing," Mumford insisted, was to produce a "completely human environment" to "fulfill our own lives and carry on the complicated structure of our civilization." This, he believed, would lead to a nation of "healthy and well balanced and alert people, capable of expressing themselves effectively through their work, their arts, their communal and family relationships." Such an environment "will not be handed down from above." Rather, Mumford insisted, "it can only come through a creative desire on the part of the workers to transform not merely their status and industrial functions but their entire environment and their standards of consumption." For Mumford, the need to build "communities that enable us to function as complete human beings at higher social and cultural levels" was imperative for "capitalism in its decay," which, he argued, "will drag us down into a lower stage of social integration . . . in which periodic depressions alternate with states of manic suicidal activity."[74] Mumford, Goldfeld, and Gropius, along with the other contributors to the catalog, presented a diverse assortment of solutions that fused art and life to solve housing problems in the United States. While they differed greatly in some regards, they all agreed that there was a housing problem in American cities and that cultural institutions, private corpo-

rations, and the national government all needed to cooperate, and perhaps collaborate, in order for needed changes to occur.

The accompanying exhibition was supposed to represent the many strategies presented in the catalog. The goal of the show was twofold: to highlight American housing problems and to present a variety of solutions. Some of the plans for the proposed solutions had been carried out already in Europe; others were theoretical. *America Can't Have Housing* was held on all three floors of the MoMA galleries. "Illustrated panels spread out bookwise" flanked the entrance to the exhibit halls. Once inside, the show contained an assortment of models, plans, photographs, and charts describing "outstanding examples of multi-family projects" in Germany and Holland, as compared to "slum improvements and proposed slum clearance in the New York district."[75] The influence of Barr, Johnson, and Hitchcock was felt throughout the show despite the many outside collaborators. The concept of "slum" was not limited to the run-down living conditions of the urban poor, for it included the "super slums" found on New York's fashionable Upper East Side. Photographs of "inefficient" and "uneconomical" Lower East Side tenements, "breeders of disease, crime and despair," were shown alongside the "super slums" of Park Avenue, "shown likewise to be wasteful of space, artistically unattractive and breeders of unhealthy neuroses and indifference."[76]

After viewing sketches and plans of European housing developments and absorbing numerous statistics such as "60,160 New Yorkers live in cellars, 9,847 in rooms without windows, 3,889 in buildings without heat" displayed under murals depicting children with tuberculosis, exterminators, and other scenes of urban horror, visitors to the exhibition were treated to an in situ replication of two model apartments. In doing so, MoMA staff adopted a popular department store technique by turning their galleries into showrooms.

The two model apartments were in keeping with the curators' "good" versus "bad" design exhibition strategy. The first was a three-room flat that the accompanying text claimed was "rescued with furnishings intact from an old-law tenement recently torn down" on New York's Lower East Side. Visitors were informed that eight people had lived in the "rancid" and "dank" windowless apartment. Thanks to Charles Nobel of the USS *Tennessee*, the tenement even came complete with cockroaches. Nobel, a mate in the United States Navy, sent a packet of roaches he found aboard his ship, noting that he thought the exhibit was a "good idea" but that "no old law tenement in New York City was complete without cockroaches." His letter

Fig. 33. Department store installations. Department stores such as R. H. Macy and Company borrowed both the language and the display methods of MoMA design shows for their in-store displays. *American Magazine of Art* highlighted the artistic nature of these displays in a 1936 article. The text reads: "The realism of an actual room gives the furniture a suitable setting. Summer furniture of modern design, but with 'Guatemalan influence' recalling folk traditions, is here seen with appropriate accessories such as paintings, ceramics, and plants and flowers chosen for their combination of the familiar with the exotic." (*American Magazine of Art*, December 1936, p. 825.)

(which received considerable treatment in the national press) was prominently displayed in the tenement apartment. After walking through the dank and crowded tenement, visitors entered a light and airy Philip Johnson-designed, international style apartment outfitted with "modern low cost" furnishings compliments of Macy's. In a later interview, Johnson recalled that "getting Macy's to donate the furniture wasn't hard because I put their label on every piece."[77] After the veritable chamber of horrors of the dark, stuffy, roach-infested tenement apartment, the "low-cost" Johnson apartment must have looked like an excellent alternative. By conclud-

ing the exhibit with Johnson's apartment, the museum ultimately endorsed the international style as an attractive way for America to have low-cost, efficient, and functional housing.

Perhaps the display strategies employed in the *America Can't Have Housing* exhibition were little more than propaganda for the museum's international style ideology. Yet the show received considerable publicity in the national press and encouraged the wider public to think about America's housing problems, thereby encouraging larger debate over aesthetic issues. C. C. Hosmer, secretary of housing for the state of New Jersey, urged all New Jersey residents to see the exhibition and predicted that visitors "will come back to their communities girded for the part they must assume if the low wage earner is to be taken out of the shambles he is compelled to call home." The *Bennington* (Vermont) *Banner* told its readers that "the problem of slums as is shown by the exhibition is not one peculiar only to New York City" but was something that "comparatively small communities need . . . brought home to them as well."[78] The show had a tremendous impact. Even the *Park Avenue Social Review* encouraged readers to rethink their housing prejudices. It stated that "the question is not whether we wish to subsidize good housing for people in the lower income groups, but whether, since we are paying such a subsidy already, we should not get a considerably better value for our money."[79]

It is easy to demonize MoMA staff as agents of cultural hegemony, doing everything within their power to enforce ideological categories rooted in somewhat arbitrary aesthetic formulas of use and beauty. Even at their most altruistic, as in the case of *America Can't Have Housing*, MoMA staff often promoted their notions of modernism at the expense of social reform. Ultimately, the show was an endorsement of International Style formalism. But perhaps it is not that simple. MoMA initiated its industrial design and architecture shows for numerous reasons, chief among which was the idea that the museum's educational programs and didactic exhibits would teach the American public not only to understand modern culture but also to participate in it. By highlighting the importance of aesthetic experience in determining artistic value, museum staff aimed to challenge rigid cultural categories and merge high art and machine-made goods. MoMA design shows argued that the work of art in the age of mass production was available to all Americans for as little as five dollars. Through their early industrial design shows, Barr, Johnson, and other museum staff hoped to democratize design by creating standards of evaluation that would be available to all Americans. In effect, they thought they were doing a public

service by democratizing industrial design and creating an accessible modern American aesthetic.

For MoMA staff, instituting "democracy in design" meant alerting the public that inexpensive, machine-made goods were a type of fine art that they could own. Thus, for the most part, the ideology behind MoMA's pedagogy of cultural consumption paralleled the goals behind the Federal Art Project's pedagogy of cultural production. The staff at both institutions believed that the merger of art and life (whether through production or consumption) had democratic possibilities on an individual as well as on a national level. For Federal Art Project administrators, art production acted as a way to get members of the broader public to interact with those in their local communities while simultaneously taking part in a national movement. They felt that participating in art activities would make people living through Depression conditions feel better in a time of crisis and ultimately become better American citizens. Similarly, Barr and Johnson believed that buying art, as they defined it, would dramatically improve the quality of life for many Americans. It would transform banal acts of everyday living into artistic events in themselves, bringing joy and beauty to all. Their ideology of modernism was not simply an aesthetic preference; it was a lifestyle grounded in everyday experience.

As the decade progressed, however, MoMA's claims to cultural expertise fragmented. Much as the Federal Art Project adapted its rhetoric and goals to accommodate changing attitudes about consumption as the basis for both economic recovery and cultural exchange, MoMA too had to make concessions to the capitalist marketplace. As commercial ventures such as Macy's began to employ the same language as MoMA concerning modern industrial design and to use many of the same strategies for educating the public about this new kind of art to sell the products in their stores, MoMA staff began to copy some of the sales techniques traditionally used by these department stores to explain its modernist philosophies. The model apartments in the *American Can't Have Housing* show, for example, in particular Philip Johnson's International-Style flat, looked much like the showrooms in Macy's furniture department. As more and more stores built art galleries on their premises and hired industrial designers to arrange their windows and showrooms, they often came into direct competition with the Museum of Modern Art in their attempts to teach the American consumer how to merge art and life. With competition from the actual marketplace, MoMA, much like the Federal Art Project, had to adapt its educational goals. In many ways, as a result of its successful desacralization efforts, the museum

became more dogmatic in enforcing its version of modernism and art, which became increasingly centered around more traditional forms of painting and sculpture. Yet, by positing a definition of art whose value was rooted in everyday experience, MoMA allowed for an alternative system of value, divorced from the sacred and tied instead to function and utility. Moreover, as a result of the staff's missionary efforts, many American consumers did become more educated, in that they adopted MoMA's admonitions that some products were better than others and that some were even "art." We can see this most clearly at the 1939 New York World's Fair.

Chapter 4

Art and Democracy in the World of Tomorrow

About half way between West Egg and New York the motor road hastily joins the railroad and runs beside it for a quarter of a mile, so as to shrink away from a certain desolate area of land. This is a valley of ashes—a fantastic farm where ashes grow like wheat into ridges and hills and grotesque gardens; where ashes take the forms of houses and chimneys and rising smoke and, finally, with a transcendent effort, of men who move dimly and already crumbling through the powdery air. Occasionally a line of gray cars crawls along an invisible track, gives out a ghastly creak, and comes to rest, and immediately the ash-gray men swarm up with leaden spades and stir up an impenetrable cloud, which screens their obscure operations from your sight.[1]

F. Scott Fitzgerald wrote the above passage to describe the stretch of land connecting the fashionable beach communities on the north shore of Long Island to New York City in his 1925 novel *The Great Gatsby*. Fitzgerald's wasteland imagery, however, should not be dismissed as mere literary embellishment. His prose described an actual site. By 1925 the negotiations of Tammany Hall politicians had turned Flushing Meadow, once three miles of beautiful marshland, into the dumping and burning grounds for the Brooklyn Ash Removal Company. It was indeed a "valley of ashes." During the 1930s, New York State Parks Commissioner Robert Moses repeatedly invoked Fitzgerald's metaphor in his quest to reclaim the municipally owned trash heap and transform it into a public park worthy of bearing his name. In his report, "The Saga of Flushing Meadow," Moses wrote, "We studied every possible means for acquiring the whole meadow, but this dream seemed too big for the vision and means of the city in the face of competition of so many urgent enterprises . . . then, the miracle happened—the idea of a World's Fair."[2]

In 1935, at the height of the Depression, a diverse group of businessmen, cultural leaders, and government officials formed the New York World's Fair Corporation. Grover Whalen, the former police commissioner

Fig. 34. Flushing Meadow, 1933. The fair was built on the site of the Corona Dumps; it was literally a valley of ashes. Clearing the site took more than three years. This process became part of the official fair history. (Collection of the author.)

of New York City and an avid New Dealer, led the group, which set up offices near the top of the newly constructed Empire State Building. The corporation included a number of public and private luminaries. Among them were New York City mayor Fiorello LaGuardia; Winthrop Aldrich, chairman of Chase Manhattan Bank; John J. Dunnigan, majority leader of the New York State Senate; Harvey Dow Gibson, president and chairman of the board of Manufacturer's Trust Company; and Percy Straus, president of Macy's Department Store. Holger Cahill and Conger Goodyear were active in the planning stages as well. Together, the diverse members of the New York World's Fair Corporation transformed Flushing Meadow from a mountain of ash into what they termed "an inspiring spectacle . . . a landmark in the history of civilization"—a world's fair.[3]

Although the fair itself ran for only two years, fair planners conceived of its effects in lasting terms. They saw it as a means of invigorating the local economy and hoped to draw over a billion dollars in revenue to the New York area through the event. When the fair ended, they wanted Flushing Meadow to become a permanent public park. But, most important, the fair embodied a lasting utopian vision of the United States, premised on advanced technology and a powerful consumption-based economy. Fair

planners and exhibitors consciously attempted to reconcile democratic ide-
ology with consumer capitalism to create an idealized vision of the "World
of Tomorrow" made possible through products and concepts available then
in the world of today. One of the ways that they attempted to do this was
by coding almost everything at the fair as "art" and then calling that art
"democratic."

Beginning with the Crystal Palace exhibition in London in 1851,
world's fairs and international expositions were important events in the
nineteenth and early twentieth centuries. Part trade shows and part national
pageants, world's fairs provide an important window into the intersection
of economic, cultural, and political policy building in an international con-
text.[4] In the past, most American fairs included art pavilions in their official
plans. Serving as temporary museums in which to display world master-
pieces to a public who might otherwise never get to see them, for many,
these art exhibitions were a counterpoise to the industrial and scientific
exhibits that dominated the majority of fair displays. In short, they were
sites for the sacralization of culture. Like churches or temples, fair art galler-
ies exuded the importance of presence; the public passed through them
quietly, absorbing the aura of the masterpieces on their way to cultural
uplift through encounter.[5] The widespread belief among American intellec-
tuals and critics that there were few, if any, great American artists often
limited art displays at American fairs to great American collections of art.
American fair exhibitions thus emphasized the connoisseurship and refined
taste of a few very wealthy American collectors. At both the Philadelphia
Centennial and the Chicago Columbian expositions, for example, the paint-
ings and sculptures on display were stylistically classical and European-
derived, while the information cards accompanying each piece included the
names of the artist and the lender, as well as some biographical information
for both. Provenance became as important as content or style in describing
the pieces on display, thus binding class and taste together and emphasizing
the ability to recognize and procure fine art rather than the ability to pro-
duce it. At nineteenth- and early twentieth-century American fairs, the
vision of the collector often took prominence over that of the artist.

The planners of the 1939 New York World's Fair attempted to chal-
lenge both the science/art dichotomy and the class-based, collection-
centered biases of earlier fair art exhibitions. There were no art pavilions
included in the fair's original plans, for example. This did not mean that
the concept of art was excluded from the fair's ideological makeup; on
the contrary, instead of identifying and displaying art as a separate entity,

everything was aestheticized, from the strip shows and the midget village in the amusement zone to the architectural plans and advanced technological displays. Art was one of the dominant idioms of the 1939 New York World's Fair. By naming and identifying objects of everyday life as art, fair planners followed the successes of institutions such as MoMA and Macy's by attempting to create a utopian space in the landscape of tomorrow in which art and life would be fully integrated along democratic lines. Every American, regardless of economic class, they argued, could experience this new art form. By merging economic and cultural production and coding everything from freak shows to industrial design and landscape architecture as art, the planners and exhibitors at the 1939 world's fair blurred the lines between public and private, commercial and national, culture and technology, and a myriad of other mythic dichotomies in an attempt to embody democracy in art as an accessible lifestyle, not an intangible sacred experience.

Not only did its organizers promote the fair as an art form in itself, divorced from the sacred and embodying the spirit of American democracy, but both the Federal Art Project's pedagogy of cultural production and the Museum of Modern Art's pedagogy of cultural consumption surfaced, and often clashed there, leading the fair to be a major site of aesthetic contestation. Local newspapers and national magazines regularly carried articles debating the relationship between art and democracy at the fair and artists, fair visitors, and New York City residents took to the streets and to the fair itself to make their positions public. The coexistence and contestation between the sacred and the quotidian, or more specifically between production- and consumption-based models of art at the fair, in many ways signal the apex of democratic modernism in the United States. Yet, the 1939 New York World's Fair also signaled the beginning of the demise of a participatory form of American modernism, marking instead a move toward more spectacular definitions of aesthetic experience rooted in more passive forms of spectatorship.

The Flushing Meadow Fairgrounds's origins as a desolate ash heap and its transformation into a "landmark spectacle" played a major role in its official history.[6] From the start, fair planners considered the fair as more than a geographical site or a time-bound event; they called it a "fabulous creation" and declared it a modern art form.[7] Holger Cahill, for example, described the fair as "an expression of the contemporary arts." Citing the work of architects and engineers, mural painters, and "architectural sculptors," the use of color and light, daily programs, spectacles, pageants, and

Fig. 35. Night shot of *George Washington* framed by *Trylon* and *Perisphere*. (Museum of the City of New York, 1939/40 World's Fair, box 7, folder 3.)

dramatic and musical events, he exclaimed that "the Fair as a whole is a vast mosaic of our present day culture which everywhere shows the skill and talent of the artist."[8] Similarly, Walter Dorwin Teague announced that the fair demonstrated that the "entire man-made world was art." "Every man who plans the shape and color of an object," he maintained, "whether it is a painting, statue, sewing machine, house, bridge or locomotive—is an artist."[9] The idea of the fair as art was not limited to its planners; it proliferated in specialty journals as well as in more mainstream newspapers and magazines. An editorial in the May 1939 *Art Digest* stated, "Fairs are no longer haphazard displays of things amazing and spectacular but are a new twentieth-century art form. The New York Fair is an entity in itself and an independent expression of a people."[10] For its boosters, the fair

was the ultimate example of a desacralized and democratic art form—simultaneously fun, educational, and profitable. It combined use and beauty, production and consumption, to create a truly modern American aesthetic.

One of the founding myths of the 1939 world's fair was that it erased the division between art and technology. In part this was true. In the early planning stages, the fair corporation hired the "Big Four" industrial designers—Walter Dorwin Teague, Henry Dreyfuss, Raymond Loewy, and Norman Bel Geddes—to design the layout and organization of the official fairgrounds. Part advertising agents and part engineers, these industrial designers were in charge of making the fair's basic philosophies tangible. Like the MoMA design staff, they believed in the larger social value of their project and promoted it with zeal. In his autobiography, *Design This Day*, Teague claimed that "industrial design offers the only hope that this mechanized world will be a fit place to live in." Similarly Bel Geddes hoped to design a new "social structure" as well as "objects of daily use." The Big Four drew on their backgrounds in advertising and theatrical design to persuade "the large American corporations that beauty—of the Bauhaus and Art Deco persuasion—could sell their products."[11] But beyond selling products, they also hoped to promote modernism as a way of life through the concept of streamlining.

Recognizable by its rounded edges and flat surfaces and rooted in scientific theories of speed and efficiency, streamlining dominated the design world during the 1930s.[12] While many were familiar with streamlined trains and cars prior to the New York World's Fair, by 1939 streamlining was ubiquitous; it had become both a metaphor and a mantra for those who wanted to combine notions of technological progress with aesthetics. As a style, streamlining simultaneously embodied the pared-down zeitgeist of the Depression years while suggesting futuristic vitality, movement, and change. From toaster ovens to engine parts to the entire "American Home," everything, it seemed, could be (and in many cases was) streamlined. Through their works, the fair's industrial design team sought the widespread merger of progress, efficiency, and aesthetics as evidence of American cultural growth. They saw streamlining as a means of making modern art available in everyday life to a wide-ranging public. Indeed, this notion of publicness was crucial to them in instituting their form of democratic modernism.

Fair planners repeatedly stressed the public nature of the fair.[13] In an early planning document, for example, Mayor LaGuardia asserted, "I want

to make it very clear that this world's fair is not a private undertaking. It is as official as government can make anything official . . . a fair dedicated to the future of the American people and the glory of our country."[14]

Yet the lines between public and private and official and corporate often blurred. Many of the same industrial designers employed by the official fair corporation were hired by private corporations to build their fair pavilions and to modernize the products on display inside them. Bel Geddes designed the official "World of Fashion" tableau, General Motors' *Futurama* exhibit, and the girlie show *Crystal Lassies* for the amusement zone. Teague, who designed the Ford Motor Company and U.S. Steel pavilions as well as the official Themecenter, articulated a direct connection between public and private enterprise at the fair and the importance of both to a functioning democracy: "The great industries of America saw in the Fair a chance to show the entire world how under the democratic system, industrial enterprise is a constructive force in the national economy—how under democracy America already leads the world in achievements and standards of living." Industrial design, he announced, "appears as the interpreter of industry to the American public."[15] By working for both official fair planners and private fair exhibitors, these designers forged a strong aesthetic link between the official fair and the corporate fair, thereby blurring the line between public and private and presenting a model of democracy firmly grounded in consumer capitalism.

This corporate model of an aestheticized future, transformed through the magic touch of the industrial designer, however, was found wanting by those who felt that world's fairs should include traditional fine arts exhibits, and articles and editorials concerning this exclusion proliferated in the press. Emily Genauer, art critic for the *New York World Telegraph*, wrote that "art is no routine affair to be harnessed and limited to industrial design, to landscape gardening, to incidental artistic treatments." Citing increased museum and gallery attendance and new traditional art "publications catering to the great masses of [the] population," she claimed that "there can be no denying this new American reaction to art." Everyone, Genauer asserted, "sees the new trend but the Fair Directors." "They who hold that art should be an important part of everyday routine and therefore relegated it to a purely functional role in the decoration of the Fair are actually serving to separate art from life in the most effective way possible."[16] As a broader segment of the American public began to accumulate cultural capital, critics such as Genauer argued that new definitions of art negated all of the progress the country had made in popularizing the fine

arts, as traditionally defined. The transformation of cultural capital to include this new type of "modern" art can be seen, then, not as a form of desacralization but rather as a type of resacralization in which only a select few had mastered the new aesthetic codes. Expanding the definition of what constituted a work of art actually served to alienate members of the public rather than include them. "Art," an editorial in the *New York Times* proclaimed, "is the visual expression of the soul of the people," and the 1939 New York World's Fair, it concluded, was "destroying" the public's collective soul by excluding art.[17]

Art journalists such as Genauer were joined by many artists themselves in their attacks on the aestheticized fair. The idea of the "fair-as-art" became a public battleground, and the fair itself became a target for criticism of the increased cooperation between American culture makers and big business. In an article in *Art Front*, for example, Ralph M. Pearson, a spokesman for the American Artists' Congress, stated, "New York City's coming World's Fair is a business man's baby . . . business is in control." Pearson and other members of the American Artists' Congress criticized the outright exclusion of artists, as properly defined, from the fair's planning stages. "No hint of a thought," Pearson wrote, "entered those business minds to the effect that art or artists might create the total flavor of such a magic pageant as a World's Fair." Like the businessmen he criticized, Pearson considered the fair as both an art form in itself and an arena for the display of art; yet he also believed that "leader artists are better equipped than any other profession to deal with harmonies and excitements of form and color" in order to "build the atmosphere of adventure, visual and esthetic, which would pull the hoped for forty millions of American citizens through the turnstiles with deep emotional reason for the excitement they craved."[18]

Pearson allowed that the fair was a "visual and esthetic adventure," but that did not mean that all participants were "artists." For Pearson and other members of the American Artists' Congress, the artist was a distinct cultural worker whose actions were integral to promoting public acceptance of American art. He wanted to use the fair to demonstrate "to all the world that [the artist] is part of the on-moving force in American art." In addition to fighting for peace, democracy, and cultural progress, Pearson and other members of the Artists' Congress were concerned with guaranteeing equal access for all artists to the opportunities afforded by the fair.[19] Pearson's resistance to letting business-driven choices determine who was an artist was shared by many others, and a number of letters and editorials by artists

followed his *Art Front* diatribe. For example, an editorial in the March 1936 *Art Front* announced: "Artists are very much concerned about the arts' contribution to this WF and are asking for a complete and informative public statement from the committee in charge. This public statement would do much to allay the suspicion that political and personal favoritism will play a large part in the awarding of jobs and contracts for the decoration and sculpture for the World's Fair."[20]

Like the fair's official planners, many members of the American Artists' Congress considered the fair a public event, and they repeatedly stressed its public nature as a reason for allowing them some degree of representation in its planning. In an official statement, the congress asserted, "While the supervision of the Fair is in the hands of a private corporation, it has the cooperation of the municipal and public officials and is essentially a public affair." Therefore, the statement concluded, "Artists as contributors and public have a right to demand a fair and open conduct of expenditures to be used for the arts and decoration." Since they conceived of the fair as a public event, these artists argued that the private contracts negated the democratic nature of the fair, since, for them, democracy stemmed from wide public participation. Nonetheless, they firmly believed that this model of aesthetic democracy could still be achieved at the fair. Citing the successes of the Federal Art Project, the Artists' Congress maintained that "the conduct of awards and jobs for work opportunities should be open to all artists" and offered to "point out the excellent results obtained from another of the public projects, the Federal Art Project, in which such opportunities have been won for the artist by the two-year fight of the Artists' Union."[21]

Continued public outrage and pressure from groups such as the American Artists' Congress and the press eventually forced the fair's planners to include two separate pavilions dedicated specifically to art: the Masterpieces of Art Building and the Contemporary Arts Building. The Masterpieces of Art Building, which was privately funded, followed the tradition of displaying great works by foreign artists. William R. Vallentiner, director of the Detroit Art Museum, spent five months traveling throughout Europe and America, arranging loans from the Louvre, the Uffizi, the National Gallery in London, and other prominent museums to assemble more than five hundred Old Master works for the exhibit. The Contemporary Arts Building was funded by the federal government and was organized by Holger Cahill and A. Conger Goodyear, then president of MoMA. The two men declared that the Contemporary Arts Building was dedicated to

the American present, to "the knowledge, the experience, and the taste of American painters, sculptors, and printmakers . . . a point of view which is cooperative and democratic."[22]

Although the arts buildings were an afterthought, their inclusion embodied the growing—and increasingly public—tension over the idea of culture as sacred and the alternative definitions of art that stemmed from both cultural production and cultural consumption. Indeed, on opening day, April 30, 1939, following much public debate and controversy, there were three distinct types of art on display: the streamlined vision of the fair's industrial design team, reflected in individual pavilions and the fair overall; the privately funded collection of "great works" in the Masterpieces Building; and the government-funded, community arts center pieces in the Contemporary Arts Building. While quite different from one another in many ways, the three visions of art all transformed cultural capital from one form to another and in so doing contained elements of cultural desacralization. Moreover, all three models stressed the need for art to transform life, and all three held aesthetic experience as central to the "democratic" nature of their project. The precise forms of democratic experience they pursued, however, were often drastically different.

The art in the Masterpieces Building was by far the most traditional. Displayed as sacred objects, in gilded frames under muted lighting, these works conveyed a sense of respect for the timeless genius of the artists who had created them and rendered the power and significance of each individual work immediately recognizable. Nevertheless, within this display mode, there was an attempt to make the masterpieces more accessible to the fair's public—to break down the sacred aura surrounding the works and democratize them by providing classless access. Regarding the exhibit, *The Official Souvenir Book of the 1939 New York World's Fair* claimed, "Here the American Public may see the great works of art which they know from innumerable reproductions but which they could never hope to see the originals without crossing the ocean." Similarly, an article in the *Albany Tribune* headlined "Paintings at World Fair are Sugar Coated Culture" stated, "The New York World Fair visitors who visit the Masterpieces of Art Pavilion save themselves running all over Europe from the National Gallery in London to the Louvre, to galleries in Florence and Amsterdam to a dozen private collections. . . . [The paintings are] organized and subdivided by nation, school and period so that visitors can take their culture in a small sugar coated pill."[23]

In the past, only wealthy Americans on a grand tour of Europe could

afford the opportunity to experience these great works of art. By assembling the works in one place, the fair simulated the grand tour and in effect streamlined art appreciation. In addition, guided tours and events such as the "Modern Day Madonna Contest" attempted to popularize the art show and democratize its content by making the works seem less sacred. The brochure for the Modern Day Madonna Contest asked the fairgoer: "Are you the Modern Madonna? Win a trip to Bermuda or other Valuable Prizes." Attempting to forge a bond between the great works and the fair audience, the contest focused on the universal mother-child relationship: "Down through the ages the great masters of painting have found in the theme of mother and child the greatest inspiration of their brushes. Over and over again, the great canvases of history present to us the theme of Madonna and Child." Imbued with the religious significance of the Virgin Mary and the baby Jesus, as well as the everyday relationship between mothers and children, the contest asked:

But who ARE these Madonnas? After all, the carefully chosen models of the Great Masters—Fra Angelico, Van Eyck, Van Dyck, Bellini, Titian and many others whose work is represented at the Masterpieces of Art—were every-day, ordinary women of their day and age. In their faces and in their personalities, the Great Masters saw that special something that makes a woman a Madonna. The women who posed for the masters were great ladies, peasants, housewives, Italian beauties, Dutch girls, German frauleins, Spanish senoritas—women of many races and many types.[24]

Aside from offering glamorous prizes, the contest asserted the importance of "every-day, ordinary" people. While the physical paintings were the result of individual genius, in many instances their inspiration came from common folk, ordinary people much like the American fair viewer.

The role of the common folk and their relationship to the fine arts was also the major focus of the exhibits in the Contemporary Arts Building. In planning the exhibits and activities for the building, Cahill and Goodyear essentially streamlined the Federal Art Project's pedagogy of cultural production and brought it to the fair. In the fair's two years, the Contemporary Arts Building held two major exhibits, both of which featured work produced on the Federal Art Project. The pieces included were chosen by regional committees and then voted upon by a "regional jury" composed of "experts" from around the country. The building also contained a model community art center, with working studios for art and handicraft demonstrations, lectures, conferences, and performances. McAlister Coleman,

writing in the June 1939 issue of *Common Sense* magazine, explained the feeling behind the Contemporary Arts Building when he wrote, "Cahill is no swivel-chair executive sitting up in an ivory tower, talking esthetics. He has roamed the continent for more than six months searching out representative art down the side streets and out in the grass roots."[25] Similarly, an editorial in the September 1938 *Daily Oklahoman* stated that "the keynote of the exhibitions is Democracy in Art, and every American artist will be given an equal chance to have his work represented in this huge exhibition."[26] Feelings of pride and regional consciousness accompanied the show. Small towns celebrated individuals whose works were chosen. Local newspapers covered the selection process in detail, and museums across the country previewed the accepted works before they were shipped to the fairgrounds in New York.

The most democratic aspect of the Contemporary Arts Building, however, was the emphasis on demonstrations. Like most Federal Art Project endeavors, public participation through experience was key to its educational ideology. In a planning memo dated February 17, 1938, Cahill sketched out the importance of demonstrations for the building's success. Evoking the theories he had laid out in the Federal Art Project's *Community Art Center Manual,* he argued that the Contemporary Arts Building "should indicate not only how art may be used to create a more pleasing environment, but also how members of a community may participate in these various art activities." The demonstration areas, Cahill maintained, "should present patterns of activity for a typical community art center and should bear the same relation to such a center as a three walled living room of the stage bears to a living room in an average American home." Like the activities in community art centers across the nation, the exhibits in the Contemporary Arts Building stressed participation in the arts as a means of establishing strong democratic communities.[27] The artists there literally acted out the benefits of the government programs for a broad audience on the national stage.

The idea of formal demonstrations on demand negated the romantic idea of the artist as inspired genius and promoted instead the idea of an attainable level of artistic talent, or at least appreciation, in each American citizen. Employing their pedagogy of cultural production, Cahill and other Contemporary Arts Building staff argued that all Americans could become a part of the national art form. They could learn "how-to-do-it" at one of the community centers, or they could watch as experts performed for them at specialized demonstrations. This ideology of inclusion and demystifica-

tion was repeatedly promoted by fair sponsors as well as by the press. On June 18, 1939 the *New York Times* reported, "Almost every day some painter, sculptor, or graphic artist explains demo," and a month later the *New York World Telegram* proclaimed, "The average American man has a keener interest in the 'how it's done' of art . . . than in the metaphysical 'why.'" According to the *Telegram*, the principal aim of the demonstrations was "to familiarize visitors with the way the artist works and to acquaint the public with the fascinating possibilities of art as a recreation or hobby."[28] According to the rhetoric of Contemporary Arts Building personnel, art no longer belonged to the upper classes. Stressing the building's ties to the New Deal art programs, Cahill repeatedly emphasized the ways in which the U.S. government attempted to democratize artistic production across the country. A pamphlet distributed by the Federal Art Project at the fair related the demonstrations at the fair to those occurring throughout America, ultimately arguing that "at no time in the history of the country has the opportunity for participation in the creative arts been given to as many people as today in the United States."[29]

In many ways, the exhibits in the Contemporary Arts Building were a last-ditch effort to save the Federal Art Project. Through the work of the latter, Cahill exclaimed, "children and adults are learning by the actual practice of art its significance and meaning in their everyday life. It is upon the fundamentals of appreciation thus acquired that the culture of the country rests."[30] This was a heavy charge, and their exhibits at the fair allowed Federal Art Project personnel to catalog their successes. As the project was in the process of being dismantled, Cahill and Goodyear displayed hundreds of paintings produced by its participants in the Contemporary Arts Building. Their emphasis on folk art and handicraft demonstrations, moreover, helped negate critiques of "subversion" on the project. Contemporary Arts Building staff argued that the works on display were simple examples of a fundamentally "American" artistic ethos. In addition, demonstrations of artistic production by Federal Art Project participants took place almost every day. The participants included children from the Harlem Community Arts Center and settlement houses, churches, Jewish organizations, and schools across New York City, as well as from other areas of the country. These children, the "future citizens of America," acted as evidence of the Federal Art Project's alternative system of aesthetic value where worth was rooted in utility rather than economics or sacred transcendence.[31]

Cahill, Goodyear, and other Contemporary Arts Building personnel

repeatedly asserted what they saw as the national importance of continued funding for the fine arts in America. For example, in the catalog for the *American Art Today* exhibit, Cahill declared, "Great traditions in art do not develop without great publics to support them." Whole nations, he maintained, "as much as the individuals and social groups which compose them, may develop standards of taste in the arts." Cahill believed that stronger relationships among the federal government, the American public, and individual artists would bring about "a renaissance of public interest in the work of the American artist" and would recover art "in the context in the life of contemporary society." This, he wrote, "will mean the recovery of social assurance for the artist and for the public it will mean the possibility of participating, on a broad and democratic scale, in the experience of creative expression."[32] Through Federal Arts Project exhibits at the fair, he hoped to prove that it was not too late to reinstate federal funding for the arts and bring on an American renaissance grounded in individual aesthetic experience in the world of tomorrow.

Elsewhere at the fair, the idea of an American cultural renaissance was tied to more consumer-friendly models of art. In an early planning document, fair planner Michael Hare argued that it should be a "Consumer's Fair." "Mere mechanical progress," he asserted, "is no longer an adequate or practical theme for a World's Fair." Instead Hare wanted to "demonstrate an American Way of Living" by telling "the story of the relationship between objects and their everyday use—how they may be used and when used purposefully how they may help us."[33] Echoing the rhetoric of MoMA's design shows, the fair's Board of Design embraced the former's pedagogy of cultural consumption as a means of linking art and life to create democratic communities. One of the primary ways that the fair encouraged the notion of democracy through consumption was by the marketing of both the products on display in the various pavilions and those at the fair itself as aestheticized commodities. For example, murals by local and national artists painted on buildings throughout the fairgrounds were one of the official forms of artistic display. In a publicity bulletin on official letterhead, Martha Connor, fashion consultant in the Department of Merchandising and Promotion at the fair, announced, "Mural Shades of the New York World's Fair 1939: To Be Promoted First for Cruise and Southern Wear and Then for Spring and Summer 1939." Accompanying the letter, which was sent to fashion magazines and department stores across the country, was a color card with swatches named for the various artists who used them in their works, such as Ciampaglia red and Feininger turquoise.

Fig. 36. Mural Shades color card. The colors on the card match the dominant color of each specified artist's mural at the fair. The text reads, "This card presents the second group of colors released for Fashion Merchandising and Promotion by the New York World's Fair 1939." (Collection of the author.)

The fair's mural shades were thus used as both a marketing device and a color mnemonic. Connor continued, "The dramatic and vivid mural paintings which decorate the New York World's Fair buildings offer a varied source of inspiration to designers and stylists. They add still another proof of the brilliance of the Fair and its influence in the use of color." She also urged designers to "report promptly to the Fashion Department at the Fair the types and items of merchandise which you plan to feature in these mural shades so that we can help you publicize them."[34] Through techniques such as the mural shades, the fair became both a marketing agent

and a form to be marketed. By compressing a work of art (a specific mural, the entire fair) to a dot of color, the Fair was physically circulated in department store windows across the country and on cruise ships, extending the influence of the fair beyond its physical and temporal reality and elevating consumer taste by association. Everyone could buy a piece of the fair (and wear it later).

The fair was also marketed through thousands of official and unofficial souvenirs (from yo-yos to walking canes to table wear), as well as through goods linked to the fair in corporate displays.[35] In a 1937 memo sent out to drum up corporate sponsors, Grover Whalen stressed the "great opportunity" it would offer American business and industry. The fair, he declared, would give businessmen the "opportunity to construct their own world of tomorrow, to build for the future along lines patterned and planned." Moreover, he announced, it "will provide the specifications; the world will come and take note." By revamping old products through streamlining their facades, the fair's industrial designers perpetuated the idea that these products were new and improved objects of art. Again, Whalen made this point clear by stressing, "We of the Fair Corporation believe . . . that what is needed at present are not so much new inventions and new products as new and improved ways of utilizing existing inventions and existing products."[36] For many, the fair became a giant advertising campaign for American businesses that needed to be jump-started as a result of the decade-long Depression.

Despite the role they played in stimulating sales and advertising goods, Whalen and other fair planners referred to the fair's industrial designers not as businessmen but as "the artists of the future." Repeatedly mentioned in press releases in terms such as "Leonardo reborn" or "artists" with "probing minds" and "great foresight," they were depicted as magicians who transformed banal products into inspired works of art. Their skills as artists were directly informed by advertising aesthetics.[37] Before becoming an industrial designer, Bel Geddes was a poster artist and theater designer; Loewy was a graphic designer for *Vogue* and *Harper's* magazines and set up window displays for Macy's and Saks' department stores; and Teague worked as a theatrical designer and advertising artist. All three were masters in transforming spaces and selling products, as well as in creating images of progress through art. In a letter to the fair's planning board, Gilbert Rhode, the industrial designer in charge of the *Community Interests* exhibit, wrote, "It is no accident that so many of the leading industrial designers have had an advertising background. I consider it relevant that I came to

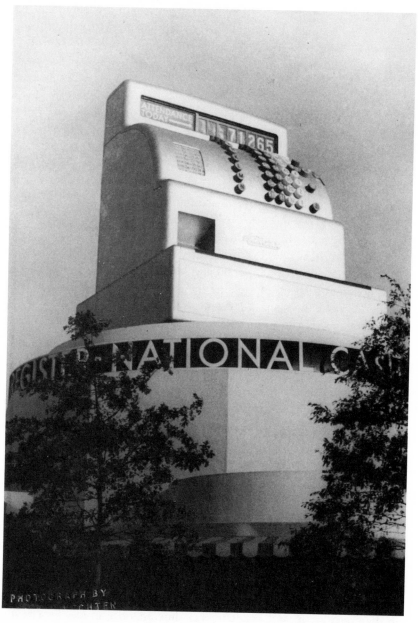

Fig. 37. Carl Van Vechten, photograph of the National Cash Register Building, August 11, 1939. The oversized cash register atop the building tallied daily attendance at the fair while advertising the National Cash Register Company through spectacular sculpted forms. (Museum of the City of New York, box 9, folder 10.)

the field of design from previous work in advertising illustration." For Rhode, "The design of a product, of an advertisement, or an exhibit [were] all problems of mass appeal." The "objective of the appeal," he argued, "is sales." Likewise, the designer Egnold Arens described himself as a "consultant in the visual aspect of selling" and a "consumer engineer."[38] Consumer engineers like Arens played a vital role in visually creating the fair's message. Its official emphasis was not just on the "World of Tomorrow," it was also on building the world. The mission statement claimed that the fair would provide a better "understanding of . . . the tools of Today . . . with which the better World of Tomorrow is to be built." The chorus to the "Official World's Fair Song" repeated after every verse, "We're the rising tide coming from far and wide / marching side by side on our way / for a brave new world / Tomorrow's world / That we shall build today."[39] This future, however, was to be constructed through buying.

The brave new world of the future, as envisioned at the fair, was a consumer's dream. Each corporate pavilion exhibited its newest model or latest design as a means of building the utopian world of tomorrow. Fair planners repeatedly promoted the idea of recognizing progress through goods. For example, in a June 1937 World's Fair Bulletin entitled, *What the World's Fair Means to Business and Industry,* Whalen stated:

In this age of super-contact—of radios, movies, and world wide advertising campaigns, of automobiles, airplanes and universal travel—the farmer of the Dakotas and the housewife in Maine follow the economic and social fashions as closely as the brokers on Wall Street or the matron on Park Avenue. And yet all the formulae of modern salesmanship have not invalidated the old adage that seeing is believing. This is particularly true where effort is not so much to market a new product as to sell a new method or procedure or a way of life involving the use of many new products.[40]

Seeing what these products were and how they worked, through demonstrations and displays, was the primary exhibition mode at the fair. Like Whalen, Bel Geddes asserted that "one of the best ways to make a solution understandable to everyone is to make it visual."[41] Visualizing the products brought them to life. In many ways, the fair was one enormous display composed of hundreds of competing exhibitions. Each exhibitor needed to draw viewers in and maintain their interest once inside. Experiential visualizations such as the fifteen-foot-high Underwood typewriter outside of the Underwood exhibit and the three-dimensional mural made entirely out of car parts in the Ford Pavilion were devices engineered to capture the

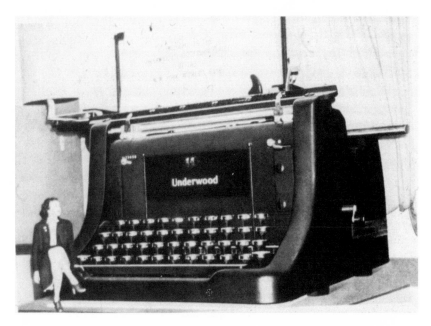

Fig. 38. Underwood display, New York World's Fair, 1939–40. Exhibits such as "the world's largest typewriter" in the Underwood display were intended to entertain visitors and sell products. (Museum of the City of New York. Print Archives, Events, New York World's Fair, Buildings 2/3 folder.)

public's attention; they visually lured them to the displays and implanted the product and its maker directly into the consumer's mind. Showcasing industrial products as "art," very accessible art available under the hood of your car or at chain stores across the country, was a means of establishing a democratic aesthetic. Everyone had access to these goods. But, unlike the consumption-based notions of a democratic aesthetic advocated by the Museum of Modern Art's early industrial design shows, the fair's democratic aesthetic experience was rooted in spectacle rather than in utility.[42]

Although fair designers were using much of the same rhetoric as MoMA in promoting consumption as a tool for desacralization, MoMA staff did not embrace the fair as the ultimate merger of use and beauty or art and life. On the contrary, the fair's indiscriminate streamlining was the very thing most MoMA industrial design staff deplored. Indeed, the 1939 New York World's Fair was one of MoMA's primary targets in its critique of the "modernistic." MoMA staff members used the Fair as a giant educa-

tional opportunity; they hoped to correct public misunderstandings about what constituted true modern design by focusing on the exhibits at the fair. John McAndrew (who succeeded Philip Johnson as the director of the architecture and industrial design department at MoMA in 1937) explicitly outlined the differences between the "modern" and the "modernistic" (or "pseudomodern") in numerous MoMA publications for visitors to the up-coming New York world's fair. The museum also held special exhibits for fair visitors. For McAndrew, the modernistic was intimately linked to the unnecessary streamlining that he felt was beginning to run rampant in the design world. Streamlining, which he defined as the process of "smoothing down . . . the form of an object, leveling the bumps and hollows until a shape is achieved which suggests a bullet, tear drop or one of the simpler fishes," was developed as "an aerodynamic strategy for use in the design of modern trains, planes, boats, and race cars to promote increased speed." Like the modernistic, however, McAndrew felt that streamlining was being "carelessly used by nearly everyone" (except, of course, members of the Museum of Modern Art), and by the late 1930s, he maintained, industrial designers had begun "restyling almost everything" in a streamlined way, often with no regard to purpose. For example, he wrote in a 1938 MoMA Bulletin that "streamlined paper cups if dropped would fall with less wind-resistance," but "they are no better than the old ones for the purpose for which they are actually intended, namely, drinking."[43]

For McAndrew and other MoMA staff members, streamlining had become a fad, rooted in changing design fashions rather than part of a grand historical narrative harking back to the aesthetics of Plato. By em-barking on a cultural outreach program to coincide with the fair, McAn-drew attempted to alert the American public to what he saw as the growing misuses of modernistic decoration and to re-stress the importance of link-ing form with function in machine-made goods. This was a difficult task to carry on outside of MoMA's walls. By 1939 industrial designers were recog-nized as experts in themselves, and the team of designers employed by the Fair—Teague, Bel Geddes, Dreyfuss, and Loewy—were recognized around the world. Furthermore, in addition to employing the same rhetoric of form and function used by MoMA staff, most American industrial design-ers in the 1930s felt that they too were making aesthetically pleasing goods available to a wide public. In a speech entitled "Industrial Design and Its Future," Teague asserted that "everything made by the hand of man is art and has within itself a potentiality of beauty." Furthermore, he continued that "out of this crucial spirit will come a new world redesigned for human

living. By eliminating waste, confusion and blunders we shall eliminate ugliness. By creating economy and efficiency, we shall substitute beauty."[44] Through streamlining, the fair's industrial designers believed that they were substituting beauty for ugliness and merging art and life, thereby fashioning a truly democratic art form by creating art for everyone regardless of class and geography. The act of streamlining a product transformed it into an artwork for living, and since all Americans had access to streamlined goods in the marketplace, they argued, then all Americans had access to what they saw as the increased benefits of a streamlined life.

Many scholars have argued that in the United States, notions of democracy and capitalism are intimately linked, and that the construction of American nationalism depends upon shared consumption rather than linguistic, ethnic, religious, or historical ties.[45] While this is debatable, one thing is certain: At the 1939 New York World's Fair, possessions were advertised as both tokens of community and works of art. Individual businessmen, cultural critics, and even the president of the United States argued that the "new and improved" aestheticized consumer goods at the fair were the glue that would mend the fractured American economy and present a compelling vision of the American way of life in the future. In the utopian world of tomorrow, they claimed, undamaged democratic social spaces would thrive through the increased consumption of streamlined products. In his remarks on opening day, for example, President Franklin Roosevelt announced, "The World's Fair in New York is a challenge to all Americans who believe in the destiny of this nation. . . . Here millions of citizens may visualize the national life that is to come. . . . All power to the sponsors."[46] For Roosevelt, as for Whalen, the ability to visualize the "national life" though consumer goods was key.

The fair's nationalistic message operated on two different visual levels. One was forward-looking, touting American economic supremacy in the world of tomorrow, while the other was nostalgic, rooted in celebrating the greatness of the American past as embodied in the country's first president. Although the fair was themed the "World of Tomorrow," it also celebrated the one hundred fiftieth anniversary of George Washington's inauguration, thereby combining hopes for the future with an idealized vision of the past. The most obvious representation of American nationalism both past and future were the three enormous forms in the center of the fairground: James Earle Fraser's mammoth marble statue of George Washington and the futuristic architectural structures in the fair's Themecenter, *Trylon* and *Perisphere.* Fraser's Washington personified the myths of America's found-

Fig. 39. James Earle Fraser, *George Washington*. In addition to forecasting the magnificent "World of Tomorrow," the fair also celebrated the one hundred fiftieth anniversary of George Washington's inauguration. This giant statue of Washington looked toward *Trylon* and *Perisphere*, thereby marking the passage of time in sculptural forms. (New York Public Library, 1939 New York World's Fair, Photograph Collection.)

ing. The towering statue of the Father of the Country served as an allegory for liberty and democracy and reminded the American people of the victorious struggles for freedom in the past. Such allusions to the ideological basis of the American Revolution and the country's founding were timely, as the nation's involvement in another war loomed in the immediate world of tomorrow.

Fair planners presented their vision of the future, premised on expanded communities, efficient lifestyles, functional architecture, and centralized planning, through the stylized architecture of its dominant icons: *Trylon*, the 700-foot obelisk, and *Perisphere*, a 200-foot globe that housed *Democracity*, an imaginary metropolis of the future. Although *Trylon* and *Perisphere* epitomized American modernity, Fair planners, like MoMA design curators, attempted to place the buildings within a grand aesthetic narrative. For example, Whalen claimed that they combined "the Greek

idea of beauty of form and harmony with the Gothic conception of reaching ever upwards for a better world," and Teague, writing in *Design This Day*, quoted Socrates' argument that absolute beauty is often discovered in "straight lines and circles, and the plane or solid figures which are formed out of them by turning-lathes and rulers and measures of angles" to describe his work at the fair.[47] By making such direct connections between past and future, the fair's planners created a historical continuum in sculpted forms. An official fair press release from December 1937 made this connection explicit by stating that the statue of Washington would be placed so that it appeared as though the first president was staring directly at *Trylon* and *Perisphere*, "his back on years of progress, his eyes on the future. The philosophical suggestion is that with 150 years of successful democratic government, founded by Washington and the men of his generation, behind the nation of today, America can face the World of Tomorrow, represented by the huge, modernistic and unorthodox structures of the Perisphere and Trylon, with the same cool assurance that the first president exhibits in his massive sculpture."[48]

Fair planners and exhibitors repeatedly juxtaposed past and future through sculpture. An enormous sundial representing time and the fates of man by Paul Manship (best known for his statue of Prometheus at Rockefeller Center) stood next to *Trylon* and *Perisphere* in the Themecenter. The invocation of this tool of antiquity amid those of tomorrow established a striking contrast. The use of statuary to suggest the passage of time was a device employed throughout the fairgrounds. Outside of the American Telephone and Telegraph (AT&T) Pavilion stood a lyrical statue of the Pony Express, while inside, AT&T presented the newest and most advanced forms of communication, offered free calls to anywhere in the United States, and displayed streamlined telephones and switchboards, which they marketed as works of art. Similarly, the Ford Motor Company Building included a series of Ford firsts in its galleries: The first engine made by Henry Ford in 1893 from scrap pieces valued at under a dollar was displayed alongside the first Model Car and the first Model A. These "firsts" led up to the Ford cars available for purchase presently as well as a model of Ford's utopian vision of the *Road of Tomorrow*. While not exactly statuary, these model cars were exhibited as works of art that simultaneously marked the passage of automotive progress and placed the Ford company squarely within the history of transportation. This historical link was made clear by the impression of the god Mercury, "a symbol of the swift, effortless magic

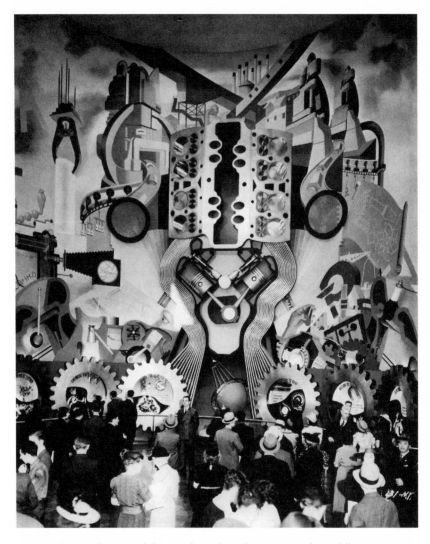

Fig. 40. Henry Billings, Mobile Mural, Ford Pavilion, New York World's Fair, 1939–40. The mural was made entirely of Ford motorcar parts and was a popular attraction at the fair during both the 1939 and 1940 seasons. (Collection of the Henry Ford Museum and Greenfield Village, Ford Archives, P. O. 5725.)

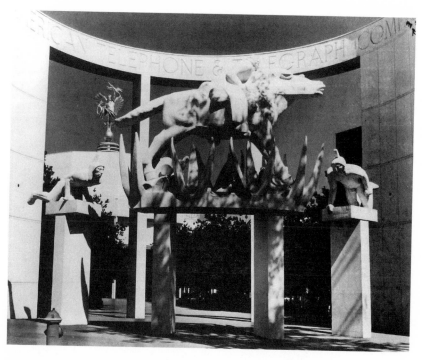

Fig. 41. AT&T Pony Express. Through the use of sculpture, corporations such as AT&T merged myth and technology and past and present. (Museum of the City of New York, Print Archives, Events, New York World's Fair, Buildings 2/3 folder.)

of modern transportation," over the door to the pavilion in which the contemporary models were on display.[49]

The use of allegorical and mythic figures such as Mercury and the Pony Express was a popular way of pictorially moving between images of past and present at the fair. Statues of the mythic Johnny Appleseed and Paul Bunyan adorned the facade of the Public Health and Medicine Building, while the internal displays asserted the power of the intellect over magic and scientifically derived medicine over fictionally derived strength.[50] Such uses of statuary provided an ersatz history for individual exhibitors while linking their products to the fair as a whole. Strategies such as Ford's evocation of a Roman god and AT&T's reference to an early American mode of communication visually transported these corporations into the past; it gave them a prehistory that made imagining their role in the world of tomorrow easier. Moreover, the use of statuary and murals to effect this

virtual time-travel made their attempts to transform their current products into artworks easier by giving them artistic points of reference in the past, whether real or mythical.

Fair planners and exhibitors also used color, like statuary, as a means of marking time and space. The Themecenter (*Trylon* and *Perisphere* and their surrounding areas) was painted white. Constitution Mall, which led directly from the Themecenter, was composed of varying shades of red, from rose to burgundy, growing deeper the farther from the center. The Avenue of the Patriots, which led north from the Themecenter, was done in yellows, ending in deep gold; and the Avenue of the Pioneers, which headed east from the center, was marked by various shades of blue—from eggshell to deep aquamarine. The arched road connecting the three avenues was appropriately named Rainbow Avenue and was composed of many different colors. Fair planners insisted on the cooperation of all participants in maintaining the color scheme. Letters such as one from J. L. Hautman on the Board of Design to El-Hanani, architect of the Palestine Pavilion, included color chips from which to choose "to harmonize with the general scheme of the Fair" with "particular reference to the sector in which the building is located." The intention of the Board of Design, the letter concluded, "is to assist the architects toward variety and freedom in color schemes within the limits imposed by the color character of each sector."[51]

Allowing for individuality within the efficiently ordered fair plan was a necessity in successfully defining the fair as an "art form." Officials recognized the need for a degree of autonomy in their planned and integrated artistic world. Fairs were about selling one's wares, and a major part of this process lay in differentiating oneself from the competition. It is doubtful that many large corporations, national governments, or private institutions would sacrifice their individuality for a common plan; therefore, fair planners had to make some allowances for individual designs within their aestheticized universe. Everything had to be approved by the Fair Board of Design, and arguments often broke out over what was acceptable and what was not. In the end, the Fair emerged as a unified whole in which, a contemporaneous publication announced, "the traditional Fair pattern of a number of separate and unrelated buildings has been abandoned," and the fair's theme ("Progress which has been made in building 'the World of Tomorrow'") "has been admirably translated into physical being."[52] Such aesthetics were more than superficial ordering mechanisms; they contained the dominant ideology behind the fair, which was to be a uniquely Ameri-

can work of art in itself, as were all the goods on display there and in the future, as imagined by fair planners and corporate participants.

The various ways that art and democracy were invoked and brought together at the fair created tension and led to a number of contests and controversies, as is evident in the foregoing discussion. The democratic community envisioned in the Contemporary Arts Building was not the same democratic community conceived of by the fair's industrial design team in *Trylon* and *Perisphere*. Nor was it the same as the democratic access promoted by the Masterpieces Building's "Modern Day Madonna Contest." This tension, however, was what allowed the myriad visions of art and democracy to coexist, which in many ways allowed a form of democratic modernism to take shape at the fair.

If one ascribes to the Deweyan ideal of democracy as grounded in face-to-face exchange, then the fair provided that forum.[53] Aesthetic value was determined and displayed in a variety of often competing ways. In the Masterpieces Building, value stemmed from more traditional notions of cultural capital grounded in artistic genius and timelessness. Instead of desacralizing art, the Masterpieces exhibits attempted to provide more democratic access to traditional, sacred forms of art. The exhibits in the Contemporary Arts Building, in contrast, further transformed cultural capital through desacralization by positing a definition of art located in everyday experience and by rooting value in wide participation and increased utility. Finally, the definitions of art and aesthetic value fashioned by the fair's industrial design team attempted to both desacralize art and democratize the sacred by completely erasing the boundaries between art and life, again along so-called democratic lines. Viewed in this way, the debates over the role and form of art at the fair demonstrate the many ways that cultural capital was being transformed throughout the decade and present models of both democracy and art as fluid, participatory, and experiential.

Yet the 1939 New York World's Fair also signals the beginning of the decline of a participatory model of democratic modernism in the United States and a resacralization of cultural capital. While the coexistence of the various models of art and democracy at the fair suggests the possibility of achieving some form of democracy in art, the fair itself was not a democratic art form. It was primarily a trade fair, selling an already nostalgic vision of a world that would never arrive. In many ways, the question of the place of consumer goods in America's future was at the heart of the fair. Would Americans living in the "World of Tomorrow" continue to live under Depression conditions, or would they have access to the goods and

services they saw in Flushing Meadow? What would the relationship be-
tween American democracy and consumption look like in the near future?
In an article in the *New Republic,* Bruce Bliven, an early supporter of the
fair, described the fair's vision of American democracy as "a tug-o-war
between commercial interests and social theorists for control." Visitors to
the fair, he exclaimed, "would not see the democracy of tomorrow, but a
salesman's dream of democracy today."[54] Ultimately, the Fair presented a
vision of democracy intimately tied to consumer capitalism and a version
of aesthetic experience linked to looking rather than doing; its dominant
pedagogical mode for educating the public was based on passive rather than
active viewing. In the end, it provided neither a model for increased cultural
desacralization nor one for the democratization of the sacred; rather, it
marked the transformation of cultural capital into a form of spectacle.

The Triumph of American Art?

In the fall of 1939, Clement Greenberg's seminal essay "Avant-Garde and Kitsch" appeared in the socialist journal *Partisan Review*. Apocalyptic in tone, Greenberg's essay foretold the gradual extinction of the avant-garde in Western culture and the emerging triumph of the "rearguard" or kitsch. "A product of the industrial revolution," kitsch included "popular, commercial art and literature with their chromotypes, magazine covers, illustrations, ads, slick and pulp fiction, comics, Tin Pan Alley music, tap dancing, Hollywood movies, etc., etc." "Kitsch," he concluded, "is the epitome of all that is spurious in the life of our times. Kitsch pretends to demand nothing of its customers except their money—not even their time."[1] Aside from the obvious cultural implications of the expanding markets for kitsch, Greenberg tied its growth to fascist victories in Europe during the 1930s. "The encouragement of kitsch," he asserted, "is merely another of the inexpensive ways in which totalitarian regimes seek to ingratiate themselves with their subjects." By bringing culture "down to their level," Greenberg believed that kitsch anesthetized the masses.

According to Greenberg, it was the function of the avant-garde to counter kitsch. He believed that modern abstract art was a revolutionary force. "Since the avant-garde forms the only living culture we now have," he wrote, "the survival in the near future of culture in general is thus threatened." Greenberg ended his essay, not by forecasting a utopian, kitsch-free future, but with an urgent plea for socialism. "Capitalism in decline," he wrote, "finds that whatever of quality it is still capable of producing becomes almost invariably a threat to its own existence." Socialism, he argued, provided a way out of this destructive cycle. Thus, he concluded, "Today we no longer look toward socialism for a new culture—as inevitably one will appear, once we do have socialism. Today we look to socialism simply for the preservation of whatever living culture we have right now."[2]

The pessimistic tone of Greenberg's essay reflects the dejection felt by many American radicals at the end of the 1930s. The 1938 Munich Pact, the

collapse of the Spanish Republic, and the Hitler-Stalin pact in 1939 had led to a loss of confidence in the promises of socialism, which had galvanized the American left throughout the decade. Although Greenberg's first published essay looks toward his later writings that celebrate the quest for authenticity as a stylistic experience and his subsequent calls for "art for art's sake" (or the creation of pure, self-referential art forms with no relationship to social life), "Avant-Garde and Kitsch" was written with a distinct social purpose: to delineate the parameters of an American avant-garde within a grand art historical narrative and ultimately to save Western culture from the manacles of totalitarianism.

While Greenberg and his fellow travelers among the left-wing intelligentsia decried the narcotic effects of mass-produced consumer kitsch in undermining democratic society and promoting fascism, another group composed of businessmen, politicians, and community leaders offered the production and consumption of consumer goods at the 1939 New York World's Fair as an antidote to the anxieties produced by the Depression and the spread of totalitarianism in Europe and Asia. According to its planners, the increased consumption of mass-produced consumer products on display at the fair would save both industrial capitalism and American democracy. There, anything and everything could be a form of art. Not only did exhibitors consider toaster ovens and automobiles art forms, they included the kitchens and roads where these items were located in their artistic categories as well. Indeed, these items were not just art; from *Futurama* to the *Kitchen of Tomorrow,* fair participants claimed that these everyday spaces merged art and life and, in so doing, embodied the spirit of American democracy by making well-crafted, well-designed products available to everyone, not only connoisseurs. As discussed in Chapter 4, the varied visions of artistic democracy on display at the fair facilitated the possibility of a democratic American modernism. At the fair, the American public participated in both creating and consuming the goods on display, in effect aestheticizing American capitalism as participatory democracy.[3] The myriad uses of art at the fair were important for two other reasons. While planners and exhibitors claimed that visitors to the fair helped to create art (they argued that the American public became "artists" themselves by first acknowledging and then buying their aestheticized utilitarian goods), the fair also laid the foundation for the participatory spectatorship of art, which would become increasingly important in the postwar years as Greenbergian definitions of modernism and aesthetic value gained precedence. In addition, by including the quotidian in definitions of high art, fair planners also

laid the groundwork for aestheticizing the basic components of the subur-
ban landscape—the kitchen and the highway.

Greenberg and the fair planners' conflicting positions regarding the
relationship between mass-produced industrial goods and definitions of art
recapitulated some of the central debates of the 1930s over desacralization
as well as over the meaning and form of American cultural capital. Both
Greenberg and the fair's industrial designers observed a world in which
consumer goods and an "American way of life" were increasingly and more
intimately linked, and both ultimately relied on experts to validate their
conceptions of aesthetic value and to dictate aesthetic experience. Yet there
were crucial differences in their conceptions of what constituted an artwork
and what determined aesthetic value, and these differences often led to
heated debates. The industrial designers associated with the 1939 world's
fair conceived of mass-produced industrial goods as art. Greenberg, how-
ever, dismissed the idea that industrial goods functioned as legitimate aes-
thetic objects and warned of the inevitable triumph of fascism resulting
from the blind consumption of mass-produced goods.

Just as these debates reached their crescendo, however, they in effect
ceased as the United States mobilized for war. From the Museum of Mod-
ern Art in midtown Manhattan to the fairgrounds in Flushing Meadow to
community art centers across the country, the war profoundly influenced
the terms of desacralization and affected the transformation of art as a
form of cultural capital. Indeed, World War II marked the beginning of a
significant shift in attitudes toward participatory democracy, American art,
and the relationship between the two. Concepts actively debated through-
out the Depression took on more fixed yet abstract meanings in the name
of patriotism during the war years. Artists and institutions at odds through-
out the preceding decade presented a more unified front in the name of
"American democracy." As news of the Stalinist purges and the Hitler-
Stalin pact divided the American left, for example, Stuart Davis's politics
became markedly less radical. In 1940 he resigned as president of the Ameri-
can Artists' Congress and, instead of critiquing government policy, became
a major supporter. The war shook his faith in the political power of art,
and throughout the 1940s, Davis increasingly believed that direct govern-
ment action, not artistic involvement, was necessary to stop the spread of
fascism.[4] In August 1941, he reversed his earlier claims that "those who
would abandon art in a time of war also abandon the principle of democ-
racy" and announced that "fascism on the political and economic level can
only be stopped by political and military action, genuine art is ineffective."[5]

Influenced by his fear of the totalitarian nature of Communism and the practical results of New Deal democracy, his idealism of the early 1930s gave way to a more pragmatic politics as the decade closed. While he still felt that artists could be politicized, Davis began to question the ability of art to effect social change.

Many other members of the left-wing art world who had once aligned themselves with the initiatives of the cultural front also began to challenge what they increasingly saw as the narrow-mindedness of agitational propaganda and social realism and to tie their art to a more general "Americanism" as well. They reevaluated both their political and their aesthetic positions and, like Davis, actively began to support federal art projects. Yet the government art projects that these once radical artists were now ready to back were under significant revision. Between November 25 and December 1, 1940, for example, the Works Progress Administration sponsored "Buy American Art Week" as a way of shifting artistic patronage from the federal government to the American people. Embraced by popular magazines such as *Life* and *Fortune*, and organized by the staffs of the Metropolitan Museum of Art and the Museum of Modern Art in New York City, the idea behind Buy American Art Week was to promote the purchase of inexpensive original artworks by the American public. Publicity documents surrounding the program asserted that "our country today is turning towards the arts as at no other time in the history of the Republic. A great tide of popular interest in American art has been rising during the past few years."[6] But unlike the rhetoric that marked Federal Art Project publications, which claimed much the same thing, the emphasis of Buy American Art Week was on the product rather than on the process of artistic creation. It targeted the American people as an art-buying rather than art-making public and transformed cultural capital back to more traditional, sacred forms by focusing on issues of aura and authenticity. Art became a form of personal as well as national investment.

In contrast to the "paint, don't debate" ethos of the Federal Art Project, where all art regardless of its aesthetic qualities had social worth, the successes and failures of Buy American Art Week were measured exclusively in economic terms. An official report documenting the week's activities began, "Public response to the first national art week, sponsored by the President and Mrs. Roosevelt, rang up more than $100,000 in cash sales of more than 15,000 works of arts and crafts." The following June, Florence Kerr, a former WPA administrator now in charge of the Buy American Art Week program, wrote that the success of the first Buy American Art Week

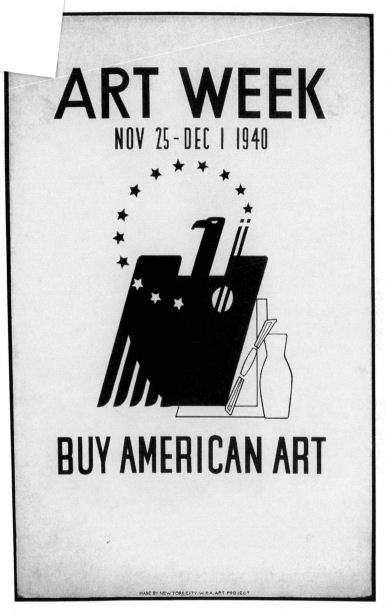

Fig. 42. *Art Week: Buy American Art,* November 25–December 1, 1940. Silkscreen poster. The red, white, and blue eagle in this publicity poster for the government-sponsored "Buy American Art Week" highlighted the idea that it was patriotic to purchase American art. (Works Progress Administration Poster Collection, Library of Congress, POS-WPA-NY.01. A68, no. 1.)

Fig. 43. Purchasing a painting. David Findley (*center*), director of the National Gallery of Art, in Washington, D.C., is shown purchasing Charles Barrow's silkscreen print *Trees in Bloom* to promote Buy American Art Week, November 17, 1941. Holger Cahill looks on as the volunteer saleswoman writes out a slip for the sale. (NARA, RG 69-3-24588.)

"gives promise of a 'home market' drawing upon local sources and catering to local needs, carrying with it the direct exchange between artist and public."[7] This exchange was primarily financial.

In many ways, Buy American Art Week was an epitaph for the aborted agenda of the Federal Art Project. Instead of focusing on the potential for all American citizens to be cultural workers, it highlighted the possibility for all American citizens to become artistic connoisseurs and consumers of art. Through activities such as Buy American Art Week, the government attempted to create a private mass market for artistic consumption in the United States. Moreover, Buy American Art Week appealed to American patriotism in "these times of world emergency." Indeed, Clifton Fadiman, in a November 24, 1940, radio broadcast entitled "Art and Our Warring World," which also included panelists Eleanor Roosevelt, Louis Wirth, and Archibald MacLeish, asserted, "I think the enjoyment and appreciation of art is one means of insuring the kind of psychological unity we are after, and that is why it is important in national defense."[8] In the early 1940s, with the country's entry into World War II, the government's desire for cultural superiority shifted from a quest for democracy in art to art in defense of democracy, as many former Federal Art Project community art centers became art centers for the national defense.[9]

In June 1940, Holger Cahill suggested that the Federal Art Project play a role in the American defense effort. About the same time, Colonel Francis Harrington, Roosevelt's new WPA administrator, an army engineer chosen in an attempt to pacify conservative critics, exclaimed to a group of national and state WPA administrators that the WPA would act as a "second line of defense." Soon afterward, Federal Art Project employees began painting murals in service clubs, decorating training bases, and creating propaganda posters, signaling a new shift in the uses of art. Six months later, in January 1941, the chief of the Army Corps of Engineers formally endorsed Cahill's plan for a nationally funded defense art project, and by the summer months all of the community art centers that had not closed had become centers for the national defense. These revamped art centers held special classes for enlisted men. Among them were courses on camouflage and contour mapmaking, as well as a number of model-making classes. Aviation motors, tank engines, trenches, traps, and mines were some the models wartime art center participants created. Once again, the federal government participated in creating alternative definitions of art and aesthetic experience, but instead of promoting cultural production and creative freedom as a means of fostering individual creative experiences, it now stressed the national

value of cooperative work for the defense movement. Artists still on the project spent most of their time silk-screening war-related posters and lithographs or holding craft classes in which participants made recreational equipment, decorations, and furniture for military installations. Following the bombing of Pearl Harbor, all remaining Federal Art Project workers became employees of the WPA War Services Subdivision, and community art centers not related to military bases were closed. Early in 1942, the WPA Art Program became the Graphic Section of the War Services Program, and in December of that year, Roosevelt announced that all art projects would be phased out by mid-1943. The WPA, he announced, had "earned its honorable discharge."[10]

Many artists who earlier had been critical of Roosevelt's cultural policies willingly joined in the war effort. In October 1941, a group calling themselves the United American Artists Committee declared that "of all his predecessors in the White House, President Roosevelt stands the closest to the artist," and therefore, American artists should back his cultural policies "in defense of the art project and in the defense of the American artist."[11] The next month, another collection of American artists known as the Coordinating Committee of Artists Groups announced that "artists must play their part in the national emergency" and use their "talents for the national defense." The following year, the Artists' Society for National Defense merged with the National Art Council for Defense to form the Artists' Council for Victory, which held two "Art in Defense" shows at the National Gallery of Art, in Washington, D.C. According to the United American Artists Committee *Bulletin*, the exhibitions demonstrated that American artists were "alive with patriotism which stirs their souls to produce their best work." Like social realists a decade before, members of the United American Artists Committee maintained that artists could produce "weapons as necessary as arms."[12]

The government, as well as a wide assortment of American artists from the left and from the right, now embraced the former rallying cry of the Communist Party USA, "art as a weapon." Yet as the need for workers in the defense industry grew, more and more art project personnel left the government art programs for jobs in the defense industry; making actual weapons rather than artistic weapons was a more pressing need, and the money was better in the war industries. As the American economy benefited from war mobilization, it was no longer necessary to valorize either work or consumption in the same ways as during the Depression years. It was, however, necessary to valorize war. Whereas the process of aestheticiz-

Fig. 44. *Airways to Peace* exhibition, July 2–October 31, 1943. Installation photo. Dramatic aerial photography was one of the ways in which MoMA captured the imagination of the museum visitor in its wartime shows. Elaborate maps and models were other display strategies employed in this show. (Digital Image © Museum of Modern Art/Licensed by SCALA/Art Resource, New York, N.Y.)

ing both production and consumption during the Depression stemmed from participating in wide-ranging debates over the meaning of American democracy, the artistic conceptualization of war took the form of a global battle between essentialized forces of good and evil: democracy versus totalitarianism.

The Museum of Modern Art played a major role in proselytizing for the national defense and aestheticizing war. All men in uniform were admitted to the museum's galleries and film showings free of charge, for example. In addition, the museum staged a number of war-related exhibitions, including a competition for propaganda posters for the U.S. Treasury and the Army Air Corps. (It exhibited the entries in September 1941.) In

many ways, such wartime contests were closer to the early Federal Art Project programs than to earlier MoMA exhibitions, which aimed to "democratize design" and make modernism comprehensible to the American public. The stress on the idea of the artist as worker, as well as the validation of community participation in the creation of art and national cultural life, recalled early Federal Art Project pedagogy rather than the consumption-oriented participation of the museum's early design shows. (Visitors to the poster competition cast their votes for best one, and the winners received a fifty-dollar war bond as a prize.) And unlike earlier MoMA exhibitions, which highlighted the choices of the museum's expert staff, the wartime poster contest rewarded the people's choice while making explicit the ties between art and American patriotism. In the preface to the Bulletin covering the show, MoMA president John Hay Whitney maintained that "the activities of the creative artist are an important social function and that in time of national emergency the artist can perform a service as valuable in its way as that of any other worker in defense."[13]

In October 1941, the museum held another exhibition entitled *Camouflage for the Civilian Defense*. The following year, it displayed a series of war maneuver models created by Norman Bel Geddes for *Life* magazine; and in July 1943, it organized an exhibit around the theme *Airways to Peace*. Billed as "an exhibition of geography for the future," the museum's galleries were filled with model airplanes and topographical maps, as well as propaganda posters and wartime goods. Through war-related shows such as these, MoMA staff made the war tangible to the American public. In addition, they called upon the public as citizens and as consumers to trust their aesthetic categories and to do their part in the war effort. In the introduction to the catalog accompanying the *Airways to Peace* show, Wendell Willkie explained that "there are no distant places any longer: the world is small and the world is one. The American people must grasp these new realities if they are to play their essential part in winning the war and building a world of peace and freedom."[14]

While shows such as *Airways to Peace* and *Camouflage for the Civilian Defense* seem radically different from those produced in the museum's earlier experimental laboratory of modern art and architecture, staff members did not entirely abandon their modernist project during the war years. They did in many cases, however, adjust their formalist criteria to meet wartime needs. For example, the museum's fifth annual exhibition of *Useful Objects Under Ten Dollars* was entitled *Useful Objects in Wartime*. Like earlier shows, the curators stressed the merger of utility and form in low-cost,

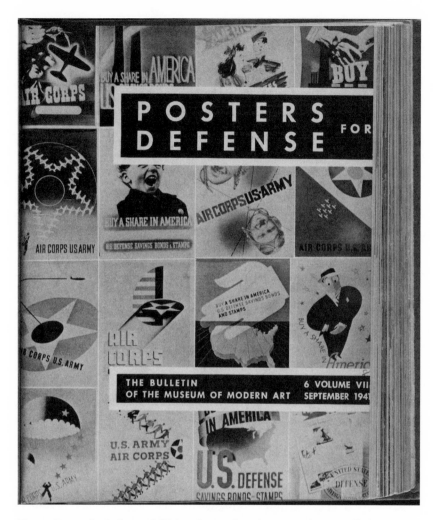

Fig. 45. *Posters for Defense* exhibition, featured on the cover, MoMA Bulletin, September 1941. To accompany the show, MoMA held a competition to pick the best poster in the exhibition. The winner received a war bond. This was one way that the museum mixed aesthetics with patriotism in its wartime shows. (Digital Image © Museum of Modern Art/Licensed by SCALA/Art Resource, New York, N.Y.)

machine-made goods. Unlike the Depression-era *Useful Object* shows, however, consumer choices were determined by wartime rationing. The exhibition was divided into three categories: household objects made of nonpriority materials; articles asked for by men and women in the army and navy; and supplies necessary for adequate civilian defense.

Even during a time of national and international crisis, then, museum staff demonstrated how art and life could merge; consumer sacrifice did not necessitate aesthetic sacrifices. MoMA curators argued that their pedagogy of cultural consumption could adapt to a wartime economy. Urging the American public to give up conveniences in the name of patriotism, the walls of the museum announced: "It is our understanding that the Japanese nightclubs have been closed for five years. That dancing is forbidden in even the Japanese private homes. That one brand of shaving soap is sufficient for this need in Germany. That German women do not wear cosmetics. That large-scale spectator sports have been abandoned in Germany." Thus, the text continued, "If the Axis civilians can part with many peacetime luxuries, for the sake of their soldiers, we think that American civilians can do that job better too." As in the museum's earlier design shows, a degree of competitive Americanism was at play in the wartime exhibits. While German modernists had to directly interfere in the production of industrial goods, early MoMA shows demonstrated how the American market produced them on its own. Likewise, the American civilian, MoMA staff argued, was better at wartime sacrifice. "The informed consumer, retailer, wholesaler and manufacturer," the curators announced, "will patriotically insist that every available one of these critical materials be used where they will serve America's fighting men best."[15]

Through their wartime exhibits, MoMA staff directly cooperated with government employees. For example, Harvey A. Anderson, chief of the Conservation and Substitution Branch of the War Production Board, helped the staff in the department of industrial design choose the objects for the *Useful Objects in Wartime* show. In a letter to the acting director of the industrial design department, Anderson wrote that he did not "believe that an aluminum or stainless steel alloy cocktail shaker is necessary to maintain the morale of the worker on the homefront. . . . These are the convictions you gain when you examine the casualty lists."[16] By relying on a different type of authority here and focusing on military rather than cultural value, MoMA once again transformed cultural capital as well as the meaning and form of a useful art. Following Anderson's admonition, the *Useful Objects in Wartime* brochure announced that "every ounce of chro-

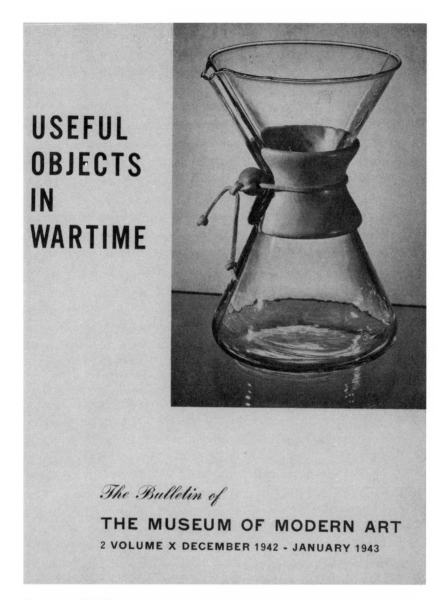

USEFUL
OBJECTS
IN
WARTIME

The Bulletin of

THE MUSEUM OF MODERN ART

2 VOLUME X DECEMBER 1942 - JANUARY 1943

Fig. 46. *Useful Objects in Wartime.* During World War II, the Museum of Modern Art adapted its rhetoric of form and function to accommodate wartime rationing. (Digital Image © Museum of Modern Art/Licensed by SCALA/Art Resource, New York, N.Y.)

mium, copper, nickel, tin, aluminum, etc. used in such items as program flashlights, chrome-plated jiggers, small lucite bowls, lucite salt and peppers," as well as other previously applauded objects under ten dollars, "means in altogether too many cases another American casualty." By forgoing goods made with these materials, MoMA proclaimed that American consumers could help save American lives. They could participate directly in the war effort by fighting bloodless battles as concerned consumers. Through their wartime design shows, museum staff forged a direct bond between the government and the public based on appeals to patriotic obligation in the marketplace. Freedom of consumer choice was enlisted in the fight for democracy and world freedom.

Similarly, the fight for freedom had a profound effect on consumer choices at the New York World's Fair before it closed on October 27, 1940. Although fair planners had excluded news of the war from fair newscasts from the start, fairgoers became increasingly concerned about the war in Europe and the nation's possible participation in it. According to a May 1939 Gallup poll taken at the fair, the majority of Americans felt that the most pressing issue facing the country was avoiding war.[17] Fair planners, believing that these fears were in part behind decreased attendance and dwindling profits, made a number of crucial changes in the fair's overall message and design in its second season. When the it reopened for its final year, the fair was no longer billed as a lesson in interdependence between nations but rather as "a super country fair." Harvey Dow Gibson, president of Manufacturer's Trust, who took over the fair's reins from Grover Whalen in an attempt to raise revenues, endeavored to attract a more diverse national crowd by playing up the "Americanness" of the 1940 fair. Instead of focusing on *Trylon* and *Perisphere* and the world of tomorrow, as they had in 1939, publicity posters made appeals to Americans living in the world of today through images of a fictional middle-American fairgoer named "Elmer," who claimed that the fair "makes you proud of your country."[18]

The newfound emphasis on American nationalism at the fair was accompanied by architectural changes as well. In the 1940 season, there was a marked aesthetic shift from the sleek, futuristic look of the early fair to a more homespun, nostalgic vision of the American past. During the break between the 1939 and 1940 seasons, the Soviet Pavilion was dismantled and sent back to the Soviet Union; in its place fair planners created the "American Common," their vision of a typical American small-town square, composed of a giant band shell, a marketplace, and an auditorium. According

to a 1940 publicity bulletin, each week a different ethnic group took over the American Common in an effort to create a "distinctive 'country fair' with its own old-world bazaars and fiestas" combined with "a brilliant patriotic gathering," which represented "America in its richest mingled traditions." In direct contrast to the "tyranny and oppression" taking place in the Soviet Union, fair planners claimed that "here will be the most direct and powerful answer to dictators who would mold all peoples into the same rigid pattern." In "almost the identical spot where the red star of the Soviets stood last year," the press release continued, "will be a 'Liberty Pole' carrying the highest flag in the Fair's whole 1,215 acres—the stars and stripes."[19] Regardless of what ethnic group was in charge of the common, every evening its participants sang the "The Star-Spangled Banner" and other patriotic songs as hyphenated-American citizens performing melting-pot ideology on a small-town stage. In addition to the American Common, Fountain Lake was renamed "Liberty Lake" and "For Peace and Freedom" replaced the "World of Tomorrow" as the official fair slogan. By 1940, the war in Europe had invaded utopia, and idealized plans for the world of tomorrow gave way to the concerns of the world of today. But fair planners did not necessarily give up their ideal of the fair as an opportunity for realizing a distinctly American art; their quest just shifted form.

Many fair planners regarded the war in Europe as more than a reason for retreat into an idealized, nostalgic vision of the past; they saw it as an opportunity for American cultural growth. For example, on October 4, 1940, three weeks before the fair closed for good, Florence Topping Green, head of the Women's Committee, delivered a speech at the American Common in which she announced that the "European War is providing the United States with its greatest opportunity to become the leader of art in the world." War she maintained, "is death to art"; "it is the achievements of artists that help to preserve culture in a nation." The "real danger," Green continued, "is not that the art of Europe will be destroyed by fleets of airplanes, as horrible as that may be, but that after the war is over the human race will be so busy with the work of reconstruction and the mere effort of living that art will be neglected for centuries." Green urged Americans to use the war as an opportunity to become the world's artistic vanguard. "If we keep out of the conflict," she reasoned, "America will be the leader in the art of the world. As long as Europe is an armed camp, the American artists will have their great chance."[20] As Green predicted, the war did have a profound effect on American art, and out of the ashes New York emerged as the capital of the international art world. Yet the war

also silenced many of the debates of the previous decade and presented a resacralized version of American modernism. One of the major reasons for these changes was that, for the first time, American artists and critics stopped forecasting the emergence of a democratic American art and instead celebrated its arrival in Abstract Expressionism.

In the spring of 1945, art critic Howard Putzel arranged an exhibition of modern paintings by eleven contemporary New York artists. The show, which he entitled *A Problem for Critics*, included work by Arshile Gorky, Adolph Gottlieb, Hans Hofmann, Lee Krasner, Jackson Pollock, Mark Rothko, and Rufino Tamayo. Putzel intentionally chose artists whose works crossed artistic schools, borrowing elements of abstract, surrealist, and expressionist painting. Regarding the show, which indeed baffled many critics, Putzel announced, "I believe we see real American painting beginning now." On the heels of Germany's surrender, Putzel's proclamation located these American abstract painters at the center of the American art world. A few years later, Clement Greenberg positioned this same group of painters at the center of the global art world when he declared that by 1940, New York City "had caught up with Paris as Paris had not yet caught up with herself, and a group of relatively obscure American artists already possessed the fullest painting culture of their time." "Never before," Greenberg insisted, "had this occurred in American art."[21] Finally, many critics agreed, American artists were producing artwork that paralleled the country's superpower status. In the years directly following World War II, Greenberg and other social and cultural critics, government officials, and large segments of the American public embraced this group of New York artists as the saviors of American culture. In addition to marking America's artistic maturity, they were the "myth-makers" who would salvage American art and culture from the potential ravages of kitsch.[22]

Despite the artists' repeated insistence that they did not constitute a unified group or paint in a definitive style, Abstract Expressionism, or the "first-generation" New York school, is the name of the movement commonly ascribed to this group of avant-garde artists working in New York City during the 1940s and 1950s. For Greenberg and many other critics, Abstract Expressionist painters embraced the basic myths of America while reconciling many of the contradictions of American democracy. For them, Abstract Expressionism represented both the individual and the collective unconscious; it simultaneously demonstrated the vastness and power of the nation while representing the innermost secrets of the individual artists' psyches. It rejected outright the machine aesthetic of European modernism

and replaced it with organic, spontaneous, automatic gestures. And with the help of Greenberg and the Museum of Modern Art, it became the dominant model of American modernism, eclipsing the Deweyan experiential models of the 1930s and replacing them with a more doctrinaire narrative in which an artwork's formal qualities became its subject.[23] As a result, in the years following World War II, the determinants of cultural value shifted away from ideals of the democratic plurality of artistic creation and back to more sacred notions of genius as embodied in the individual artist as a cultural hero.

Indeed, the photographs of Pollock in a tight black T-shirt and faded jeans, cigarette dangling from the side of his mouth as he dripped paint onto an enormous canvas, became familiar images to Americans in the postwar years.[24] First published in *Life* in August 1949 and reprinted in countless surveys and monographs, the image of a brooding Pollock, splattering his "unconscious mind" onto canvas or slouched over his drink at the Cedar Tavern, romanticized him in the popular imagination as the all-American artist, while scholars and critics heralded his work, and that of his fellow Abstract Expressionists, as "the triumph of American art."[25] *Life*, as well the other Henry Luce publications *Time* and *Fortune*, played a major role in the canonization of Abstract Expressionist art as a "democratic" form of American modern art. Through repeated articles and photo spreads, *Life* explained the worth of this form of modern painting to a sometimes skeptical American public. Often the *Life* forums were presented as debates among well-respected cultural experts. For example, in October 1948, it sponsored a round table on modern art, in which "fifteen distinguished critics and connoisseurs" undertook "to clarify the strange art of today." By using such a format the magazine maintained a veneer of democratic access within the mass-produced medium. *Life* presented itself as a forum for art criticism and public discussion—a seeming transformation of cultural capital into more popular forms. Yet, unlike those of the 1930s, *Life*'s debates were not really public; they were always debates among experts, well edited and contained within the pages of the magazine.

The organizers of *Life*'s 1948 modern art round table presented their debate with the caveat that "there is no more complicated subject in the world than aesthetics." To "shed some light on this," the editors brought together "known enthusiasts" of modern art as well as "those who had registered serious criticisms of it" to do battle. Addressing what they saw as the sources of the "layman's" "antagonism" toward modern art (it was "difficult to understand" and "ugly" and "strange"), the organizers of the

Fig. 47. *Life's* Round Table on Modern Art, October 11, 1948. Members of *Life's* round table on modern art (*clockwise, lower left*): James W. Fosburgh; Russell W. Davenport; Meyer Schapiro; Georges Duthuit; Aldous Huxley (*leaning forward*); Francis Henry Taylor (*behind Huxley*); Sir Leigh Ashton; R. Kirk Askew, Jr.; Raymond Mortimer; Alfred Frankfurter; Theodore Greene (*head in hand*); James J. Sweeney; Charles Sawyer; and H. W. Janson. Held in the Museum of Modern Art penthouse. The text accompanying this picture reads, "Fifteen distinguished critics and connoisseurs undertake to clarify the strange art of today." (Leonard McCombe/Time-Life. © Time Inc. Getty Images, Reprinted by permission.)

round table began with the question, "How can a civilization like ours continue to flourish without the influence of a living art that is understood and enjoyed by the public?"[26] The place of the "layman" was of pivotal concern at the round table, but not as a co-creator of it so much as a passive appreciator. The "distinguished critics" claimed that they were not arguing over the "moral values of our age" or the "great obvious truths of human life" but rather over how to explain the development of postwar "abstract art" to the American public, who they feared would dismiss it outright because of the "controversy and confusion" surrounding it. Indeed, the primary goal of the round table was to come up with a way to make modern art more palatable to the laymen and women of America, to explain definitively what it meant and why it was important beyond the hallowed walls of the museum or gallery. *Life* employed the language of desacralization but filtered it through its hand-picked cultural arbiters who invoked a pedagogy of expertise. In so doing, the magazine shifted away from Deweyan notions of education and participatory experience back toward more sacred, trickle-down versions of aesthetic value rooted in the vicarious experience of this "new" form of art.[27]

A dominant term in *Life*'s modern art round table was *zeitgeist*, or "the spirit of the times." Kirk Askew, a New York City art dealer, declared, "There is a zeitgeist of seeing which is inherent in the painter and the man looking at the painting," while Sir Leigh Ashton, director of the Victoria and Albert Museum in London, explained that "modern art is a reflection of our times, whether you like it or not. When the public doesn't understand one particular phase of modern art we must not reject it for that reason." The question then became, "how to make the public understand" or, at least, accept the answers that the experts at the round table provided. Theodore Green of the philosophy department at Yale University argued that "painting must be related to the entire culture and that its difficulties are in great measure the difficulties of that culture." But as with the sciences, he explained, artistic difficulties and success should be measured by the geniuses of the culture. "Are you going to go to Einstein," he asked, "and say 'don't be too difficult'?" In some cases, he argued, the public needed to accept on faith the greatness of what they did not understand. Other participants in *Life*'s round table stressed the need for developing a publicly accessible language for understanding abstract art by building an official artistic community around it. "As you build a community," the editors explained, "you will get a common language and a common belief."

But both this common language and belief came from above. The readers of *Life* were witnesses to, not participants in, its creation.

Although most of the participants invoked concerns about the "public," their ideas were not publicly driven in the same way that artistic debates had been a decade before. While the underlying goals of *Life*'s modern art round table appeared to resemble those of Federal Art Project administrators and MoMA staff with its emphasis on desacralizing art through experience, in this case, however, the American public did not actively participate in the creative experience, either by creating or by buying the goods. Rather, they were instructed how to appreciate it by a series of experts. Public experience of abstract art was rooted in mass-produced appreciation, and cultural capital was shifted to those experts who could explain it.

Life was not the only source of large-scale public art appreciation at this time. In addition to increased art appreciation classes at museums and universities across the country, organizations such as the Art Appreciation Movement held "huge advertising campaigns" and "public dinners and publicity" across the United States "to arouse the interest of the general public." Much like the terms under discussion in *Life*'s modern art round table, the issues raised in art appreciation drives across the nation were not malleable or open to larger public debate. Instead, the primary objective of *Life*'s round-table participants and other post–World War II art appreciation courses was to convince the American public that the experts were right. The "democracy" of postwar American modernism was rooted in acquiescence.[28]

Interestingly, like those linking art to democracy during the 1930s, *Life* touted experience as the foundation for its conceptualization of artistic democracy. In his remarks for the modern art round table, for example, Clement Greenberg argued that an appreciation of abstract painting "cannot be learned from a textbook or from someone else's words but only through experience. The layman has to learn to look not for ideas but for experience first." Similarly, art historian Meyer Schapiro explained that "the function of the individual, is an openness to experience . . . not only in art but in the broader field of life itself." For Schapiro, the "tremendous individualistic struggle which makes modern art so difficult for the layman is really one of the great assets of our civilization for it is at bottom the struggle for freedom." One by one, the members of the round table agreed that there were ties between freedom, democracy, and the experience of American abstraction. This belief was perhaps most dramatically asserted by art history professor H. W. Janson, who claimed that the modern artist,

Fig. 48. Hans Namuth, Jackson Pollock, 1950. This image was one of the series of photographs that Hans Namuth took of Jackson Pollock at work in his Long Island studio. The photographs, which show Pollock flinging paint onto his oversized canvases, have been widely circulated ever since. (Courtesy of Hans Namuth Estate.)

in "insisting upon highly individualistic experiences," was fulfilling a "very valuable function" by "preserving something that is in great danger— namely, our ability to remain individuals." Never losing track of growing public anxieties over the loss of individuality within mass culture, the participants in *Life*'s "Round table on Modern Art" advocated artistic consensus in the name of freedom, democracy, and individuality as weapons against totalitarianism.[29] Ultimately, the editors of the round table hoped that their efforts would convince the American public that modern art was "an inescapable cultural by-product of the great process of freedom which is so critical in our time" and that as a result, the "layman who might otherwise be disposed to throw all modern art in the ashcan may think twice—and may on second thought reconsider."[30] What began as a question of worth (is this art any good?) ended with a plea for maintaining American democratic freedom through a model of aesthetic value that advocated individuality through predefined modes of spectatorship.

Other articles specifically on American abstract painting followed in subsequent issues of *Life* and took a similar analytical line. In August 1949 the magazine featured an article on Jackson Pollock. Asking, "Is he the greatest living painter in the United States?" the piece included the now-famous photographs of Pollock at work, flinging paint, sand, and ashes over mammoth canvases: the myth of the lone, virile American artist had been solidified in the magazine's glossy pages. While *Life* might present Pollock's art in terms of a question, the answer did not really matter. Like the "Round Table on Modern Art," the debate was answered within the pages of the magazine. An army of experts, most of them affiliated with the Museum of Modern Art, were there to explicate the ideals embedded in Pollock's paintings and level charges of philistinism at disbelievers.[31] In subsequent issues, *Life* compared selected Abstract Expressionist paintings with scenes found in reality. It displayed a Franz Kline abstraction next to an enormous building crane, a Mark Rothko alongside a sunset. By finding real life corollaries for these abstract works of art, *Life* made them seem less abstract and a bit more comprehensible to the American public.

Yet the treatment of art in *Life* was precisely the opposite of how the critics validating these works were advising the public to experience them. The experts as well as the editors at *Life* were instructing the American public on what these paintings meant (freedom, individuality, and consensus) and how they should be read—like sunsets or modern building materials. By equating the virility of Pollock's drips, the sublime properties of Rothko's color, and the technological nature of Kline's forms with Ameri-

Figs. 49, 50. Photo spread from *Four Pioneers of American Art, Life,* November 16, 1959. As part of its effort to explain Abstract Expressionist art to its readers, *Life* compared the artworks to more familiar items: a Mark Rothko painting to a sunset, a Franz Kline abstraction to a building crane. (© 1959 Time Inc. Reprinted by permission.)

can cultural superiority, magazine editors and museum curators presented a vision of American art in which the individual artist remained outside of society. Abstract Expressionist artists, like the public who viewed their works in repeated media coverage, were presented as commentators on rather than participants in the creation of a democratic art form. While mass-market publications such as *Life*, *Vogue*, and *Good Housekeeping* ran repeated articles on Pollock and other New York school painters, often questioning the validity of their success, they still, in effect, legitimated their work and furthered their celebrity. The "experience" of abstraction that participants argued sustained freedom and individuality ultimately was predetermined. The question was part of the answer, and *Life* played the role of both questioner and respondent, changing the venue of artistic debate from the streets to its pages. Indeed, the headline for an article in the November 9, 1959, issue, "Baffling U.S. Art: What It Is About," was posed as an answer, not as a question. Acknowledging that "the work of the abstract expressionists is a source of bafflement and irritation to the public at large," *Life*'s experts endeavored "to explain how abstract expressionism developed and what it aims to communicate." The message, however, was not open to individual debate but rather circulated in the mass media; in a way, then the avant-garde and kitsch had merged in the pages of *Life*.[32]

Rather than break down artistic hierarchies, however, the canonization of high modernism in the popular press led to their reinscription. In 1946, Greenberg lamented that "high culture, which in the civilized past has always functioned on the basis of sharp class distinctions, is endangered—at least for the time being—by this sweeping process which, by wiping out social distinctions between the more or less cultivated, renders standards of art and thought provisional. . . . It becomes increasingly difficult to tell who is serious and who is not. At the same time as the average college graduate becomes more literate the average intellectual becomes more banal both in personal and professional activity."[33] As a result of his need to delineate the parameters of high culture, Greenberg constructed a narrative of modernism that, according to the philosopher Arthur Danto, "identified a certain local style of abstraction with the philosophical truth of art." By identifying the essence of painting with its formal qualities—the flatness of the picture plane, the paint on the canvas—Greenberg "put painting on an unshakable foundation derived from discovering its own philosophical essence."[34] For Greenberg, the substance of Abstract Expressionism became its subject. "Step by step," Danto writes, "Greenberg constructed a narrative of modernism to replace the narrative of traditional representative

Fig. 51. "Baffling U.S. Art: What It Is About," *Life*, November 16, 1959. In this article, the magazine attempted to explain the baffling art to its readers. Note that the title is not posed as a question but rather as a declaration. (© 1959 Time Inc. Reprinted by permission.)

painting," in which one style begot the next in a logical historical continuum.[35] Ultimately, Danto argues that "modernism came to an end when the dilemma recognized by Greenberg between works of art and mere real objects could no longer be articulated in visual terms"—when there was no apparent difference between a Brillo box and Warhol's Brillo box, between Donald Duck and Lichtenstein's portrayal of Donald Duck—and "when it became imperative to quit a materialist reading in favor of an aesthetics of meaning."[36] As a result, the philosophy of art became the project and the critic its creator.

Indeed, despite the continued allegations that "my four-year-old could do that," only Abstract Expressionist painters could produce Abstract Expressionist art, and as a legitimate art form, both the art and the artists had to be validated by experts. First Harold Rosenberg, with his theory of action painting, and then Greenberg and his high modernist formalism, legitimized the handful of artists who, they argued, rendered abstractly the collective unconscious of the cold war American public. By the mid-1950s, the 1930s definitions of democracy rooted in the active collaboration of mean-

ing making had given way to more fixed abstract definitions of democracy rooted in consensus and passive appreciation. In 1952 Ad Reinhardt and Robert Motherwell, two well-known Abstract Expressionist artists and the editors of *Art in America,* exclaimed that "by 1950, Modern Art in the United States had reached a point of sustained achievement worthy of a detached and democratic treatment."[37] For Motherwell and Reinhardt, democracy in art was detached rather than participatory, and this was a worthy achievement.

While Abstract Expressionism did inspire debate and discussion, it was not the street-level debate of the Depression decade. The American public could neither set the terms of the debate nor even participate in the discussion. Abstract Expressionism, like much of cold war culture, was rooted in spectatorship and second-hand experience, mediated through reproductions and the opinions of experts and journalists. Since Putzel first posed the question in 1945, critics have promoted Abstract Expressionism as the dominant model of American modernism, the "triumph of American art." In many ways, Abstract Expressionism does mark such a triumph. If one follows Baudrillard's contention that America represents "the original version of modernity," then the treatment of painters such as Pollock and Rothko in the pages of *Life* parallels the rise of a postmodern world that has become increasingly Americanized, grounded in spectacle and simulacra; in which artistic experience, the merger of aesthetics and everyday life, has become increasingly mediated through the proliferation of representations and vicarious experiences. But this history of American modernism need not be so rigid nor so bleak. The participatory models of American democratic modernism from the 1930s have not disappeared completely; they live on in the community art projects of the 1960s and in the regular explosive episodes we have come to call the "culture wars." While the Federal Art Project and the Museum of Modern Art's alternative definitions of art and aesthetic value paved the way for the possibility of Greenberg's grand formalist narrative and the canonization of Abstract Expressionism as *the* American art, and their Dewey-inspired pedagogical theories in many ways prefigured the rise of the spectacle as well as the postmodern debates that Danto identifies as marking the end of art, they also present working models for challenging the sacred and destabilizing hierarchical notions of cultural capital.

Like Greenberg, both Federal Art Project and MoMA staff in the 1930s were heavily invested in creating grand narratives into which their new aesthetic philosophies would fit. But for both the Federal Art Project's and

MoMA's pedagogical models, public participation and firsthand individual experience played a crucial role in defining democracy. Through their new narratives both institutions simultaneously challenged the sacredness of art and transformed how aesthetic value had been determined. Moreover, the individuals at both institutions passionately believed in the transformative power of art to do some social good. Instead of blindly accepting the postwar spectator-based model of American modernism, we need to return to the moment preceding its ascendancy and revisit the cultural models of the 1930s to understand how cultural capital in the United States has been distributed in today's society. Following Dewey and Mumford, we need to be guardedly optimistic and believe in the possibility of an aesthetic based in individual experience and alternative definitions of value in order to invite more voices to enter into and make progress toward an art for the millions.

Notes

Introduction. The Democratization of American Culture

1. Lewis Mumford, *American Taste* (New York: Grabhorn Press, 1929), 3.

2. Walt Whitman, "Democratic Vistas," in James E. Miller, ed., *Complete Poetry and Selected Prose by Walt Whitman* (New York: Houghton Mifflin, 1959), 479.

3. Mumford, *American Taste*, 7.

4. Mumford continued, "Instead of sampling and gormandizing among the ancient banquets of art, taste must rather appreciate the healthy fare of its own day" (*American Taste*, 32–33).

5. In their landmark work on postmodern architecture, *Learning from Las Vegas* (Cambridge, Mass.: MIT Press, 1977), Robert Venturi, Steven Izenour, and Denise Scott Brown call for an embrace of the everyday styles and symbols evident in Las Vegas signage and strip architecture instead of the dominant "heroic" forms that dominated the study of architecture until that point. By many accounts, this text marks the emergence of the postmodern analysis of architecture.

6. Jean Baudrillard, *America*, trans. Chris Turner (1986; New York: Verso, 1988), 104.

7. For more on nineteenth-century American art and nationalism, see David Lubin, *Picturing a Nation* (New Haven, Conn.: Yale University Press, 1996); Angela Miller, *Empire of the Eye* (Ithaca, N.Y.: Cornell University Press, 1993); Barbara Novak, *Nature and Culture* (New York: Oxford University Press, 1981); and John W. McCoubrey, *American Tradition in Painting* (1963; reprint, Philadelphia: University of Pennsylvania Press, 2000). For a historiographic overview of American art history, see also Elizabeth Johns, "Histories of American Art: The Changing Quest," *Art Journal* 44, no. 4 (Winter 1984): 338–44; and Wanda Corn, "Coming of Age: Historical Scholarship in American Art," *Art Bulletin* 70, no. 2 (June 1988): 188–207.

8. For more on the recent culture wars, see Richard Bolton, ed., *Culture Wars* (New Press, 1992); Marjorie Heins, *Sex, Sin, and Blasphemy* (New Press, 1998); Steven Dubin, *Arresting Images* (New York: Routledge, 1994); and Lawrence Rothfield, ed., *Unsettling Sensation* (New Brunswick, N.J.: Rutgers University Press, 2001).

9. There are certainly members of the general public who continue to see the arts as an important part of their daily lives. What I am arguing, however, is that their voices are largely absent from public debates over art in public life. There are, of course, exceptions. One such exception was the work of the Gran Fury collective in the late 1980s and early 1990s, which successfully used the visual arts to protest

contemporary AIDS policy and increase public awareness of both the disease and the American government's inaction. See Richard Meyer, "This Is to Enrage You," in Nina Felshin, *But Is It Art?* (Seattle: Bay Press, 1995).

10. Matthew Arnold, *Culture and Anarchy,* ed. J. Dover Wilson (New York: Cambridge University Press, 1932), 6.

11. Both the idea of a "usable past" and that of the "genial middle ground" come from Van Wyck Brooks's essay "America's Coming of Age," *Dial* 64 (April 11, 1918): 337–41. Wanda Corn includes Mumford and Charles Sheeler along with Brooks as part of a "history-for-modernist's sake movement in the 1920s." Wanda Corn, *The Great American Thing* (Berkeley: University of California Press, 1999), (317). For more on this, see Joan Shelley Rubin, *The Making of Middlebrow Culture* (Chapel Hill: University of North Carolina Press, 1992), in particular chapter 1. See also Casey Nelson Blake, *Beloved Community : The Cultural Criticism of Randolph Bourne, Van Wyck Brooks, Waldo Frank, and Lewis Mumford* (Chapel Hill : University of North Carolina Press, 1990); and Alfred Haworth Jones, "The Search for a Usable Past in the New Deal Era," *American Quarterly* 23, no. 5 (December 1971): 710–24.

12. Lawrence Levine, *Highbrow/Lowbrow: The Emergence of Cultural Hierarchy in America* (Cambridge, Mass.: Harvard University Press, 1988); Paul J. DiMaggio, "Cultural Entrepreneurship in Nineteenth-Century Boston," in DiMaggio, ed., *Nonprofit Enterprise in the Arts* (New York: Oxford University Press, 1986), 41–61. For more on the sacralization of culture, see Neil Harris, *Cultural Excursions* (Chicago: University of Chicago Press, 1990); Kathleen McCarthy, *Women's Culture* (Chicago: University of Chicago Press, 1991); and Ralph Locke, "Music Lovers, Patrons, and the Sacralization of Culture in America," in Locke and Cyrilla Barr, eds., *Cultivating Music in America* (Berkeley: University of California Press, 1997). For more on the creation of cultural hierarchies in America, see Rubin, *Making of Middlebrow Culture;* also see Kirk Varnadoe and Adam Gopnik, *High and Low* (New York: Abrams, 1990); Varnadoe and Gopnik, *Readings in Popular Culture* (New York: Abrams, 1990); Thomas Crow, "Modernism and Mass Culture in the Visual Arts," in Francis Frascina, ed., *Pollock and After* (New York: Harper & Row, 1985); Herbert Gans, *Popular Culture and High Culture* (New York: Basic Books, 1974); Clement Greenberg, "Avant Garde and Kitsch," *Partisan Review* (Fall 1939), reprinted in *Art and Culture: Critical Essays* (Boston: Beacon Press, 1961); Andreas Huyssen, *After the Great Divide* (Bloomington: Indiana University Press, 1986); John Kasson, *Amusing the Million* (New York: Hill and Wang, 1978); and Chandra Mukerji and Michael Schudson, introduction to *Rethinking Popular Culture* (Berkeley: University of California Press, 1991).

13. According to Levine, "The reason we have had such difficulty defining categories like 'high' and 'popular' culture and distinguishing with any kind of precision or consistency the boundaries between them is because we have insisted upon treating them as immutable givens" (*Highbrow/Lowbrow,* 236, 241). Many scholars and critics have criticized Levine's and DiMaggio's arguments for too rigidly accepting the boundaries of sacralization as well as for disregarding notions of aesthetic pleasure in their accounts of nineteenth-century audiences. See in particu-

lar Locke, "Music Lovers," and Daniel H. Borus, "Cultural Hierarchy and Aesthetics Reconsidered," *Intellectual History Newsletter* 23 (2001): 61–70.

14. By incorporation Trachtenberg means "the emergence of a changed, more tightly structured society with new hierarchies of control and also changed conceptions of that society" in response to the increasingly corporate form of ownership. By 1904, he writes, about three hundred corporations controlled two-fifths and influenced four-fifths of the country's industry, and by 1929 "the two hundred largest corporations held 48 percent of all corporate assets." Alan Trachtenberg, *The Incorporation of America* (New York: Hill and Wang, 1982), 4.

15. In *Amusing the Million*, John Kasson discusses the emergence of a strong tension between the hallowed galleries of the Metropolitan and the mass entertainments of Coney Island.

16. Quoted in Levine, *Highbrow/Lowbrow*, 154, from Daniel M. Fox, *Engines of Culture: Philanthropy and Art Museums* (Madison State Historical Society of Wisconsin for the Department of History: University of Wisconsin, 1963), 12.

17. This notion of the aura comes from Walter Benjamin, "The Work of Art in the Age of Mechanical Reproduction," in *Illuminations*, ed. Hannah Arendt (New York: Schocken Books, 1968), 217–252. For Benjamin, "Even the most perfect reproduction of a work of art is lacking in one element: its [the original's] presence in time and space, its unique existence at the place where it happens to be" (220). For Benjamin, this is what makes an object "authentic," and "the authenticity of a thing is the essence of all that is transmissible from its beginning, ranging from its substantive duration to its testimony to the history which it has experienced. . . . What is really jeopardized by reproduction when the historical testimony is affected is the authority of the object. . . . That which withers in the age of mechanical reproduction is the aura of the work of art" (221). He defines the aura as "the unique phenomenon of a distance, however close it may be" (222).

18. Following Pierre Bourdieu, DiMaggio calls the men and women who seized control of the consumption—and to some extent the production—of high culture in America "cultural capitalists" because they were both capitalists in the economic sense and collectors of cultural capital. For Bourdieu, taste, an amorphous category based on the aesthetic preferences of social elites, acts as a means of creating symbolic boundaries based on social distinctions. Pierre Bourdieu, *Distinction*, trans. Richard Nice (Cambridge, Mass.: Harvard University Press, 1984). Bourdieu's notion of capital includes the different assets, attributes, or qualities that can be exchanged for other goods, services, or positions. He identifies several types of capital, including economic capital, social capital, and symbolic or cultural capital. Bourdieu, *Outline of a Theory of Practice*, trans. Richard Nice (New York: Cambridge University Press, 1977). Central to these forms of capital is the notion of *habitus*, or the "total, early, imperceptible learning, performed within the family from the earliest days of life and extended by a scholastic learning which presupposes and completes it" (*Distinction*, 6). Don Slater provides an excellent overview of Bourdieu's theory of distinction in *Consumer Culture and Modernity* (Malden, Mass.: Polity Press, 1997), 159–63. He writes that, for Bourdieu, "taste—cultural patterns of choice and preference—is seen as a resource which is deployed by groups within the stratification system in order to establish or enhance their loca-

tion within the social order" (162). According to Slater, habitus is "habitual and customary. . . . Above all [it] is embodied, learned and acted out on the level of the body" (162).

While Bourdieu's work specifically refers to mid-twentieth-century France, his theories are relevant to scholars exploring American culture. According to Barry Shank, Bourdieu's "theorization of the transformative nature of capital, its capacity to shift from symbolic, to social to economic with none of those forms being primary . . . forces the analyst (historian, sociologist) to look beyond the self-reporting of the participants in the social system being studied." Moreover, Shank argues that Bourdieu is particularly relevant to American cultural historians because Bourdieu sees culture as "an arena where capital—understood as the contested product of unequal social relations—is produced, and markets are the fields in which the contests over capital produce and reproduce social relations"; as a result, "cultural history becomes a fundamentally important social practice." Barry Shank, "Pierre Bourdieu and the Field of Cultural History," *Intellectual History Newsletter* 23 (2001): 96–109. For an excellent application of Bourdieu in an American context, see Janice Radway, *A Feeling for Books* (Chapel Hill: University of North Carolina Press, 1997). For more on Bourdieu, see Craig Calhoun, Edward LiPuma, and Moishe Postone, eds., *Bourdieu: Critical Perspectives* (Chicago: University of Chicago Press, 1993); Borus, "Cultural Hierarchy and Aesthetics Reconsidered"; and Slater, *Consumer Culture and Modernity*, 159–63.

19. The thorough desacralization of art would explode the concept of art completely by destroying the artwork's aura and detaching its production from space and time. The desacralization that took place in the 1930s occurred in different degrees ranging from challenging genteel definitions of artists and works of art to making them more accessible to the mass public by in effect democratizing sacralization.

20. Don Slater writes that utility is "what makes us able to compare apples and oranges." Citing Jeremy Bentham's definition of utility as "that property in any object whereby it tends to produce benefit, advantage, pleasure, good or happiness, or reduce pain," Slater argues that "utility is a highly formal and abstract concept because it replaces the multiplicity of human desires with a single desire, the desire for utility" (44–45). I will discuss this in much more detail in Chapter 3.

21. Waldo Frank, *The Rediscovery of America* (New York: Scribner, 1929).

22. Thomas Craven, "The Curse of French Culture," *Forum* 80 (July 1929). In *The Great American Thing* Wanda Corn compellingly demonstrates that American modernism was not merely derivative of European styles and forms but rather that there was an active transatlantic dialogue among American and European modernists in the early part of the twentieth century.

23. For more on the American Academy of Design and the changing American art market in the late nineteenth and early twentieth centuries, see Celeste Connors, *Democratic Visions* (Berkeley: University of California Press, 2001), in particular chapter 3, "A Direct Point of Contact," 51–75. Connors writes: "In the first half of the nineteenth century, American 'aristocrats' (upper-class white men) had sponsored select artists, with whom they enjoyed personal relationships." But, she continues, "by 1900 . . . a new figure had entered the scene: the dealer." Dealers "did more to change how art was sold; by promoting a new taste for European

works, they changed what was sold. From the 1880s well in to the twentieth century, their profits came mainly from the sales of old master and contemporary European works" (52).

24. Robert Henri, "Letter, 1916," in Margery Ryerson, ed., *The Art Spirit* (Philadelphia: Lippincott, 1923); "New York Anarchists: Here Is the Revolutionary Creed of Robert Henri and His Followers," *New York Herald,* June 10, 1906.

25. According to Wanda Corn, "Within the larger field of competing modernisms, the Stieglitz circle . . . situated itself as a modernist aristocracy in New York. . . . Unlike other avant-garde groups that shocked the bourgeoisie or mocked its tastes and habits, they felt superior and genteelly ignored it" (*Great American Thing*, 23). Celeste Connors provides a different take on Stieglitz's relationship to the American public. In *Democratic Visions*, she compellingly argues that Stieglitz and his followers followed directly from Whitman in their efforts to use art to create democratic communities. According to Connors, Stieglitz placed greater trust in the American public than those who preceded him. For example, in a 1924 letter to Sherwood Anderson he wrote, "Yes, the people would respond if given half a chance. They might not make the artist rich, but they'd give him a chance to work, I'm sure of it" (Stieglitz quoted in Connors, 67–68).

26. For more on the Ash Can School of painting, see Rebecca Zurier, Robert W. Snyder, and Virginia M. Mecklenburg, *Metropolitan Lives: The Ashcan Artists and Their New York* (Washington, D.C.: National Museum of American Art; New York: Norton, 1995).

27. The artist and teacher John Weischel sponsored a variety of art shows in New York City restaurants, schools, theaters, and settlement houses through his People's Art Guild. His goal was to connect modern art directly to social and political concerns. Stieglitz mocked the guild as "naïve," and by 1919 it had closed. But the People's Art Guild provides an important precursor to the efforts detailed in this book during the 1930s and deserves further study. For more on Steiglitz and Weischel, see David Bjelajac, *American Art* (New York: Abrams, 2001), 309.

28. According to Corn, Stieglitz was a "spiritual leader [who] constituted . . . a lay brotherhood that would lead America into its first moments of cultural worth" (Corn, *Great American Thing*, 14). Connors argues much the same view in *Democratic Visions*.

29. In the introduction to *Modernism Inc.* (New York: New York University Press, 2001), Jani Scandura and Michael Thurston echo Jean Baudrillard's pronouncement that "the United States as America is the original version of modernity" when they write that "the United States as America might be seen to signify the modern in its purest form" (4). For more on the idea of an iconography of modernism, see Terry Smith, *Making the Modern* (Chicago: University of Chicago Press, 1993). For Smith, "the iconography of Modern America" falls into three loose categories: "1) the industrial plant and the manufacturing worker . . . the agricultural site and the farm worker; 2) the vertical city and the crowd and . . . 3) the stylized product and the consumer" (7).

30. R. L. Duffus, *The American Renaissance* (New York: Knopf, 1928).

31. Edward Alden Jewell, *Americans* (New York: Knopf, 1930), 9.

32. For an overview of American Studies scholarly trends, see Gene Wise,

"Paradigm Dramas in American Studies: A Cultural and Institutional History of the Movement," *American Quarterly* 3, no. 31 (1979): 293–337.

33. For critiques of American exceptionalist scholarship, see the articles in Amy Kaplan and Donald Pease, eds., *Cultures of United States Imperialism* (Durham: Duke University Press, 1993), in particular, Kaplan, "Left Alone with America," 5–11. See also John Carlos Rowe, *The New American Studies* (Minneapolis: University of Minnesota Press, 2002); and the essays in Pease and Robyn Weigman, eds., *The Futures of American Studies* (Durham, N.C.: Duke University Press, 2002).

34. Corn, *Great American Thing*, xiv.

35. Raymond Williams writes in *Keywords* (New York: Oxford University Press, 1976), 93–98, that "democracy is a very old word but its meanings have always been complex" and goes on to provide a five-page etymology of the term. Similarly, in his 1946 essay "Politics and the English Language," George Orwell asserts that the word democracy has "several different meanings which cannot be reconciled with one another." He continues, "Not only is there no agreed upon definition of the term but the attempt to make one is resisted from all sides," since, if democracy, which is almost universally a term of praise, were "tied down to any one meaning," the various governments that describe themselves as democratic "might have to stop using the word." Orwell, "Politics and the English Language," in *A Collection of Essays by George Orwell* (New York: Harvest/Harcourt Brace Jovanovich, 1946), 162.

36. In this way they employed Benedict Anderson's notion of the nation as an "imagined community," as discussed in his *Imagined Communities* (New York: Verso, 1991).

37. Andreas Huyssen begins *After the Great Divide* with the assertion that "ever since the mid-nineteenth century, the culture of modernity has been characterized by a volatile relationship between high art and mass culture" (vii). This tension informs my definition of modernism, as does Marshall Berman's notion of modernism in *All That Is Solid Melts into Air* (New York: Penguin Books, 1982) as "any attempt by modern men and women to become subjects as well as objects of modernization, to get a grip on the modern world and make themselves at home in it." Modernity is "a mode of vital experience—experience of space and time, of the self and others, of life's possibilities and perils." For Berman, what characterizes the modern in both art and thought is "paradox and contradiction" as well as "perpetual self-critique and self-renewal" (6). The 1930s are indeed such a period, marked by repeated paradox and renewal.

38. Regarding the emergence of new technologies of communication following the Civil War, Alan Trachtenberg writes in *The Incorporation of America* that "vicarious experience began to erode direct physical experience of the world. Viewing and looking at representations, words and images . . . people found themselves addressed more often as passive spectators than as active participants, consumers of images and sensations produced by others" (122). He discusses the ramifications of this new form of experience on "high culture" in his examination of the White City at the Chicago World's Fair in 1893. "Visitors to the Fair found themselves as

spectators, witnesses to an unanswerable performance which they had no hand in producing or maintaining" (231).

39. John Dewey, *Art as Experience* (New York: Perigee Books, 1934), 286. For an excellent analysis of Dewey's aesthetic theory, see Richard Shusterman, *Pragmatist Aesthetics* (Lanham, Md.: Rowman and Littlefield, 2000). See also Stewart Beuttner, "Dewey and the Visual Arts," *Journal of Aesthetics and Art Criticism* 33 (1975): 383–91; and Mark Mattern, "John Dewey, Art and Public Life," *Journal of Politics* 61 (February 1999): 54–75. Like Dewey, the German political philosopher Jürgen Habermas contends in *The Structural Transformation of the Public Sphere* (Cambridge, Mass.: MIT Press, 1989) that the circulation of ideas in the public sphere through "rational-critical debate" is a crucial component of a functioning democracy (82–83). Although Habermas focuses on German coffeehouses, his public sphere theory is helpful in contemplating the American context as well. For more on Habermas's public sphere theory, see the essays in Craig Calhoun, ed., *Habermas and the Public Sphere* (Cambridge, Mass.: MIT Press, 1993); for a good overview of the uses of Habermas in an American context, see the introduction to Mary Ryan, *Women in Public* (Baltimore: Johns Hopkins University Press, 1990).

40. Dewey, *Art*, 6.

41. Dewey, *Art*, 187, 227, 140, 3.

42. Dewey, *School and Society*, 92.

43. Dewey, *Art*, 17. Shusterman reads Dewey's aesthetic theory as one of continuity. He writes that "Dewey is intent on making connections rather than distinctions." His aesthetics of continuity "connects more than art and life; it insists on the fundamental continuity of a host of traditional binary notions. . . . Fine v. applied art, high v. popular art, spatial v. temporal arts and artists v. the ordinary people who constitute their audience" (*Pragmatist Aesthetics*, 13).

44. "Slippery" is Shusterman's term, but it seems appropriate here.

45. Dewey, *Art*, 214, 47.

46. Dewey, *Art*, 16. Shusterman suggests that in many ways Dewey prefigures postmodernist arguments about the "socio-historical dimension of art history," in particular the work of Arthur Danto, who famously argued that all art/theory is "structured and conditioned by social practices and institutions which inform one's life and thought," leading him to his "end of art" thesis, where theory and criticism replace art. See Danto, "The Artworld," *Journal of Philosophy* 61 (1964): 581; and *The Philosophical Disenfranchisement of Art* (New York: Columbia University Press, 1986). The links between Dewey and Danto will be explored in more depth in my final chapter.

47. According to Dewey, "Were works of art placed in a directly human context in popular esteem, they would have a much wider appeal than they can have when pigeon-hole theories of art win general acceptance" (*Art*, 11).

48. Matthew Baigell, *The American Scene* (New York: Praeger, 1974), 59.

49. See Barbara Rose, *American Art Since 1900* (New York: Holt, Rinehart and Wilson, 1987), 94. In particular, see chapter 5, "The Thirties: Reaction and Rebellion."

50. Art historian David Bjelajac defines modernist art by "its self-conscious interest in experimentation with the materials and creative processes of each indi-

vidual medium." Modernist artists, he writes, "tended to stress the subjective uniqueness of their own particular visions. They willfully manipulated subjects, colors, shapes and forms in new expressive ways and thereby called attention to the relativity of vision and the contradictions, ambiguities and uncertainties of modern, urban life" (*American Art,* 286). Similarly, Helen Langa convincingly demonstrates how a number of artists in the Graphic Arts Division of the Federal Art Project presented "a significant alternative to the conception of American modernism as a series of movements entirely focused on innovative formal practices" ("Modernism and Modernity During the New Deal Era," *SECAC Review* 12, no. 4 (1994): 273). She writes, "The choice of working with modernist styles could convey artists' beliefs in the need for a radical revisioning of both art and society. It is important to recognize that artists who used modernist stylistic elements to depict social realist themes were working within a matrix of political and social contexts that were more complex than the assertion of personal aesthetic preferences" (278). For more on the nature of modernist artistic practices in the United States during the interwar decades, see John R. Lane and Susan C. Larsen, *Abstract Painting and Sculpture in America, 1927–1944* (New York: Abrams, 1984); Susan Noyes Platt, *Modernism in the 1920s* (Ann Arbor: UMI Research Press, 1985); and Virginia M. Mecklenburg, *The Patricia and Philip Frost Collection, American Abstraction, 1930–1945* (Washington, D.C.: Smithsonian Institution Press, 1989).

51. Irving Sandler, *The Triumph of American Painting* (New York: Harper and Row, 1974). See Barbara Rose, "Art of This Century," chapter 6 in *American Art Since 1900.* Interestingly, for Rose, "this century" began following World War II. See also Serge Guibault, *How New York Stole the Idea of Modern Art* (Chicago: University of Chicago Press, 1983). Clement Greenberg gives the New York school artists a European rather than an American ancestry. As Wanda Corn notes in *Great American Thing,* many art historians have followed Greenberg's lead. In *The Triumph of American Painting,* Irving Sandler credits the European influence on Abstract Expressionist artists. He begins his study with "the arrival of the Europeans," Ferdinand Léger, Piet Mondrian, Salvador Dali, Yves Tanguy, and Andre Masson, whose presence transformed New York City into the center of the international art scene, a "presence that instilled in American modernists a sense of confidence" (31). And Barbara Rose writes that "the collapse of American modernism in the twenties was more complete, tragic and inevitable than the European détente" (339).

52. Michael Denning's recent book, *The Cultural Front* (New York: Verso, 1996), provides an excellent look at the political culture of the 1930s. Denning, however, does not deal explicitly with the visual arts, in part, I would guess, because they complicate his thesis regarding the "laboring of America."

Chapter 1. Like the Farmer or Bricklayer

1. Harry Hopkins to WPA administrators, memorandum (1935), reel DC54, Record Group 69, hereafter RG, Federal Art Project Collection, Archives of American Art (hereafter AAA) New York.

2. Biddle, diary entry, November 8, 1933; reprinted in George Biddle, *An American Artist's Story* (Boston: Little, Brown, 1939), 269–70.

3. Holger Cahill, "Art and Democracy," speech, June 7, 1938, Town Hall, New York City, box 1, Holger Cahill Papers, AAA.

4. For more on the arts and crafts movement in the United States, see T. J. Jackson Lears, *No Place of Grace* (New York: Pantheon, 1981), in particular chapter 2; and Celeste Connor, *Democratic Visions* (Berkeley: University of California Press, 2001). Connors compellingly links the arts and crafts ethos to Alfred Stieglitz and the group of artists who surrounded him in New York City in the early twentieth century.

5. Cahill, "Art and Democracy."

6. See, for example, the debates over the Washington Monument and the Capitol Rotunda paintings in particular, described in Kirk Savage, "The Self Made Monument"; and Sally Webster, "Writing History/Painting History," both in Harriet Senie and Sally Webster, eds., *Critical Issues in Public Art* (Washington, D.C.: Smithsonian Institution Press, 1998), 5–32, 34–43.

7. Olin Dows, "The New Deal's Treasury Art Program: A Memoir," in Francis V. O'Connor ed., *The New Deal Art Projects: An Anthology of Memoirs* (Washington, D.C.: Smithsonian Institution Press, 1972), 12.

8. For more on the Treasury art projects, see Karal Ann Marling, *Wall to Wall America* (Minneapolis: University of Minnesota Press, 1982); Barbara Melosh, *Engendering Culture* (Washington, D.C.: Smithsonian Institution Press, 1991); and Richard D. McKinzie, *A New Deal for Artists* (Princeton, N.J.: Princeton University Press, 1973).

9. George Biddle to Edward Bruce, memorandum, November 16, 1933, RG 121/124, Biddle Papers, National Archives, hereafter NA.

10. Forbes Watson to Bruce, memorandum, n.d., RG 121/106, Watson papers, NA.

11. Matthew Arnold, *Culture and Anarchy*, ed. J. Dover Wilson (New York: Cambridge University Press, 1932), 6.

12. Bruce, memorandum, July 27, 1934, RG121/114.

13. Olin Dows to Bruce, July 15, 1935, RG 121/122.

14. Stuart Davis to Dows, April 20, 1936, RG121/122.

15. Cahill, "The WPA Federal Art Project, A Summary of Activities and Accomplishments" (1938) in RG69, box 2062, p. 22, NA. In addition to having to prove repeatedly that art was a legitimate and valuable form of work, Federal Art Project administrators had to evaluate artists to determine who qualified for work on the project—in terms both of relief and of artistic talent. To qualify for relief, first an administrator visited the artists at home to make sure they met the relief criteria. They then had to meet Federal Art Project criteria. This was often a long and demeaning process.

16. Horace Kallen, "Democracy Versus the Melting Pot," *Nation* (February 25, 1915).

17. John Dewey, *Art and Experience* (New York: Minton, Balch, 1934).

18. Cahill, "Speech in Honor of John Dewey's Eightieth Birthday," in Francis

V. O'Connor, ed., *Art for the Millions* (Boston: New York Graphic Society, 1973), 33–46.

19. Biographical information for Holger Cahill from Wendy Jeffers, "Holger Cahill and American Art," *Archives of American Art Journal,* 31 (1991): 2–11.

20. Cahill quoted in Jeffers, "Holger Cahill and American Art," 5.

21. Cahill, "Art and Democracy."

22. The stress on art's usefulness as well as the desire to see the artist as a cultural worker parallels closely what Michael Denning calls the "laboring of American culture" in *The Cultural Front* (New York: Verso, 1999). As I will demonstrate in this chapter, however, the desire articulated by artists such as Stuart Davis to maintain a degree of artistic integrity—they are workers but special—complicates Denning's paradigm.

23. Stuart Davis, journal entry, August 27, 1937. In Stuart Davis Papers, Houghton Library, Harvard University.

24. Stuart Davis is an interesting character. For more on his life and art, see Patricia Hill, *Stuart Davis* (New York: Abrams, 1996); Lowery Stokes Sims, "Stuart Davis in the 1930s: A Search for Social Relevance in Abstract Art," in *Stuart Davis: American Painter* (New York: Metropolitan Museum of Art, 1992), 57–69; Diane Kelder, ed., *Stuart Davis* (New York: Praeger, 1971); Kelder, "Stuart Davis: Pragmatist of American Modernism," *Art Journal* 39 (Fall 1979): 35–36; and John R. Lane, *Stuart Davis* (Brooklyn: Brooklyn Museum, 1978), 40.

25. Davis, journal entry, June 24, 1937.

26. Davis, journal entry, August 27, 1937.

27. Davis, "The New York American Scene," 6. Following art historian John Lane, who argued that Davis was a "social pragmatist," Diane Kelder writes that Davis was also a cultural pragmatist. "The careful accumulation of 'data,' the insistence on a 'scientific procedure,' the . . . lengthy discussions of physical and philosophical issues, and the constant verification of working assumptions in a tangible drawing or diagram," she argues, "seem directly related to what William James termed 'the pragmatists' mission of transformation' [in this case of art, not philosophy] and its methods in the interests of all that is profitable to our lives." Kelder, "Stuart Davis: Pragmatist," 35–36; Lane, *Stuart Davis,* 40.

28. Davis, journal entry, June 1, 1938.

29. Stuart Davis, "Why an Artist's Congress," in Matthew Baigell and Julia Williams, eds., *Artists Against War and Fascism: Papers of the First American Artists Congress* (New Brunswick, N.J.: Rutgers University Press, 1986), 66–70.

30. Stuart Davis's journal entry for June 30, 1939, reads, "A people's art automatically implies a people who value art. The social duty of contemporary artists is to insist on their right as part of the people to participate in art. You can't participate in art by stopping the production of art. A democratic people's government must include the artists—Federal Art Project—government responsibility to art—people are worthy of art." And, his entry for January 10, 1938: "The factory worker, the doctor and the artist who are class conscious will agree that it is to their advantage as the members of a single class to support Roosevelt against the monopolies."

31. Davis, quoted in Kelder, ed., *Stuart Davis,* 14. In fact, Davis was so impressed by Hines's music that he named his son Earl.

32. For more on the relationship between Davis's paintings and jazz, see Hill, *Stuart Davis*; Sims, *Stuart Davis*; Kelder, "Stuart Davis: Pragmatist," and introduction to *Stuart Davis*.

33. Davis, letter to Edith Halpert regarding his art, in Davis File, Museum of Modern Art (hereafter MoMA) Library. In 1927, Halpert's Downtown Gallery began to represent Davis; she continued to represent him throughout the thirties.

34. Davis, journal entry, February 6, 1938.

35. "The world of modern art is the world of production, efficiency, quick transportation and communication." Stuart Davis, journal entry, January 10, 1938.

36. Davis, journal entry, July 5, 1936.

37. This chapter does not contain an in-depth artistic analysis of the paintings of either Grant Wood or Ben Shahn. I bring them up only to make the point that stylistically the "two sides" were similar. For more on Wood, see James M. Dennis, *Grant Wood: A Study in American Art and Culture* (Columbia: University of Missouri Press, 1986); Nancy Heller and Julia Williams, *Painters of the American Scene* (New York: Galahad Books, 1982); and Wanda Corn, *Grant Wood* (New Haven, Conn.: Yale University Press, 1983). For more on Shahn, see James Thrall Soby, *Ben Shahn* (New York: Braziller, 1963); and David Shapiro, *Social Realism* (New York: Ungar, 1973).

38. For example, throughout the decade, Thomas Hart Benton and Stuart Davis engaged one another in heated debate over what each considered to be the proper relationship between art and politics in American art. Both Benton and Davis self-consciously and very publicly depicted themselves as ideological and aesthetic spokesmen for each side of the politically polarized debate. Moreover, they each repeatedly challenged the other regarding the proper relationship between art and political ideology. Yet, despite their vociferous articulation of their different positions, even in the midst of their debates, Benton's and Davis's positions were often quite similar. Both men claimed an allegiance with the American worker. Furthermore, throughout their careers both men maintained that they were producing "democratic" and uniquely "American" art. Benton repeated over and over that his art was "the art of the United States," while Davis asserted, "I am an American, born in Philadelphia of American stock. I studied art in America, I paint what I see in America, in other words, I paint the American scene." Neither, however, was calling for the radical restructuring of American culture. Nor were they advocating for full desacralization, since each adhered to traditional notions of art as something unique. Yet both Benton and Davis believed that though their paintings, they were linking art and democracy. "Today the artist must take the side of Democracy," Davis announced. Similarly, Benton exclaimed, "In this new atmosphere of Democratic liberalism . . . [we must push] our arts into wide public attention." For both men, this freedom was stylistic. Democracy in art would enable them to paint the subjects they pleased in whatever manner they desired. Davis, journal entry, August 27, 1937.

39. Moses Soyer is pictured in the lower right corner while his assistants work on his mural *Children at Play*.

40. Rockwell Kent quoted in Frances Pohl, "Rockwell Kent and the Vermont

Marble Workers," paper given to the American Historical Association annual meeting, January 2001, Boston.

41. Kent's desire for a "good life" recalls the struggles for "Eight hours for what we will," explored in Roy Rosenzweig's study of industrial workers in Worcester, Massachusetts, *Eight Hours for What We Will* (New York: Cambridge University Press, 1983).

42. "Kent's interest and involvement in the labor movement are reflected in correspondence with officials and members of a wide variety and large number of unions and related organizations, among them the Farmers' Educational and Cooperative Union of America, Farmers' Union of the New York Milk Shed, International Workers Order, National Maritime Union, and United Office and Professional Workers of America. Of special interest is his participation, often in leadership roles, in various attempts to organize artists. From the "Series Description" to the Rockwell Kent Papers, AAA, *http://artarchives.si.edu/findaids/kentrock/kentrock_m7.htm*.

43. John C. Rogers, "Art and Freedom," *Art Front* (December 1936): 15.

44. Robert Gwathmey interview in Studs Terkel, *Hard Times* (New York: Pantheon, 1970), 374.

45. Harold Rosenberg, *Art on the Edge* (New York: Macmillan, 1975), 197.

46. "Draft Manifesto of the John Reed Clubs," *New Masses* (June 1932): 14.

47. John Reed Club statement, *Creative Art* (March 1933): 1.

48. This debate is more complicated than my brief representation would make it appear. Erika Doss addresses it in part in her analysis of Thomas Hart Benton, *From Regionalism to Abstract Expressionism* (Chicago: University of Chicago Press, 1991); Cecile Whiting also treats it in more depth in *Antifascism and American Art* (New Haven, Conn.: Yale University Press, 1989). See also Serge Guilbaut, *How New York Stole the Idea of Modern Art* (Chicago: University of Chicago Press, 1983); Miriam and David Shapiro, *Art as a Weapon* (New York: Ungar, 1973); and Baigell and Williams, *Artists Against War and Fascism*.

49. Unemployed Artists' Group Manifesto quoted in Gerald Monroe, "The Artists' Union of New York," *Art Journal* 32, no. 1 (Fall 1972): 17. For more on the Artists' Union, see David Shapiro, "Social Realism Reconsidered," in Shapiro, ed., *Social Realism; Art as a Weapon*; Francine Tyler, "Artists Respond to the Great Depression and the Threat of Fascism," Ph.D. diss., New York University, 1991.

50. Robert Jay Wolff, "The Artists' Union in Chicago," in O'Connor, *Art for the Millions*.

51. Peyton Boswell, *Art Digest* 1 (March 1936): 3.

52. Stuart Davis, "The Artist Today: The Standpoint of the Artists' Union," *American Magazine of Art* (August 1935): 476.

53. Editorial page, *Art Front* (November 1934).

54. Front cover, *Art Front* (January 1935).

55. Audrey McMahon, "Art in Democracy," radio address, August 26, 1938, WEVD, transcript in box 76, RG69, NA.

56. Philip Evergood quoted in John I. H. Baur, *Philip Evergood* (New York: Praeger, 1960), 52.

57. Davis, "Why an Artist's Congress," 66–70.

58. George Biddle to Franklin D. Roosevelt, May 9, 1933, reprinted in Biddle, *American Artist's Story*, 269–70.

59. Cahill, "The WPA Federal Art Project, A Summary of Activities and Accomplishments" (1938), box 2062, RG69, p. 22, NA.

60. Cahill, "WPA Federal Art Project."

61. Robert Cronbach, "The New Deal Sculpture Projects," in O'Connor, *New Deal Art Projects*, 140.

62. Suzanne LaFollette, review of Federal Art Project at Museum of Modern Art, *Nation* (October 16, 1936).

63. Thaddeus Clapp quoted in O'Connor, *Art for the Millions*, 206.

64. Cronbach, "New Deal Sculpture Projects," 140.

65. Art historian Helen Langa identifies a similar experience for artists employed in the Graphic Division of the Federal Art Project. She writes that these artists "discovered that waged labor presented them with not only some economic security, but also the unforeseen benefits of comradeship and cooperation, as well as new possibilities for experimentation in subject and technique and new opportunities to exhibit their works to an unusually wide audience." Helen Langa, "Modernism and Modernity During the New Deal Era," *SECAC Review*, 274.

66. Cronbach, "New Deal Sculpture Projects," 140.

67. Gwathmey interview in Terkel, *Hard Times*, 374.

68. Jacob Kanien, "The Graphic Division of the FAP," in O'Connor, *Art for the Millions*, 166.

69. Black intellectuals promoted the idea that racial prejudice could be gradually eliminated through the arts. For example, in *Black Manhattan* (New York: Dial Press, 1929), James Weldon Johnson announced, "Through his artistic efforts the Negro is smashing [an] immemorial stereotype faster than he has ever done . . . impressing upon the national mind the conviction that he is a creator as well as a creature . . . helping to transform American civilization." During the 1920s, Harlem was celebrated by blacks and whites alike as the "greatest Negro city in the world." Describing Harlem in the 1920s, Johnson proclaimed that "it had movement, color, gaiety, singing, dancing, boisterous laughter and loud talk" (283–84).

70. In March 1925, Locke, the first black Rhodes scholar and head of the philosophy department at Howard University, guest-edited the March 1935 issue of *Survey Graphic*, which was devoted to the arts in Harlem. Locke's essay in the collection, entitled "The New Negro," linked the artwork of blacks in Harlem with the arts of Africa, and by association with African influences on European modernism.

71. Langston Hughes quoted in introduction to the Viking Portable Library *Langston Hughes* (New York: Penguin Books, 1976), 2.

72. Robert Blackburn interview with Paul Cummings for the Archives of American Art, December 4, 1970. Transcript in AAA.

73. Jacob Lawrence interview with Wheat quoted in Wheat, *Jacob Lawrence* (Seattle: University of Washington Press for the Seattle Art Museum, 1987), 28.

74. Romare Bearden and Harry Henderson, *A History of African American Artists* (New York: Pantheon, 1993), 227. I do not want to gloss over the difficulties that blacks faced during the Depression. As Cheryl Lynn Greenberg has convinc-

ingly argued in *Or Does It Explode?* (New York: Oxford University Press, 1991), in many ways the Depression was worse for blacks than for whites. Moreover, despite their newfound status as members of the American working class, artists still faced hardships and negative critiques—particularly as the Federal Art Project increasingly came under attack.

75. Clippings from *Chicago Tribune,* December 19, 20, 22, 1940, in RG69/DI, NA.

76. Holger Cahill to Ellen Woodward, "Report on the First Three Years of the Federal Art Project," September 21, 1938, box 2, Cahill Papers, AAA.

77. Holger Cahill, speech to the Southern Women's National Democratic Organization, December 6, 1936, New York, speeches, reel 0284, Cahill Papers, AAA.

78. Cahill quoted in NA, Federal Art Project Manual, Work Projects Administration (Washington, D.C.: 1935), 1.

79. Thomas Pancer, "Development of Community Art Centers" speech before 30th Annual convention of the American Federation of Art May 19, 1939 copy in RG69/2115.

80. Lucienne Bloch, "Murals for Use," in O'Connor, *Art for the Millions,* 76–77. For more on the WPA mural projects, see Harris, *Federal Art and National Culture*; Hills, *Social Concern and Urban Realism* (Boston: Boston University Art Gallery, 1983); Marling, *Wall to Wall America*; Melosh, *Engendering Culture*; Park and Markowitz, *Democratic Vistas* (Philadelphia: Temple University Press, 1984); and McKinzie, *A New Deal for Artists.*

81. Lawrence Dermondy, letter, reel 91, Norman Lewis Papers, AAA.

82. Charles Alston to Audrey McMahon, reel 91, Norman Lewis Papers, AAA.

83. For more on Rivera's mural, see Laurence Hurlburt, *The Mexican Muralists in the United States* (Albuquerque: University of New Mexico Press, 1989).

Chapter 2: Future Citizens and a Usable Past

1. For more on the iconography of New Deal murals, see Karal Anne Marling, *Wall to Wall America* (Minneapolis: University of Minnesota Press, 1982); and Barbara Melosh, *Engendering Culture* (Washington, D.C.: Smithsonian Institution Press, 1991).

2. Holger Cahill interview in *Time* (September 5, 1938): 35.

3. Daniel Defenbacher, "Art in Action," in Francis V. O'Connor, ed., *Art for the Millions* (Boston: New York Graphic Society, 1973), 226.

4. Parker, speech before the Art Reference Round Table Group of the American Library Association, June 14, 1938, Kansas City, Missouri, box 2, Cahill Papers, AAA.

5. Cahill, notes for 1937 speech, box 1, uncataloged Cahill Papers, AAA.

6. The manual was published in October 1937 as WPA Art Circular no. 1, *A Manual for Federally Sponsored Community Centers,* MoMA Library.

7. Parker, speech before the Art Reference Round Table Group.

8. Parker, speech before the Art Reference Round Table Group.

9. Thomas Parker, speech before the General Conference of the 35th Annual Meeting of American Teachers Association, July 29, 1938, Tuskegee Institute, reel 1105, AAA.

10. Mrs. E. P. Roberts to Cahill, December 10, 1935, Cahill Papers, pp. 181–82, AAA.

11. In a review of the 1935 YWCA exhibition for the *New York Post* ("View of the Above Exhibit," May 1, 1935), Jerome Klein wrote, "New York has exploited the celebrated music and dancing of Harlem, but it has been scarcely aware of that community's painters and sculptors." This exhibition, he asserted, would change that. Another reviewer exclaimed, "At last Harlem is going to have a chance to see itself as Harlem sees it. . . . The show, the first of its kind to be given in Harlem—or, as far as it is known, in any part of the city—will indeed attempt to record the life of Harlem in every respect." Reel 91, frame 22, Norman Lewis Papers, AAA.

12. A sample report from Audrey McMahon to Paul Edwards, "re. Events of the Week March 14–19, 1938 on the Federal Art Project," read as follows: "The Harlem Community Art Center continues to attract widespread public interest. Last week it was visited by a group of 35 students from Middlebury, Vermont, on March 18. The next day a group of 80 students from Montclair Teachers College, Montclair, New Jersey visited the center. Also 15 girls from 11 to 15 years of age under the sponsorship of Miss Sumpter and Miss Clark of the 137th Street branch of the Y.W.C.A. visited the various classes and as a result of this visit 10 of them registered for work in the Center. The Harlem CAC promises to be a model for other art centers. A recent visitor to the center from Salt Lake City Utah, Miss Caroline K. Parry, plans to establish an art center in that city using many ideas derived from the Harlem Community Art Center," Box 2, Cahill Papers, AAA.

13. Harlem artist Vertis Hayes praised the Federal Art Project for "sharing in a broad cultural program" in which "the cultural standard of this country will be determined." Prior to the WPA and the establishment of art centers like the one in Harlem, he argued, "the area around Fifth Avenue, Madison Avenue, and 57th Street" dominated the national art scene. "57th Street alone," he claimed, "perhaps has more galleries than any other three cities combined." Furthermore, he continued, "There are more Negro artists living in New York than any other city, yet most of the art galleries exclude work done by Negroes from any of their exhibitions." Hayes saluted the Harlem Community Art Center as a first step in rectifying this inequality and for instigating a cultural remapping of New York City and the country as a whole. The center, Hayes wrote, "has become an active cultural force filling a long neglected need in Harlem." It "stands as a tribute to the Federal Art Project and a service to the community without which it would be a great deal poorer." Vertis Hayes, "The Negro Artist Today," in Francis V. O'Connor, ed., *An Art for the Millions* (Boston: New York Graphic Society, 1973), 210–12.

14. Parker, speech before the Art Reference Round Table.

15. From WPA Record Group 69, reel DC54, AAA.

16. Correspondence between Cahill and McDonald-Wright, box 2, uncataloged Cahill Papers, AAA.

17. For more on this subject, see Jonathan Harris, *Federal Art and National Culture* (New York: Cambridge University Press, 1995), 28–43.

18. Cahill, notes for 1936 speech, box 1, uncataloged Cahill Papers, AAA.

19. "The Artist Teaches," n.d., microfilm reel 1107, Cahill Papers, AAA.

20. "The Artist Teaches."

21. Cahill, notes for 1939 speech, box 1, uncataloged Cahill Papers, AAA.

22. Article by Samuel Friedman for Frances Pollack, Department of Information, Federal Art Project, October 12, 1936, box 7, in Cahill Papers, AAA.

23. Cahill, draft for 1937 speech, box 1, uncataloged Cahill Papers, AAA.

24. Cahill, "The WPA Federal Art Project: A Summary of Activities and Accomplishments" (1938), box 2062, RG 69, p. 18, NA.

25. Cahill, "Art and Democracy," speech, June 7, 1938, Town Hall, New York City, box 1, Cahill Papers, AAA.

26. Irving J. Marantz, "The Artist as Social Worker," in O'Connor, ed., *Art for the Millions*, 197–98.

27. Article by Samuel Friedman for Frances Pollack, Department of Information, Federal Art Project, October 12, 1936, box 7, in Cahill Papers, AAA.

28. "Art and Medicine," *Hygiene Magazine* (May 1939): 408.

29. Gwendolyn Bennett, "The Harlem Community Art Center," in O'Connor, ed., *Art for the Millions*, 213.

30. Article by Samuel Friedman for Frances Pollack, Department of Information, Federal Art Project, October 12, 1936, Box 7, Cahill Papers, AAA.

31. Cahill used the term "usable past" often. Originally coined by Van Wyck Brooks in his essay for *Dial* (April 11, 1918), the desire to locate cultural forms from America's past to use in the future took off during the 1930s. See Alfred Haworth Jones, "The Search for a Usable Past in the New Deal Era," *American Quarterly* 23, no. 5 (December 1971): 710–724; Warren Susman, "History and the Intellectual: The Uses of a Usable Past" and "Culture and Commitment," both in *Culture as History* (New York: Pantheon, 1984), 7–26; 184–210; and Joan Shelley Rubin, "Constance Rourke in Context: The Uses of Myth," *American Quarterly* 28, no. 5 (Winter 1976): 575–588.

32. Holger Cahill, introduction to Erwin Christensen, *The Index of American Design* (Washington, D.C.: Smithsonian Institution Press, 1950), xiii. Much of the information regarding the history of the index comes from this essay.

33. In spring 1936, C. Adolph Glassgold succeeded Ruth Reeves as national coordinator. In 1940, Glassgold was succeeded by Benjamin Knotts.

34. Rourke's landmark 1931 study, *American Humor*, is subtitled *A Study in National Character*. Rourke located American vernacular culture in folk heroes such as Davy Crockett and Paul Bunyan and in folk types such as minstrel men, Yankee peddlers, and backwoodsmen in folk art. She was also interested in folk art, in particular African American traditions and Shaker furniture and barns. Her essay "The Roots of American Culture" addresses similar themes. For more on Rourke, see Joan Shelley Rubin, *Constance Rourke and American Culture* (Chapel Hill: University of North Carolina Press, 1980); Rubin, "Constance Rourke in Context"; and Rubin, "A Convergence of Vision: Constance Rourke, Charles Sheeler, and American Art," *American Quarterly* 42, no. 2 (June 1990): 191–222.

35. Constance Rourke, "What Is American Design?" in O'Connor, *Art for the Millions*, 165–67.

36. Cahill, introduction to Christensen, *Index of American Design*, xiv.

37. "Undoubtedly," Cahill argued in his introduction, "these changes were stimulated by the needs of an agricultural civilization in a forest frontier where every acre of farmland had to be cleared of trees. Possibly useful hints came from the eastern Pennsylvania wedge ax which had no cutting edge. Perhaps the two developments came independently. In any event we have here a tool transformed into something more useful and beautiful than anything in its ancestry" (xvi).

38. Cahill, introduction to Christensen, *Index of American Design*, xvi.

39. "Problems of distortion and of lighting are difficult. The Camera cannot search out the forms of objects deeply undercut or modeled in high relief, match color as closely as the artist or render the interplay of form, color and texture which creates the characteristic beauty of so many products of early American craftsmen" (xiv–xv).

40. Such a position closely mirrors Benjamin's as outlined in "The Work of Art in the Age of Mechanical Reproduction," in *Illuminations*, ed. Hannah Arendt (New York: Schocken Books, 1968). The use of the term "essence" directly evokes his notion of "aura," as discussed in the Introduction to this book.

41. Cahill, introduction to Christensen, *Index of American Design*, xvi.

42. Cahill, introduction to Christensen, *Index of American Design*, xi.

43. Benjamin Knotts, foreword to *I Remember That* (New York: Metropolitan Museum of Art, 1942).

44. Holger Cahill, *Emblems of Unity and Freedom* (New York: Metropolitan Museum of Art), 1942, n.p.

45. Cahill, introduction to Christensen, *Index of American Design*, xvi.

46. Ralph M. Easley to Franklin Roosevelt, July 9, 1937, reel 1084, Francis V. O'Connor Papers, AAA.

47. Elizabeth Dilling, *The Roosevelt Red Record and Its Background* (1936). In addition, Dilling argued: "Just as Socialism proposes to enforce sex equality and rob mankind of its natural birthright of an individual mother and father and home, of belief in God and His commandments, so it proposes to obliterate racial lines everywhere by enforcing social equality and social intermingling and promoting inter-breeding. The inter-racial idea is one of the strongest dogmas of Socialism-Communism. Wholesome, self-respecting, honest friendship between the separate races is not what is sought at all. This is bitterly derided as mere 'bourgeois' race 'chauvinism' or pride. There must be complete surrender of individuality, blending and inter-marriage to satisfy Communist objectives." Selections reprinted in David Brion Davis, ed., *The Fear of Conspiracy* (Ithaca, N.Y.: Cornell University Press, 1971), 273–76.

48. Each theme was broken down into categories of presentation: "Forum," "Theater," "Exhibits," "Studio," and "Outside tie-ups." Cahill, "Supplement to the Community Art Center Manual," reel DC54, RG 69, AAA.

49. Parker, speech to the Twenty-fifth Conference of Settlements, May 22, 1937. Parker specifically attacked Thomas Craven as the "splenetic art commentator for Mr. Hearst." He continued, "Craven's short-sighted plan of a program consisting of a group of hand picked geniuses would do nothing to correct the unequal distribution that existed in America before the advent of the Federal Art Project."

Furthermore, he argued, "Historians will some day describe our era as a period of gigantic forces changing with blinding rapidity." Notes for speech in Federal Arts project papers reel 1105, AAA.

50. In her recent book, *A Consumer's Republic* (New York: Knopf, 2003), Lizabeth Cohen charts the emergence of increased awareness of consumption in government policy as well as a growing turn toward private consumer activism during the Great Depression. As Cohen points out, historians differ on the dating of this shift, with some tracing the emergence of a consumer ethos to the early days of the Republic. For more on this subject, see Christopher Clark, *The Roots of Rural Capitalism* (Ithaca, N.Y.: Cornell University Press, 1992); Neil McKendrick, John Brewer, and J. H. Plumb, *The Birth of a Consumer Society* (Bloomington: Indiana University Press, 1982); and Lawrence B. Glickman, ed., *Consumer Society and American History* (Ithaca, N.Y.: Cornell University Press, 1999).

51. For more on the shift to a consumption–based culture, see all of the articles in Richard Wightman Fox and Jackson Lears, eds., *The Culture of Consumption* (New York: Pantheon, 1983); Stuart Ewen, *Captains of Consciousness* (New York: McGraw-Hill, 1976); Roland Marchand, *Advertising the American Dream* (Berkeley: University of California Press, 1985); and Michele Bogart, *Artists, Advertising, and the Borders of Art* (Chicago: University of Chicago Press, 1995).

52. Robert S. Lynd and Helen Merrell Lynd, *Middletown* (New York: Harcourt Brace, 1929), 80, 88. Buying became intimately tied to community life. Middletown's credo that buying locally was "good for the nation and good for the community" mirrored changes in New Deal policy.

53. Cahill, "Supplement to the Community Art Center Manual."

54. Parker, speech to the Twenty-fifth Conference of Settlements, May 22, 1937.

Chapter 3. Democracy in Design

1. *Fashions of the Hour* was essentially an annotated catalog "published several times a year and distributed gratuitously to readers all over the country who wish to order by mail through the personal Shopping Bureau." From *The Store Book, Marshall Field and Company* (Chicago: Marshall Field, 1933), 37. *Fashions of the Hour* was just one component in the implementation of "the Marshall Field and Company Idea," which was "to do the right thing at the right time, in the right way; to do some things better than they were ever done before; to eliminate errors; to know both sides of the question; to be courteous; to be an example; to love our work; to anticipate requirements; to develop resources; to recognize no impediments; to master circumstances; to act from reason rather than rule; to be satisfied with nothing short of perfection" (endpiece, *The Store Book*).

2. Sarah Carr to Alfred Barr, January 15, 1930, series 9, roll 3262, Alfred Barr Papers, AAA.

3. Barr to Carr, January 1930. Barr papers, series 9, roll 3262, AAA.

4. Regarding the skyscraper bookcase, Barr complained that "the designer

asserted that our furniture should reflect the most characteristic forms of our architecture. He then proceeded to design bureaus and book-cases reminiscent of skyscrapers but absurdly impractical because they were too irregular, too high, and the shelves frequently opened at opposite sides of the casing. Similarly cubist chairs and tables," he continued, "were uncomfortable and because of their insistent angularity, tiresome to the eye" (Barr, "The Modern Chair," manuscript for Marshall Field and Company's *Fashions of the Hour*, series 9, roll 3263, Barr Papers, AAA).

5. For more on these distinctions, see Terry Smith, *Making the Modern* (Chicago: University of Chicago Press, 1993).

6. For many, the idea of consumer culture presents a contradiction in terms, since, as Don Slater writes in *Consumer Culture and Identity* (Malden, Mass.: Polity Press, 1997), "culture has been defined as the social preservation of authentic values that cannot be negotiated by money and market exchange"(25). The idea of cultural democracy in the marketplace plays upon this contradiction by leveling the playing field—anyone with a dollar has equal access to cultural uplift. Slater ties this directly to the creation of identity in modern societies: "Modern identity is best understood through the image of consumption. We choose a self-identity from the shop window of the pluralized social world; actions, experiences and objects are all reflexively encountered as part of the need to construct and maintain self identity. . . . Identity itself can be seen as a saleable commodity. Self is not an inner sense of authenticity but rather a calculable condition of social survival and success." (85). The relationship between self-identity and the marketplace has been the subject of much critical analysis. For Frankfurt School theorists such as Herbert Marcuse, Theodor Adorno, and Max Horkheimer, there is no possibility for an authentic self within mass culture or the "culture industry," since for them, consumer culture marks the absence of the oppositional culture needed to promote critical consciousness and individual agency and instead reduces individuals to members of the mass. See, in particular, Theodor Adorno and Max Horkheimer, *The Dialectic of Enlightenment*, trans. John Cumming (New York: Herder and Herder, 1972); and Herbert Marcuse, *One Dimensional Man* (Boston: Beacon Press, 1964). For an application of this reasoning in the United States, see C. Wright Mills, "The Cultural Apparatus," in *Power, Politics, and People; The Collected Essays of C. Wright Mills*, ed. Irving Louis Horowitz (New York: Oxford University Press, 1963). For cultural studies practitioners, however, there is room within mass-produced cultural forms for the emergence of both an oppositional culture and an authentic self. See, for example, the work of Birmingham theorists such as Dick Hebdige, John Fiske, and Angela McRobbie for the ways in which this is possible. Dick Hebdige, *Subculture: The Meaning of Style* (New York: Routledge, 1981); John Fiske, *Reading the Popular* (Boston: Unwin Hyman, 1989); and Angela McRobbie, "Settling Accounts with Subculture," in Tony Bennett, ed., *Culture, Ideology, and Social Process* (London: Open University Press, 1980). In the United States, the work of Janice Radway, *Reading the Romance* (Chapel Hill: University of North Carolina Press, 1984); and Tricia Rose, *Black Noise* (Middletown, Conn.: Wesleyan University Press, 1994), also provide excellent challenges to Frankfurt School pessimism about the radical potential of mass culture.

7. Neil Harris, Philip Fisher, William Leach, and Tony Bennett have all writ-

ten about the similarities between museum and department store display techniques. See Neil Harris, *Cultural Excursions* (Chicago: University of Chicago Press, 1990); Philip Fisher, *Making and Effacing Art* (New York: Oxford University Press, 1991); William Leach, *Land of Desire* (New York: Pantheon, 1993); and Tony Bennett, The *Birth of the Museum* (New York: Routledge, 1995). For more on the relationship between consumer culture and middlebrow aesthetics, see Joan Shelley Rubin, *The Making of Middlebrow Culture* (Chapel Hill: University of North Carolina Press, 1992).

8. See Leach, *Land of Desire*; and Harris, *Cultural Excursions.*

9. Barr, "Modern Chair," 13.

10. I am not sure who coined the phrase "democracy in design," but it it is used in MoMA press releases for the *Machine Art* and *Useful Objects* shows as well as in many of the reviews of these shows. See MoMA clippings scrapbooks and press releases for *Machine Art* and the *Useful Objects* shows, MoMA Archives.

11. Andreas Huyssen famously articulated the relationship between gender and cultural hierarchies in his essay "Mass Culture as Woman: Modernism's Other," in *After the Great Divide* (Bloomington: Indiana University Press, 1986).

12. Barr, "Modern Chair," 13.

13. For more on the feminization of consumption, see Susan Porter Benson, *Counter Cultures* (Urbana: University of Illinois Press, 1986); Kathy Peiss, *Cheap Amusements* (Philadelphia: Temple University Press, 1986); Elaine Abelson, *When Ladies Go A-Thieving* (New York: Oxford University Press, 1989); and Nan Enstad, *Ladies of Labor, Girls of Adventure* (New York: Columbia University Press, 1999).

14. Alan Wallach, in *Exhibiting Contradiction* (Amherst: University of Massachusetts Press, 1998), identifies the early years of MoMA as its "utopian" period, marked by "a process of experimentation, of trial and error out of which emerged a complex modernist aesthetic construct. . . . In the process," he argues, "MoMA produced a history of modernism that justified this aesthetic [and] made it seem historically inevitable" (75). For Wallach, the utopian period was followed by periods of vindication and nostalgia. He concludes that "the history of MoMA . . . is not simply a history of policies and persons but also a history of 'mutation'" (87). I agree with Wallach that in understanding modernism's past—and present—it is important to view all of the stages of this mutation, not just the later two.

15. From MoMA mission statement published in the Bulletin of the Museum of Modern Art (hereafter MoMA Bulletin) (November 1929): 1.

16. The trustees of the Albright Museum, in Buffalo, N.Y., found Goodyear's embrace of modern art shameful; Bliss, Quinn, and Rockefeller saw it as evidence of a kindred spirit.

17. For more on the relationship between Barr's missionary zeal and his upbringing, see Alice Goldfarb Marquis, *Alfred H. Barr, Jr.: Missionary for the Modern* (New York: Contemporary Books, 1989); and Sybil Gordon Kantor, *Alfred H. Barr, Jr., and the Intellectual Origins of the Museum of Modern Art* (Cambridge, Mass.: MIT Press, 2002).

18. Quoted in Alfred H. Barr, *Painting and Sculpture in the Museum of Modern Art, 1929–1967* (New York:' MoMA, 1967), 620.

19. Alfred Barr, *A New Art Museum* (New York: MoMA, 1929), n.p.

20. For more on the relationship between concepts of "high" and "low" culture and modernism, see Huyssen, *After the Great Divide*; and "High and Low in an Expanded Field," *Modernism/Modernity* 9, no. 3 (September 2002): For Huyssen, "The term Great Divide not only referred to the imaginary divide between mass culture and modernism, but also to the other divide so central to debates at the time, namely that between modernism and postmodernism. A main argument of Huyssen's study was that both divides were generated by very specific political and aesthetic constellations and were always belied by the complexities of real relations in artistic practices" ("High and Low," 373, n. 7). The Museum of Modern Art's early classification systems are a good example of such constellations.

21. Kantor argues that "Barr's openness to the complexities of modernism was unjustly ignored" (*Barr*, 241).

22. For more on the differences between the art historical approaches of Princeton and Harvard, see Kantor, *Barr*, chapters 1–4.

23. Barr quoted in Kantor, *Barr*, 34.

24. Paul Sachs, "Tales of an Epoch," vol. 15, pt. 2, p. 2359, January 1959 in Paul Sachs Director's Files, Fogg Art Museum Archives. Transcribed copy in Columbia University Oral History Office.

25. Alfred Barr, *Modern Works of Art: Fifth Anniversary Exhibition* (New York: MoMA, 1935), 11.

26. Alfred Barr, *The Public as Artist*, MoMA Bulletin (1932).

27. Margaret Scolari Barr, interview with Paul Cummings, Barr papers February 22 and April 8, 1974, AAA.

28. Alfred Barr and Holger Cahill, eds., *Art in America in Modern Times* (New York: Reynal and Hitchcock, 1934).

29. Artemas C. Packard quoted in Carol Morgan, "From Modernist Utopia to Cold War Reality" in Barbara Rose, ed., *The Museum of Modern Art at Mid-Century* (New York: Museum of Modern Art and Thames & Hudson, 1995), 153.

30. Morgan, "From Modernist Utopia to Cold War Reality, " 155.

31. Alfred Barr quoted in Marquis, *Alfred H. Barr*, 41.

32. Douglas Crimp notes in *On the Museum's Ruins* (Cambridge, Mass.: MIT Press, 1993) that to celebrate its fiftieth anniversary, MoMA mounted an exhibition entitled *Art of the Twenties*. He writes, "indeed a major impression left by the show was that aesthetic activities in the 1920s was wholly dispersed across the various mediums, that painting and sculpture held no hegemony at all" (66). *Art of the Twenties* was overshadowed that year by the blockbuster exhibition *Pablo Picasso: A Retrospective*, which left a much different impression about the primacy of painting and sculpture within MoMA's history of modernism.

33. A. Conger Goodyear, foreword to *American Painting and Sculpture* (New York: MoMA, 1932), 7.

34. Alfred Barr to Dorothy Miller, October 10, 1940, quoted in Kantor, *Barr*, 237. He did say, however, that "the tendency of the public [is] to identify art with painting and sculpture—two fields in which America is not yet, I'm afraid, quite the equal of France."

35. Cahill, *American Sources of Modern Art* (New York: MoMA, 1933), 22.

36. The Museum of Modern Art held a number of shows that combined an-

thropological exhibitions with modern art. Among them were *Twenty Centuries of Mexican Art* (1940), *Indian Art of the United States* (1941), and *African Art*. For more on these shows, see Shelly Errington, *The Death of Authentic Primitive Art* (Berkeley: University of California Press, 1998); Mary Anne Staniszewski, *The Power of Display* (Cambridge, Mass.: MIT Press, 1998); George Marcus and Fred Meyers, eds., *The Traffic in Culture* (Berkeley: University of California Press, 1995); Janet C. Berlo, *The Early Years of Native American Art History* (Seattle: University of Washington Press, 1992); and W. Jackson Rushing, *Native American Art and the New York Avant-Garde* (Austin: University of Texas Press, 1995).

37. Cahill, *American Sources of Modern Art*, 1.

38. Cahill, *American Folk Art: The Art of the Common Man in America, 1750–1900* (New York, MoMa, 1932), 3.

39. Cahill's positing of feeling as a source of value in many ways parallels that delineated by Raymond Williams in "A Structure of Feeling." For more on Williams see Terry Eagleton, ed., *Raymond Williams: Critical Perspectives* (Boston: Northeastern University Press, 1989).

40. To qualify as a high-quality product a piece must "achieve the formal ideas of beauty which have become the major stylistic concepts of our time." Barr and Johnson were more flexible concerning historical significance. This category, they wrote, "applies to objects not necessarily works of art but which nevertheless have contributed importantly to the development of design." Quoted in Arthur Drexler and Greta Daniel, *Introduction to Twentieth Century Design from the Collection of The Museum of Modern Art* (Garden City, N.Y.: Doubleday, 1959), 4.

41. Philip Johnson, "The Modern Room," in Alfred Barr and Holger Cahill, eds., *American Art* (New York: MoMA, 1934), 130.

42. At the end of the decade, however, John McAndrew, curator of the Architecture and Industrial Design Department following Johnson, began to point out examples of the "modernistic" in articles and museum publications.

43. Crucial to this was the idea of consumer choice, or freedom in the marketplace. For more on the links between consumer sovereignty and active citizenship, see Slater, *Consumer Culture*, 36–39, and chapters 4, "The Culture of Commodities," and 5, "The Meaning of Things" (100–147).

44. Johnson, "Modern Room," 130.

45. For more on the creation of "aura" and the relationship between art and mass production, see Walter Benjamin, "The Work of Art in the Age of Mechanical Reproduction," in *Illuminations*, ed. Hannah Arendt (New York: Schocken Books, 1968), 217–52.

46. Series 9, Barr Papers, AAA.

47. Alfred Barr, *Museum of Modern Art Annual Report (1938)*. Chronologically filed annual report in MoMA Archives.

48. Barr quoted in MoMA press release for *Useful Objects Under Five Dollars*, n.d., folder 116, MoMA Archives. The press release templates, such as this one, were not dated, since the same press release was sent to stop after stop on the show's circuit.

49. Plato and Thomas Aquinas quoted in Barr and Johnson, *Machine Art* (New York: MoMA, 1934), n.p.

50. L. P. Jacks quoted in Barr and Johnson, *Machine Art*, n.p.

51. Barr, introduction to *Machine Art*, 2.

52. In the nineteenth century, Johnson claimed, "Machines made bad designs while good designs continued to be executed by primitive methods" (*Machine Art*, n.p.).

53. Johnson, *Machine Art*, n.p.

54. "About the House Column," *New Yorker; New York Sunday Journal and American*, n.d., press clippings for *Machine Art*, MoMA Archives.

55. Samuel Kootz letter printed as "Postscript to Useful Objects Exhibition," MoMA Bulletin 6, no. 6 (January 1940): 6, MoMA Archives.

56. Gorham exchange listed alphabetically in *Machine Art* correspondence, MoMA Archives.

57. John Woodman Higgins, speech to the New England Conference of the American Association of Museums, Worcester, Mass., October 1933. Copy of speech in miscellaneous Industrial Design Folder, MoMA Library.

58. *Boston Transcript*, March 17, 1934, in MoMA publicity scrapbooks, MoMA Archives.

59. Form letter to lenders in *Machine Art* show, *Machine Art* file, MoMA Archives.

60. Amelia Earhart quoted in publicity documents, *Machine Art* file, MoMA Archives.

61. *Springfield (Mass.) Republican*, March 14, 1934, MoMA publicity scrapbooks, n.p., MoMA Archives.

62. Press releases, MoMA Archives. These are just a few examples of the museum's attempts to convince female viewers/consumers that the goods on display were art.

63. Gwendolyn Wright, *Moralism and the Modern Home* (Chicago: University of Chicago Press, 1980); Dolores Hayden, *Redesigning the American Dream* (New York: Norton, 1984); Ellen Lupton, *Mechanical Brides* (New York: Cooper-Hewitt National Museum of Design; Princeton, N.J.: Princeton University Press, 1993).

64. *Retailing Magazine*, December 20, 1940, publicity documents, MoMA Archives.

65. For more on art and department stores, see Leach, *Land of Desire*; Harris, *Cultural Excursions*; and Benson, *Counter Cultures*.

66. Robert W. deForest quoted in Zelda F. Popkin, "Art: Three Aisles Over," *Outlook and Independent* 156 (November 16, 1930): 515.

67. Frederick Kiesler, *Contemporary Art Applied to the Store and Its Display* (New York: Bretano, 1930), 66–68.

68. "Art in Store Windows," *Art Digest* (April 15, 1937): 27.

69. Polly Petit, "Art in Display," *American Magazine of Art* 29, no. 12 (December 1936): 824.

70. *New Yorker*, n.d., publicity scrapbooks, MoMA Archives.

71. For more on the alleged link between consumption and happiness, see Roland Marchand, *Advertising the American Dream* (Berkeley: University of California Press, 1985).

72. In rather opaque language the two men defined the International Style as

marked first by "a new conception of architecture as volume rather than mass"; second by "regularity rather than axial symmetry . . . as the means of ordering design"; and third by the proscription of "arbitrary applied decoration." Nevertheless, they warned that "this new style is not international in the sense that the production of one country is just like that of another," nor did it erase the visions of individual architects; rather, the international style resulted from what they perceived as the emergence of parallel trends in architecture across the Western world. Johnson and Hitchcock, *The International Style: Architecture Since 1922* (New York: MoMA, 1932), 22.

73. Carol Aronovici, ed., foreword to *America Can't Have Housing* (New York: MoMA, 1934).

74. Walter Gropius, "Minimum Dwellings and Small Buildings," 41–43; Abraham Goldfeld, "The Management Problem in Public Housing," 66–68; Lewis Mumford, "The Social Imperatives in Housing," 15–19, all in Aronovici, *America Can't Have Housing*.

75. *Boston Herald*, October 24, 1934; *New York Times*, May 27, 1934.

76. From MoMA press release, published in *Terre Haute Tribune*, June 11, 1934, and in *Commonweal*, June 8, 1934, n.p., MoMA publicity scrapbooks, MoMA Archives.

77. Philip Johnson interview with Sybil Kantor, 1989, quoted in Kantor, *Barr*, 284.

78. *Elizabeth (N.J.) Journal*, November 2, 1934; *Bennington Banner*, March 6, 1936, MoMA publicity scrapbooks for *America Can't Have Housing*, n.p., MoMA Archives.

79. *Park Avenue Social Review* (June 1934): 22.

Chapter 4. Art and Democracy in the World of Tomorrow

1. F. Scott Fitzgerald, *The Great Gatsby* (New York: Scribner, 1925), 26.

2. Robert Moses quoted in Robert A. Caro, *The Power Broker* (New York: Vintage Books, 1975), 1082–83.

3. Frontispiece to fair souvenir book, *New York World's Fair Views* (New York: New York World's Fair Corp., 1939).

4. Contemporary scholarship on world's fairs tends to fall into two categories: fairs as hegemonic vehicles promoting white supremacy and colonizing racist ideologies; or fairs as agents of the culture industry—mesmerizing the masses through a commodified form. Both are valid analyses. It would be impossible to argue that fairs were not elaborated marketplaces or sites for disseminating dominant discourses. Huge private corporations displayed their newest wares alongside exhibits created by individual nations to demonstrate their national and international superiority. Limiting analysis to these two paradigms, however, often confines the scope of interpretation by prefiguring the outcome. While conceptions of nationalism and commodification inform much of my analysis of the 1939 New York World's Fair, by considering the fair as an art form and examining the often contradictory

definitions of art displayed there, this chapter investigates the relationship between nationalism and commodification as manifested in the perceived merger of art and life on display at the 1939 New York World's Fair over the relationship between art and democracy that had been taking place in New York during the 1930s. All of the artistic debates outlined in the previous chapters surfaced at the fair, often in surprising ways.

5. Paul Greenhalgh writes in *Ephemeral Vistas* (Manchester: Manchester University Press, 1988), "The Fine Arts were an important ingredient in any international exhibition of caliber. They were the . . . non-functional aspect of human endeavor every nation had to be seen to participate in to avoid charges of philistinism" (198).

6. See Caro, *The Power Broker*; and Frank Monaghan, *The Official History of the Fair* (New York: Britannica, 1937). Interestingly, phoenixlike imagery—out of the ashes rose the fair—was also heavily used to describe the 1893 Chicago Columbian Exposition in which the white city lauded as "the foremost wonder of the world" was created in the wake of the devastating fire that burned four miles of Chicago, killed three hundred people, left over a hundred thousand homeless, and destroyed $200 million worth of property. See William Cronon, *Nature's Metropolis* (New York: Norton, 1991), 345.

7. *New York World's Fair Views*, n.p.

8. Holger Cahill, *American Art Today* (New York: National Art Society, 1939), 1.

9. Walter Dorwin Teague, "Why Disguise Your Product?" *Electrical Engineering* 22 (October 1938): 363.

10. *Art Digest* (May 1939), box 571, 1939 New York World's Fair clipping file (hereafter NYWF), New York Public Library (hereafter NYPL).

11. Walter Dorwin Teague, "Industrial Design of The New York World's Fair," Norman Bel Geddes, cited in Bush, 160.

12. Donald Bush, *The Streamlined Decade* (New York: G. Braziller, 1975); Martin Greif, *Depression Modern* (New York: Universe Books, 1975).

13. "Midget Artistes" brochure, Amusement Zone box, NYWF, NYPL.

14. La Guardia quoted on webpage for the University of Virginia's project, *America in the 1930s*, http://xroads.virginia/~1930s/Display/39WF.

15. Teague, "Industrial Design at the New York World's Fair."

16. Emily Genauer, "Hope for Art Show at World's Fair," *New York World Telegraph*, February 5, 1938, 13.

17. *New York Times*, November 21, 1938, n.p., box 571, NYWF, NYPL.

18. The fair, Pearson argues, "was fathered by 118 prominent citizens as incorporators, of whom 58 are representatives of big business, 22 are bankers, 13 lawyers, 12 officials connected with public service, 6 from professions and education, 5 from all art fields, and 2 are representatives of labor. Please ponder the implications of this proportional representation as the proper set up for the control of policy in such great community enterprises as a World's Fair. 80 business minds vs. 39 of all other persuasions if we list the lawyers on the professional side of the fence. Two to one, this, in favor of business—or three to one, almost, if the lawyers are shifted to

the business side, where in relation to the arts, they undoubtedly belong." Ralph Pearson, "The Coming World's Fair," *Art Front* (March 1936): 4.

19. The American Artists' Congress is discussed in Chapter 1, above.

20. Pearson, "The Coming World's Fair," 4. Emphasis mine.

21. American Artists' Congress *Newsletter* (June 1936): 1.

22. Cahill, *America Today*, 1–2.

23. *New York World's Fair News*, n.p., *Albany Tribune*, August 5, 1939, n.p., box 571, NYFW, NYPL.

24. First prize was a round trip to Bermuda, including a week at a famous hotel. Second prize was a parlor suite for two at the Hotel Lexington, New York, for five days; third prize, a large bottle of Chanel perfume. Fourth prize, one hat made to order by Lilly Dache; fifth prize, one course of beauty treatment or the equivalent in cosmetics from Helena Rubinstein's Fifth Avenue salon; and sixth prize, one travel case fitted with Barbara Gould cosmetics. From "Modern Day Madonna Brochure," misc. file, 1939 NYWF, NYPL.

25. McAlister Coleman, "Grassroots at World's Fair," *Common Sense* (June 1939): 9.

26. *Daily Oklahoman*, September 4, 1938, n.p., Both in box 571, NYWF, NYPL.

27. See Chapter 2 for more on the *Community Art Center Manual*.

28. *New York Times*, June 18, 1939; *New York World Telegram*, clipping file, NYWF, MoMA Archives.

29. "The Federal Art Project at the 1939 New York World's Fair," brochure, misc. fair file, MoMA Library.

30. Cahill, *American Art Today*, ix.

31. See Chapter 2 for links between community art centers, children, and notions of "future citizenship."

32. Cahill, *American Art Today*, 20–21.

33. Michael M. Hare, "Basic Speeches on the World Fair with Relation to Theme and Architecture," December 22, 1936, file Pr1.41, NYWF, NYPL.

34. Marcia Conner letter, November 14, 1938, misc. folder, NYWF, MoMA Library.

35. The Wolfsonian Museum of Propaganda and the Decorative Arts, Miami, has over two hundred pieces relating to the 1939 New York World's Fair; I have been given many a world's fair souvenir over the years; and the Smithsonian Museum of National History, according to curator Charlie McGovern, has thousands of fair-related pieces.

36. Grover Whalen, *What the World's Fair Means to Business and Industry*, n.p., June 1937, NYWF Press Office, publicity bulletins, Special Collections, NYPL.

37. For more on the relationship between advertising and the fine arts, see Michele H. Bogart, *Artists, Advertising, and the Borders of Art* (Chicago: University of Chicago Press, 1995); and Roland Marchand, *Advertising the American Dream* (Berkeley: University of California Press, 1985).

38. Gilbert Rhode to Robert Kohn, October 27, 1937, File C1.02, Rhode File, NYWF, NYPL; Egnold Arens, "The New York World's Fair, 1939," *Architectural Forum* 68 (April 1938): 442–43.

39. *Democracity* voiceover and "Official Song" quoted in the *Official Guide, New York World's Fair, 1939* (New York: Exposition Publications, 1939), 27–29.

40. Whalen, *What the World's Fair Means to Business and Industry.*

41. Bel Geddes quoted in Bush, *Streamlined Decade*, 160.

42. The literature on the idea of the spectacle is vast. I am employing the concept put forth by Guy Debord in *The Society of the Spectacle* (Detroit: Red & Black, 1983): "In societies where modern conditions of production prevail, all of life presents itself as an immense accumulation of *spectacles*. Everything that was directly lived has moved away into a representation" (paragraph 1). While Debord and the Situationists were writing about a particular set of historically bound circumstances in mid-twentieth-century France, the 1939 New York World's Fair certainly provides a rich site for examining a similar transformation in the United States. For Debord, "The spectacle is not a collection of images, but a social relation among people, mediated by images" (paragraph 4). Regarding the rise of spectacular society in the United States, see also Daniel Boorstin, *The Image: A Guide to Pseudo-events in America* (New York: Atheneum, 1971); Umberto Eco, *Travels in Hyperreality* (New York: Harcourt Brace Jovanovich, 1990), and Jean Baudrillard, *Simulacra and Simulation* (Ann Arbor: University of Michigan Press, 1986), and *America* (New York: Verso, 1988).

43. John McAndrew, *Modernistic and Streamlined*, MoMA Bulletin 5, no. 6 (December 1938): 2.

44. Walter Dorwin Teague, "Industrial Design and Its Future," address delivered at the annual reception of the School of Architecture and Applied Arts, New York University, November, 18, 1936, file C1, NYWF, NYPL.

45. In an essay entitled "Democratic Social Space: Whitman, Melville, and the Promise of American Transparency," in Philip Fisher, ed., *The New American Studies* (Berkeley: University of California Press, 1990), Fisher argues that in the United States the creation of nationalism, or what he calls "democratic social space," was premised not on shared religion, language, ideology, or historical considerations, as in most other countries, but on economic considerations (70–111). Similarly, in *Advertising the American Dream*, Roland Marchand discusses what he terms the "democracy of goods."

46. President Franklin D. Roosevelt quoted in *The Official Souvenir Book of the World's Fair*, n.p.

47. Grover Whalen, quoted in New York Fair Corporation, "Your World of Tomorrow," informational brochure on *Democracity* (New York, 1939), n.p. Collection Queens Museum. Walter Dorwin Teague, *Design This Day* (New York: Harcourt, Brace, 1940).

48. Press release quoted in Robert Rydel, *The World of Fairs* (Chicago: University of Chicago Press, 1993), 131.

49. Ford Motor Company, "The Road of Tomorrow," pamphlet, Wolfsonian Collection.

50. There were also a number of allegorical statues representing civil rights and the universal rights of humanity throughout the fairgrounds. Their inclusion, like the statue of Washington, celebrated "American democracy" as it existed in the past, informed the present, and reached into the future.

51. J. L. Hautman to El-Hanani, May 17, 1938, Palestine Pavilion box, NYWF, NYPL.

52. *Encyclopaedia Britannica*, 1938, s.v. "New York World's Fair."

53. Or rational-critical debate, in Habermasian terms. For more on this topic, see the essays in Craig Calhoun, ed., *Habermas and the Public Sphere* (Cambridge, Mass.: MIT Press, 1992).

54. Bruce Bliven, "Gone Tomorrow," *New Republic* 98 (May 7, 1939): 42–49.

Chapter 5. The Triumph of American Art?

1. Clement Greenberg, "Avant-Garde and Kitsch," *Partisan Review* (Fall 1939); reprinted in *Art and Culture: Critical Essays* (Boston: Beacon Press, 1961), 9–10, 8.

2. Greenberg, "Avant-Garde and Kitsch," 19, 21.

3. I discuss the ways in which the American public acted as both producer and consumer at the fair. In "The People's Fair," in *Culture as History* (New York: Pantheon, 1984), Warren Susman argues that the 1939 New York World's Fair was the first to emphasize the process of manufacture—to include "the people" in the manufacturing process. The final step in this process was, of course, the consumption of the product (153).

4. "The artist today," Davis argued, "knows more and capitalist society has given individual liberties which made special investigations possible. That at the same time it has failed to support him properly is bad, it must be remedied by social reorganization. But," he asserted, "in cutting out the rotten part of social organization it would be stupid to destroy the positive, scientific values that have developed even under the bad conditions." N.d., reel 31, Stuart Davis Papers, 1922–1937, Davis Journals, Houghton Library, Harvard University.

5. Davis Journals, August 1941, reel 37, Stuart Davis Papers.

6. "Buy American Art Week," national report and publicity information, Buy American Art Week file," MoMA Library.

7. Florence Kerr, national report press release, June 22, 1941, MoMA Archives.

8. Transcript of radio program, "Art and Our Warring World," broadcast on NBC Radio, November 24, 1940, MoMA Archives. For more on "Buy American Art Week," see Serge Guilbaut, *How New York Stole the Idea of Modern Art* (Chicago: University of Chicago Press, 1983), 55–57.

9. For more on the transformation of WPA community art centers into art for the defense centers, see Richard D. McKinzie, *The New Deal for Artists* (Princeton, N.J.: Princeton University Press, 1973), chapter 9, "Relief Art on the Defense, 1938–1943," 149–72.

10. Franklin Roosevelt to Philip Fleming, December 4, 1942, reel HP4, AAA. For more on the defense projects, see McKinzie, *New Deal*, Chapter 9, "Relief Art on the Defense, 1938–1943," 149–172.

11. United American Artists Committee, October 1941, roll 483, Julien Levi Papers, AAA.

12. United American Artists Committee *Bulletin*, March 1942, roll 483, Julien Levi Papers. Co-Ordinating Artists' Committee Conference notes, November 3, 1941, roll 483, Julien Levi Papers.

13. John Hay Whitney, preface to MoMA Bulletin, *Posters for the National Defense* (New York: MoMA, 1941), 1.

14. Wendell Willkie, introduction to *"Airways to Peace: An Exhibition of Geography for the Future,"* MoMA Bulletin 11, no. 1 (August 1943): 3.

15. Exhibition, *Useful Objects in Wartime*, MoMA Archives.

16. Letter published in *Useful Objects in Wartime* Bulletin, n.p., MoMA Archives.

17. Gallup results in Susman, "The People's Fair," 218.

18. Robert Stern, Gregory Gilmartin, and Thomas Mellin, *New York 1930* (New York: Rizzoli, 1987), 755.

19. *World's Fair Bulletin No. 1*, n.d., quoted in Robert Rydell, *World of Fairs* (Chicago: University of Chicago Press, 1993), 186.

20. Florence Topping Green quoted in Fair news release, no. 2370, box 519, NYWF, NYPL.

21. Howard Putzel, exhibition, New York, NY, 1945; *A Problem for Critics* and Greenberg, "The Thirties in New York," in John O'Brien, ed., *Clement Greenberg: The Collected Essays and Criticism* (Chicago: University of Chicago Press, 1986).

22. "Myth makers" was a term commonly used to describe Abstract Expressionist painters. For more on the term, see Michael Leja, *Reframing Abstract Expressionism* (New Haven, Conn.: Yale University Press, 1993).

23. According to Arthur Danto, in *After the End of Art* (Princeton, N.J.: Princeton University Press, 1997), for Greenberg, "the substance of art slowly becomes the subject of art" (66).

24. The Pollock mythic persona still exists. In 1998, he was the subject of a major retrospective at the Museum of Modern Art. Writing in the October 19, 1998, *New Yorker*, Adam Gopnick compared Pollock to Walt Whitman as well as to James Dean and Marlon Brando. Pollock is the subject of two major motion pictures and, perhaps most important, was featured on a U.S. postage stamp. The stamp features one of the famous Namuth paintings; his cigarette, however, has been airbrushed out. In 1999, smoking was no longer "cool." Adam Gopnick, "Jackson Pollock in Perspective," *New Yorker* (October 19, 1998): 76.

25. There is a huge secondary literature on Abstract Expressionist painting. Perhaps because of its decidedly nonrepresentational nature, over the past fifty years Abstract Expressionist art has been read in many different ways, much of it overtly political. I have divided the criticism on Abstract Expressionism into three schools: contemporaneous celebrations, 1970s conspiracy theories, and current revisionist histories. The most famous celebrations include Harold Rosenberg, "The American Action Painters," *Art News* 51 (December 1952): 22–23, 48–50; and Clement Greenberg and Irving Sandler, *The Triumph of American Art*. The conspiracy theories include Max Kozlof, "Abstract Expressionism During the Cold War," *Artforum* 9 (May 1973): 43–54; and Eve Cockcroft, "Abstract Expressionism: Weapon of the Cold War," *Artforum* 10 (June 1974): 39–41. Both are reprinted in Francis Frascina, ed., *Pollock and After* (New York: Harper and Row, 1985). The most nota-

ble work in this category is Guibaut, *How New York Stole the Idea of Modern Art*. The best contemporary works on Abstract Expressionism include Erika Doss, *Benton, Pollock, and the Politics of Modernism* (Chicago: University of Chicago Press, 1991); Leja, *Reframing Abstract Expressionism*; and Stephen Polcari, *Abstract Expressionism and the Modern Experience* (New York: Cambridge University Press, 1991). Scholarship on Abstract Expressionism has come in waves, with each new generation promoting a different political project.

26. They also asked this question: *"Is modern art as a whole, a good or bad development, that is to say, is it something that a responsible people can support or can they neglect it as a minor and impermant phase of culture?"* (italics in original). "A *Life* Round Table on Modern Art," *Life* (October 11, 1948): 56, 65–67.

27. Regarding the proliferation of visual data—newspapers, journals, and books—between 1870 and 1890, Alan Trachtenberg writes, "The apparently unique, the shocking, the 'new' provided a way of making history seem immediate and personal just at a moment when its individuality and unpredictability had seemed to disappear." He differentiates between experience and information, arguing that "the more people needed newspapers for a sense of the world, the less did newspapers seem to be able to satisfy that need by yesterday's means and the greater the need for shock and sensation, for spectacle," *The Incorporation of America* (New York: Hill and Wang, 1982), 125.

28. See Doss, *Benton, Pollock and the Politics of Modernism*.

29. "*Life* Round Table," 56, 65–67.

30. "*Life* Round Table," 67.

31. The articles had major commercial results as well: Pollock's dealer sold out of his paintings soon after the *Life* article ran.

32. "Baffling U.S. Art: What It Is About," *Life* (November 16, 1959).

33. Clement Greenberg, "The Present Prospects of American Painting and Sculpture" (1946); reprinted in O'Brien, *Clement Greenberg*, 2: 163. Greenberg was also the main source for a *New York Times* magazine article entitled, "Here a Critic Gives Some Clues to the Reasons why Pollock's Work Has Been Commanding Prices That Are Astronomical" (*New York Times Sunday Magazine*, April 16, 1961). This article also featured the Namuth photographs of Pollock at work.

34. Danto, *After the End of Art*, 14, 68.

35. Danto, *After the End of Art*, 7. For Danto, "The great master narratives which first defined traditional art, and then modernist art, have not only come to an end, but that contemporary art no longer allows itself to be represented by master narratives at all" (xiii).

36. Danto, *After the End of Art*, 76.

37. Robert Motherwell and Ad Reinhardt, eds., *Modern Artists in America* (New York: Wittenborn Schultz, 1951).

Index

Acknowledgments

This book has benefited from the wisdom, criticism, and expertise of many people. At New York University Lizabeth Cohen, Andrew Ross, Thomas Bender, and Barbara Kirschenblatt-Gimblet offered stellar advice and together taught me the true meaning of interdisciplinary work. In particular, I would like to thank Lizabeth Cohen for her continued support and advice. Liz pushed me to clarify my thoughts and frame my ideas, and she demanded vigorous analysis in both my thinking and my language. Because of her patience, guidance, and thoughtful suggestions, this work is much stronger. Tom Bender suggested I frame this project around the idea of desacralization, and Andrew Ross repeatedly encouraged me to consider the larger political implications of instituting democracy in art. Thank you.

My graduate-student compadres, Amy Richter, David Serlin, Michael Lerner, Betsy Duquette, Francesca Coppa, and Bridget Brown, also helped tremendously with the writing process—as critics, as support group, and as friends. David and Amy were there since the very beginning of this project and continued throughout to help me fine-tune my argument and organize my often jumbled ideas. I look forward to the productive exchange of ideas for many years to come.

Beth Drenning (a.k.a. Jack) has been an excellent friend and sounding board since high school. I thank her for listening to me ramble about this project over Thai food in the East Village, on walks around Delaware Park, and via email from Down Under. Her thoughtful comments on the Introduction pushed me to infuse it with some of the passion that I feel for the subject.

Many of my colleagues and students in the Eastman Humanities Department and the Program in Visual and Cultural Studies at the University of Rochester also assisted in the shaping of this book. Jonathan Baldo, Tim Scheie, Jean Pedersen, and Ernestine McHugh helped me negotiate the process of writing a proposal and applying for grants. Rachel Ablow, Reinhild Steingrover, Kimberly Healy, and Andres Nader, as well as other members of the Susan Junior group, provided much-needed support and

friendship as well. Our regular coffees under the guise of the Susan B. Anthony Center for Women and Gender Studies meetings hit "the spot." I would also like to thank Paula Mamuscia for all of her technical assistance, Kim Kopatz and Stephanie Hranjec for their help with the visual resources collection, Catherine Zuromskis and Daniella Sandler for their excellent research skills, and Lucy Curzon for taking exceptional care of my children while I made the final revisions.

The Rochester U.S. History group (RUSH) read drafts of the first two chapters. In particular I want to thank Alison Parker, Mark Rice, and J. P. Dyson for their helpful suggestions.

Thank you to all of the archivists and librarians who helped me along the way; in particular those at the Museum of Modern Art, the National Archives, the Queens Historical Society, the Rockefeller Archives, the Fogg Museum and Houghton Library at Harvard University, the Wolfsonian Museum of Propaganda and the Decorative Arts, the Museum of the City of New York, the New York Public Library, the Schomburg Library, the Archives of American Art, Bobst Library at New York University, and Rush Rhees Library at the University of Rochester.

For their help in securing the permissions and reproductions for the many images within, I would like to thank Anne Gurnsey, Faye Haun, and Eileen Morales at the Museum of the City of New York; Cara Maniaci Behrman at VAGA, New York; Holly Reed at the National Archives; Lucienne Allen at Old Stage Studios; Richard Sorensen at the Smithsonian Museum of American Art; Victoria Jennings at the New York Art Commission; Judy Throm at the Archives of American Art; Ryan Jensen and John Biencewicz at Art Resources; Pat Magnani at the Neuberger Museum at SUNY—Purchase; Jim Orr at the Ford Archives and Old Greenfield Village; Dorothy Davilla at the Fogg Museum at Harvard University; Joan Recupero at the Syracuse University Art Museum; Rona Tucillo at Getty Images; and Grace Anderson-Smith at Time-Life Inc.

In addition, I would like to thank the Society for the Preservation of American Modernism (SPAM) and the Eastman Faculty Development Fund for helping to offset the cost of including all of these images.

Bob Lockhart, my editor at the University of Pennsylvania Press, was exemplary. I appreciate his thoughtful comments as well as his level of professionalism. He made this endeavor a thoroughly enjoyable one. His enthusiasm for the project inspired me to clarify my thoughts—and make my deadlines. I would also like to thank Casey Blake and Dan Borus for their careful readings of my draft manuscript. Their questions and insights

allowed me to extend the scope of my argument while refining its central premise.

My family was a source of boundless support and encouragement. My brother Joseph Saab and his family—Martha, Carmen, Lily, and Margaret—my sister Bridget Van Sickle, along with Mark and Leo, and Dave and Pegge Brauer, as well as the extended Brauer brood, provided an excellent support network; calming me when I needed it and cheering with me when appropriate. I would particularly like to thank my parents, Richard and Maureen Saab, for their unflagging assistance: emotional, financial, and practical. They instilled in me a love of learning at an early age as well as the tenacity necessary to finish this work. Thank you for being proud of what I do and for never questioning why I chose this crazy career path—at least not to my face.

Finally, I dedicate this book to Stephen Brauer, my intellectual sparring partner as well as life partner. Thank you for reading countless drafts, for fixing my commas, for administering to innumerable book-related maladies, for regularly loading and unloading the dishwasher, and, most important, for bringing joy into my life. And to my two guys, Phineas Saab Brauer and Wilson Saab Brauer, you inspire me to fuse art and life every day.